3D Game Environments

3D Game Environments

Create Professional 3D Game Worlds

Luke Ahearn

AMSTERDAM • BOSTON • HEIDELBERG • LONDON
NEW YORK • OXFORD • PARIS • SAN DIEGO
SAN FRANCISCO • SINGAPORE • SYDNEY • TOKYO

Focal Press is an imprint of Elsevier

Senior Acquisitions Editor: Laura Lewin
Publishing Services Manager: George Morrison
Project Manager: Mónica González de Mendoza
Associate Editor: Georgia Kennedy
Marketing Manager: Marcel Koppes
Cover Design: Eric Decicco

Focal Press is an imprint of Elsevier
30 Corporate Drive, Suite 400, Burlington, MA 01803, USA
Linacre House, Jordan Hill, Oxford OX2 8DP, UK

Recognizing the importance of preserving what has been written, Elsevier prints its
books on acid-free paper whenever possible.

Library of Congress Cataloging-in-Publication Data
Ahearn, Luke.
 3D game environments : create professional 3D game worlds / Luke Ahearn.
 p. cm.
 Includes index.
 ISBN-13: 978-0-240-80895-6 (pbk. : alk. paper) 1. Computer games—
Programming. 2. Computer graphics. 3. Three-dimensional display
systems. I. Title.
 QA76.76.C672A42143 2008
 794.8'1526—dc22

 2008001735

British Library Cataloguing-in-Publication Data
A catalogue record for this book is available from the British Library.

ISBN: 978-0-240-80895-6

For information on all Focal Press publications
visit our website at www.books.elsevier.com

08 09 10 11 12 5 4 3 2 1

Printed in China

Working together to grow
libraries in developing countries

www.elsevier.com | www.bookaid.org | www.sabre.org

ELSEVIER BOOK AID International Sabre Foundation

Contents

Chapter 10

Chapter 11

To Julie, Ellen, and Cooper.

Acknowledgments

NVIDIA, for permission to use their images.

Makers of SpeedTree, Oblivion, Age of Conan, Plant Life, Tree Magik, Bryce, Torque, L3DT, Caustics Generator, Deep Paint, and PD Particles.

Everyone who makes available all the numerous tools and resources for the game development community.

All my readers. Ann Sidenblad, Gary Strawn, Sara Vangorden, aka Cory Edo, and the mystery readers at Focal.

All the people at Focal Press for their support and expertise.

The Author

Luke Ahearn has over 15 years of professional game development experience, and has served in lead positions such as designer, producer, and art director on seven published game titles, including *Dead Reckoning* and *America's Army*, and worked as a background artist at EA. He has authored six books on game development, and has operated his own computer game company for ten years. Currently, he is art director and partner at ICPU.

Introduction

Let me begin by saying that this is not a book about game level design; rather, it is about creating art for a game world. This is an important distinction. Game level design is the point at which all the planning, technology, and design converge; and creating the art for that game level is only one part that feeds into that huge process. Yet it is an important part, one that requires you to be creative but also technically aware of the tools and processes being used to develop the game. In the back of this book you will find a DVD that contains all of the software listed, all the figures from the book, and all of the file for the projects and exercises in the book. The 3D files are in the Max format and the images are both JPEG and Photoshop files.

One of the most important areas for the game artist is optimization, so the book begins with that topic. A game programmer at EA, Gary Strawn, laid out the problem this way: "[As I read through your book I was] constantly reminded how bad communication between artists and programmers often is. Programmers assume the artists will optimize everything, while artists assume the programmers are in charge of optimization. The truth is that it takes both. Every game is different and technology is always changing so it's vital that the artists and programmers are in constant communication."

The creation of the art for the game world happens before, during, and after the level has been laid out and tested—in other words, during production, the most intense time of the game's life for the artist. So you, as a game or environmental artist, need to be ready to create art that fills many predetermined design and technical sockets quickly and iterate quickly through changes too.

APPROACH

The purpose of this book is to look at the task before us in universal terms that will plug into any situation you are developing under. At the basic core, you can use almost any commercial two-dimensional (2D) and three-dimensional (3D) software to create the needed assets for a large number

of the commercial game engines. In practice, there are large gulfs between the monetary cost of one commercial product versus another, as well as between the results of any two products, but at the core they are all doing the same basic thing. This book gives you the foundation to learn more rapidly the basics of any set of tools you may end up using for development.

Since we are working with environments that are not tied to any specific technology or game, we won't specify particular world data such as jump heights, mantle heights (climbing over waist-high objects), or the numerous other barriers and guidelines of a level—but we will work with generic values. In other words, one generic unit could be anything from an inch to a mile—it doesn't matter. The key is to be consistent with your units. If one unit equals a mile, then how big would a house be in a relative sense? If one unit equals a foot, then a human might be six units in a relative sense. (You may be surprised to know that in a game, a character may be eight feet in relative terms and the door he is walking through is fifteen feet high. The point is, this is all a starting point; you end up doing what works best for the game and discarding accuracy.)

ARTIST VERSUS LEVEL DESIGNER

This book is strictly about environmental art—creating art—and not level design or designing the world for game play. I want to make the focus of this book as clear as possible. But even though this book is focused on creating game art, before you start creating art for a game, it helps to have a basic understanding of level design because we can't make the art for the game without the game being designed first.

Another reason I want this to be clear is because some development studios hire one person to do both of these jobs. In my opinion it is better to have two different people do these two different jobs. There are some people who can do both jobs well, but I think it is better to let the game designer design the level for playability and let the artist make it look good, especially since we are now seeing assets in games that are far more detailed and complex to create. You need the artist working full time. And the level designer's job is so important I would want that person totally focused on the task full time as well. However, if the decision to hire one person to do both of these jobs is a conscious and well-considered decision on the

part of the studio hiring and an experienced developer, then it should work out fine.

Note: If you want to be one of those people who can do both jobs, then you need to also study level design, and there are lots of great sources for that information already. Phil Co wrote one of the best books on the subject, as has Andrew Rollings. But beware! There are a lot of lousy books too. Most of the verbose studies on what's fun are akin to ripping a flower apart to understand beauty.

Finally, the game artist should have many questions already answered before creating any art. So you need to know the questions to ask. Most of these questions can only be answered after the level has been designed and you know where the player can go and what he can and can't do.

Even though I don't cover it in this book, I can't stress enough how important good level design is. It's one reason I think you need a person dedicated to the task. Sure, the art can look great and draw the attention of the player, but if the game play is poor, users will soon stop playing and word will spread rapidly that the game is a dud. If you are playing a game you really like, I would bet that a good deal of the credit goes to great level design. The locations, story lines, and mission flow are all extremely important, and it is the artist's job to support and enhance the goals of the level designer (and all leads as well), as they work to make these aspects of the game as good as possible.

The jobs of level designer and environmental artist are very different.

The Level Designer

Level designers design the areas of the world the player can go into. They design the layout, the puzzles, the challenging obstacles, and the like. They are responsible for making the game fun. This is easier said than done. A lot of tweaking and testing goes into this, but at the end of the day the ability to design a great game is really a talent some people just have. The level designer is often the single person on the team who brings all of the separate parts of the game into one place and creates the entity known as "the game."

Level designers must work with lead designers and artists to make sure they capture mood and setting. They will work with the programmers to make sure they implement things correctly and will often need to learn some

basic programming or scripting to properly implement the events of the game. They will work with the artists as they begin to incorporate the art into the world. The level designer needs to know how assets are stored and where, what they are named, and so on. He or she will probably be the one that implements a lot of the optimizations discussed in Chapter 1 and will either ask, or need to be told, how the artist intended the art to be used in the game. As the artist you might want to go see how the art you created looks in the game and then make any changes necessary. The level designers also inevitably need to work with the producers and project managers, as their job depends on all of the other team members, more so than any other job. They use everything created by the team to make the ultimate creation.

Level designers do a lot. They lay out the world map, script behavior, place enemies and triggers, profile the games performance, and on and on. Here is a list of some of their many tasks.

- Laying out the world in detail, whether on paper or with a computer application

- Learning the game editor in order to build the world: creating terrain, buildings, and the general world space the player moves in

- Importing and prepping art assets for use in the game

- Placing start points, spawn points, and power-ups such as ammo and health

- Making map navigation work, with doors, teleporters, and the like

- Placing sound entities for music and effects

- Lighting the level for mood as well as game play

- Scripting events

- Laying paths for the artificial intelligence (AI) bots

- Utilizing all available optimizations

- Testing the game play continuously

The Environmental Artist

Environmental artists are akin to the set designers on a movie set. And like the set designer, we have to know a lot about the world we are creating

and how the audience will view that world. This is made a bit tougher because, unlike in the movies where the set designer controls exactly what the viewer sees, in a game the player can usually move around the world with some degree of freedom. The environmental artist should have access to the art bible and design document (it wouldn't hurt to read them either). When you begin creating art for a game, you need a lot of information. At EA during the production of GoldenEye, we not only had a team of lead artists, designers, and directors (who all worked together incredibly harmoniously considering the size of the development), we also had access to a library of everything Bond—every movie, every book, every poster. The walls were covered in the concept art for the game. It was easy to see what they wanted the game to look and feel like. In this book we look at each project from this point. For instance, we don't just start creating an environment; we first look at all the questions that should be asked and answered before anything can be created. Among the major factors affecting art creation are:

- theme

- perspective

- genre

- world size

- technology

- and, of course, time, money, and other limitations

Any serious development should have these aspects well thought out before development begins.

THEME

What is the setting of the game? Fantasy? Urban? If urban, is it modern-day, clean and shiny, dirty and grungy? Is it postapocalyptic? Theme can be tricky, especially if you are dealing with virtual development (over the Internet) or if the people involved have different understandings of what fantasy is. When I hear the word "fantasy," I think of *The Lord of the Rings*, but recently I was speaking with an individual who thought I was talking about a game idea based on a sexual fantasy. Even experienced gamers might assume that fantasy means *World of Warcraft*, and that look is very different from *The Lord of the Rings* in style.

PERSPECTIVE

How will the player see this world? Up close and personal from the point of view of a person walking, or from behind the windshield of a speeding car or an airplane? Player perspective drastically influences the development of game assets and the game world in general.

GENRE

Is this an adventure for exploring, or a fast-action shooter or driving game? Genre is a complex topic as games get more complicated and genres are blended and reinvented.

WORLD SIZE

Will the levels be huge like in a massively multiplayer online (MMO) game, or small like the hall of a space station in a shooter?

TECHNOLOGY

Are we using a licensed engine or an in-house tool set? What are we developing for—PC, Xbox? Will the levels load or stream? Are we using Max or Maya to create assets?

By the time you start working on environmental art, many things should already be known:

- Technical budgets: frame rates, texture memory, polygon counts, and the like

- Technical stats: file formats, acceptable resolution and sizes

- A naming and storage convention

- How collision will be handled

- Characters, monsters, and nonplayer characters

- A list of the environments you have to build with reference

- Any special items you might have to build, such as ammo, power-ups, special doors, objects mentioned in the design document

- How the players can move and what they have access to in the world. Can the players fly? Can they climb walls? Player movement will have a huge impact on the game world.

- What size should things be in the world? How high are stairs, doorways, and countertops? How high and far can players jump?

- The mood you are trying to set. Is this a horror game or a comedy?

- Are you using a license to an existing world or character?

WHOM THIS BOOK IS FOR

This book is for individuals who are just getting comfortable with the creation of basic 2D and 3D assets and want to deepen their understanding so they can effectively create assets for 3D applications like games and web applications such as *Second Life*. Game developers, architects, simulation developers, web designers, and anyone who needs to create assets for a 3D computer application and is just starting out will find this book useful.

OVERVIEW

Section One: The Basics

Chapter 1: Orientation to Game World Optimizations

Making a game run at its very best is called *optimization*. It is a common belief that this is solely the domain of the programmer—but nothing could be further from the truth. It is, in fact, everyone's job to optimize from day one. Because the artists have a huge impact on how well a game runs, we need to know, and use, every trick possible to achieve this. Artists need to be familiar with the most common methods of game world optimization, as much of what can be done to optimize a game is under the artist's control and takes place during asset creation or the implementation of the asset into the world.

Chapter 2: 3D Concepts

This chapter introduces the basic concepts of 3D modeling you will most likely be working with. Once you understand these concepts, you can more easily use the tools at your disposal to create the art in this book. We will

not discuss how to do any of the specific functions for any given 3D application; for that you need to consult the application's documentation. The good news is that as game artists, while we work in both 2D and 3D, we do so at a pretty basic level of functionality, so that we can easily achieve these results in virtually any 3D package.

Chapter 3: Shaders and Materials

Shaders allow for a stunning level of realism in games. Simply put, a shader is a miniprogram that processes graphic effects in real time. For example, the reflections on a surface can move in real time instead of being "baked" or permanently painted into a surface. Shader effects are very powerful visually, even if viewers are unaware of what they are seeing. For example, the average player would have a hard time defining why the game he or she is playing looks so good. It may be the real-time reflections, normal mapping, or the specular mapping being processed in real time.

There are two main types of shader on modern graphics processors (GPUs): vertex and pixel shaders. Vertex shaders manipulate geometry (vertices and their attributes) in real time. Pixel shaders manipulate rendered pixels in real time.

The ability to manipulate an individual pixel or vertex in real time is what makes the shader so powerful. Shaders can be used for many complex material appearances and image effects: hair, fire, shadows, water, reflections, and so forth. The list of possible effects is almost endless. Although consumer-level hardware has only recently become capable of handling the intense demand that real-time shaders puts on a system, the knowledge of these processes have been around for decades. In fact, many of the techniques you will read about are based on algorithms named for well-known mathematical geniuses; Phong and Blinn are recognizable names if you are a 3D artist.

Section Two: Low-Polygon Environments with Simple Shaders

Chapter 4: Introduction to the Low-Polygon Large Urban Area

The large urban environment is a pretty common setting in games. Driving is a primary activity, along with stealing cars and running over pedestrians.

Large city areas offer some unique challenges, but in many ways they are the easiest to deal with in terms of creating environmental assets. From a programmer's point of view, it is challenging to create the environment for driving in a very large area where the player can see distant buildings and drive for miles—that is, speaking strictly of the textures and models needed to fill the city. These elements tend to be repetitive by nature and inorganic. In this chapter we establish the general information needed to start creating the world.

Chapter 5: Modeling the Large Urban Environment

In this chapter we model and UV map all the parts of the large urban environment, making reference to the various technical aspects of asset creation discussed earlier in the book (so be sure you understand the basic concepts previously presented). Although large and seemingly complex, the large urban environment is based on a few categories of model, each category containing a few simple meshes. A few meshes in the following categories will completely populate our city: base streets, repeating buildings, landmark structures, and props and decorations.

By the end of this chapter you will be able to take the information, suggestions, and guidelines and develop a city scene of your own that looks unique, the way you want it to, and can operate technically in the 3D environment you are working in.

Chapter 6: Texturing the Large Urban Environment

In this chapter we create textures for all of the buildings, landmarks, props, and details from the previous sections. We create tiling base materials, tiling illumination-mapped building windows, nontiling details, non-tiling illumination-mapped details, non-tiling full-brightness details, and non-tiling details requiring alpha channeling.

Section Three: Terrain, Foliage, and More Advanced Asset Creation

Chapter 7: Introduction to Natural Environments

Building a large foliated outdoor environment can be challenging, but once you break it down to its basic elements, a game environment can be fairly

easy to create. The distinction here is that we are building a game environment, not a real environment. A real outdoor environment has many species of trees and plants with scientifically specific details. All we have to do is make this space look good and believable. To do this, we need to understand what elements should be in a certain environment; for the game artist the focus is mainly on color and shape. Of course we should try to have some degree of basic accuracy (which we can obtain by looking at pictures), but ultimately the environment we create will not stand up to the scrutiny of a botanist.

Chapter 8: Terrain

In this chapter we look at the basics of terrain creation and editing common to most terrain tools. There are three general ways to create terrain for games: manually using a 3D application, using tools in a game editor, and using a terrain generator. Since in-game terrain tools are usually tailored to that game or game engine and combine basic terrain editing features with proprietary features, we first look at the basics of terrain creation and then at some terrain-creation software. Once you understand the basics of terrain editing, you should be able to quickly master almost any in-game terrain editor.

Chapter 9: Filling the World—Trees, Plants, Rocks, Water, and Sky

While creating trees, plants, and rocks is not a huge challenge, they can take a bit of time to create. In addition, you have to do a lot of work with the alpha channel to make the foliage look just right. Inevitably it takes a number of steps to separate a tree branch from its background. I think it is much faster, and you get a better result, when you create these assets by hand. Even if you can't paint, there are numerous tools that allow for the painting, and assembly, of these assets. We look at several applications in this chapter, including TreeMagik G3, Plant Life, SpeedTree, Caustics Generator, and Deep Paint 2.0.

Chapter 10: Modeling and Texturing the Jungle Base

The jungle has grown over this once-impressive base deep in the jungle. We create all the models for the jungle base. Many of the models will be

generated for us; likewise the textures. So we can focus on making this space what we want it to be. Simple details such as which way bars on a window are bent (in or out) will tell the player if something broke in or out. Larger details may involve color choices (slick and corporate or drab and military), and the quality of the material from which any given object is created can indicate how substantial the enterprise was that existed here.

We will be creating various models and textures. Among the mechanical models are an electrically charged double access gate; an old building with doors, barred windows, and old vent pipes; a guard tower; a heavy-duty gate to keep whatever is in the jungle out; a concrete bunker-type wall to hold a massive gate; industrial light towers; and assorted signs that say ominous things. The organic models we create include rocks, plants, trees, a foliage backdrop, ground, and a skybox. The mechanical textures we develop include rusted metal, concrete, and wood; lenses for the industrial light towers; the assorted signs that say ominous things; and a specific texture for the massive doors. Finally, we create organic textures for the rocks, plants, trees, foliage backdrops, and skybox we modeled.

Chapter 11: Focus on the Futuristic Interior—Normal Maps and Multipass Shaders

This chapter focuses on the creation of normal maps and how shaders work together. Complementary maps such as color (diffuse), specular, illumination, and others combine to create the stunning in-game scenes we are starting to see. To understand a normal map, we analyze how lighting in games generally works. Then we look at the creation of the normal map.

CHAPTER 1

Orientation to Game World Optimizations

INTRODUCTION

A computer game must look good and run well. This is the mantra for the game artist. Until you have tried to accomplish this goal, you have no idea how at odds each of these objectives is with the other. Although the primary focus of this book is the generation of art assets for computer game environments, we can't escape the fact that creating art for a game is more than just making a pretty picture. When you create art for a game you need to create art that will accomplish several goals, the least of which is that your art must work technically in the game environment and work as efficiently as possible in that environment. This requires planning and creating your art to very specific guidelines. Those guidelines may change depending on many variables (we will examine these later), but they are all essentially the same variables. In any case, you need to be very well aware of what those variables are and build accordingly.

Making a game run at its very best is called *optimization*. It is a common belief that this is solely the domain of the programmer—but nothing could be further from the truth. It is, in fact, everyone's job to optimize from day one. The artists have a huge impact on how well a game runs, so we need to know every trick possible to achieve this. It cannot be stressed enough that you have to be familiar with the most common methods of game world optimization, because much of what can be done to optimize a game is under your control and takes place during asset creation or the implementation of the asset into the world.

There are many things that can or need to be done during the actual assembly of the game world—which might fall to you. Since the computer game must not only look good, but run well too, throughout the book we look at how to apply many of these optimization techniques. You will have to use every trick available to you. If you don't, the game world will not run

well enough to use or will not look as good as it can. If you fail to make the game look as good as possible due to a lack of optimization, you are wasting an opportunity as valuable as gold in game development.

Performance is usually expressed as frames per second (FPS) in a game, and there is a definite limit to what you can do as an artist, programmer, or designer based on this—no matter what system specs you are working with. If frame rate is inefficiently used in one place and goes undetected, then it is by definition diminishing the available frame rate in other areas of the game. One of my pet peeves is the last-minute gutting of a game to make it run. I have seen entire levels that have taken weeks and months to perfect gutted at the last minute. Trade-offs are unavoidable, but if you don't look at your game in its totality and track your frame rate (among other resources), you are going to get caught unaware at the end of development as the game comes together and doesn't run as you had hoped.

Let me repeat (because this drives me absolutely nuts): you have to track your resources. Just because you can run through your level at 120 frames per second doesn't mean performance is assured. You have to consider several things first before celebrating the blistering frame rate. Are you using the target machine, or are you using a high-end machine typical of most development studios? What is left to implement in the game? Are the collision detection and physics in place? What about running artificial intelligence (AI) and game logic? Sometimes the addition of a heads-up display or interface slows things down. As soon as you fire a weapon you are potentially triggering collision detection, creating hundreds of assets (particles) triggering sound events, displaying decals on walls, and so on. Think about the addition of other players and characters, and their weapons. Suddenly you have thousands more polygons on the screen, a few more large textures loading, and other assets and events. In short, can you think of every possible thing the final game will have running and guess what your frame rate target should *actually* be? You probably can't get a dead-on correct answer early in development, but an educated guess (have lunch with the programmers and question them—they'll love you for it) and the awareness that your actual frame rate will be cut in half when the game is up and running in full will help you hit a more realistic target and prevent the total raping of a game level at the last minute.

This chapter looks at some of the most common tools and techniques (accessible to the artist) used for optimizing a game world. I present them

from the artist's point of view, meaning how the tool or technique works and what control the artist generally has over it. Usually you will see that most of these tools and techniques are explored or presented from the programmer's point of view (they are very involved programmatically, to put it mildly), but artists really need to understand these devices, as they are critical to making a level look good and run well. I break optimization down into three major areas: asset, collision, and occlusion based. Aside from the things we as artists can do to optimize the game, there are of course many other areas that also need to be optimized. Most of these optimizations are found in the program code. Things like memory management, CPU and GPU code, artificial intelligence, collision code, networking, sound, and the game play itself all eat up resources and need to be optimized by the programmers.

Note: YOU! Yes, you! You the artist are responsible for a great deal of the optimization in a game. In every phase, from planning to creating the assets, to producing the assets, to introducing those assets into the game world, there are opportunities to optimize.

Even after your assets are introduced into the game world, there are opportunities to optimize. In fact, many of the optimizations possible in a game are available to the artist in the game itself. Most game development engines have a tool that will show you a read-out on screen that allows for the viewing and analysis of all the aspects of the game as it runs. As the artist you can look at the world in many modes and see what areas can be optimized. You can look at the number of polygons on screen, overlapping textures that may cause an inefficiency, and you can even see what the computer is drawing that we may not see as a player. In Figure 1-1 you can see that while the player can't see the rat on the other side of the wall, the game engine would draw it anyway because the radius of visibility can be seen by the player camera. You can improve performance by going into the editor and correcting this in a variety of ways: removing the rat, setting a draw distance, and other ways we will look at in this chapter, which are listed below.

- Asset-based optimizations

- MIP mapping

- Texture pages

- Unlit textures

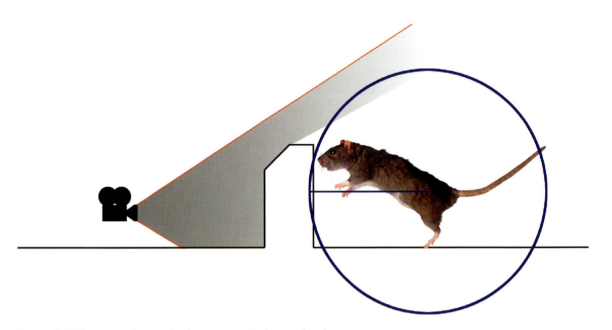

Figure 1-1 The rat can be seen by the game engine but not the player.

- Multiple UV channels
- Lightmaps
- Masking and transparency
- Texture size and compression
- Particle systems
- Forced perspective
- Polygon optimization
- LOD
- Collision-based optimizations
- Collision objects
- Collision types
- Occlusion-based optimizations
- Occlusion and culling

- View frustum

- Distance fog

- Cull distance

- Cells and portals

ASSET-BASED OPTIMIZATIONS

Asset-based optimizations are simply those optimizations you can imple-
ment and effect during asset production. Assets are the art we create, and
they present the first opportunity we have to apply any optimizations.
Technically there are always opportunities from day one to keep optimiza-
tions in mind and apply them during the design phase, but often the artist
is not present during this time. Our first opportunity is usually when we
start to create the assets for the game. Some optimizations are possible in
the design and planning of the assets; for example, the design of how a
texture is laid out affects how the UV maps are laid out and that in turn
can affect performance.

MIP MAPPING

MIP mapping, sometimes called *texture LOD* (level of detail), is usually a
programmer-controlled function, but sometimes the artist is given control
of this too. The explanation is pretty simple. A large texture seen at a far
distance in a game world looks the same as a smaller texture due to the
fact that both are being displayed using the same number of pixels on
screen; it is therefore a waste of resources to use a large texture on an object
that is far away in the game world. In addition, using a larger texture on a
small, faraway object usually doesn't look as good as the smaller texture
would, due to the fact that the larger texture is being resized on the fly by
the game engine. To solve both these problems, programmers usually
implement some form of MIP mapping. MIP stands for the Latin phrase
multum in parvo, which means "many things in a small place." MIP mapping
is the creation of multiple sizes of a texture for display at various distances
in the game (Figure 1-2). Sometimes you can see the MIP maps pop as
they change from larger to smaller, especially in older games. MIP mapping
allows the texture to be viewed close-up and in detail, as well as render
faster (and look better) from a distance. Figure 1-3 shows the MIP-mapped

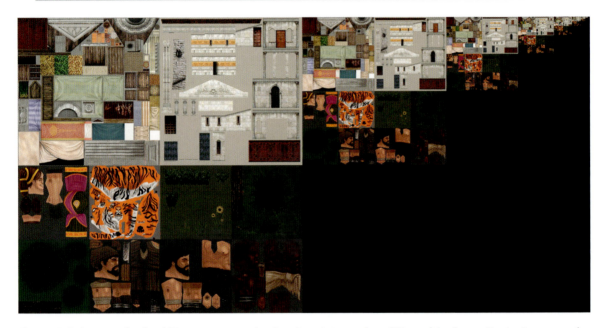

Figure 1-2 A texture that has MIP maps associated with it. Sample image from "Glory of the Roman Empire," courtesy of Haemimont Games.

texture of some jungle vines. Notice the alpha channel is MIP-mapped as well. Fortunately NVIDIA created several tools to make all this easier for the artist (Figure 1-4). The DXT Compression Plug-in is one of the most useful, and I discuss that later in this chapter in the section on texture size and compression. With this tool you can control many variables that affect the visual quality of the image.

TEXTURE PAGES (OR T-PAGES, ATLAS TEXTURES, OR TEXTURE PACKING)

This section comes with a bit of a disclaimer. It seems that the industry is now moving away from texture atlases. While atlases will continue to be

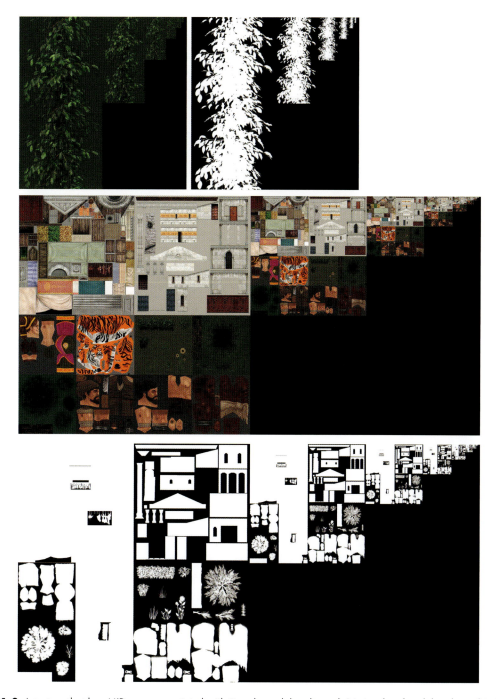

Figure 1-3 A texture that has MIP maps associated with it and an alpha channel. Notice that the alpha channel is MIP-mapped as well. Sample image from "Glory of the Roman Empire," courtesy of Haemimont Games.

Figure 1-4 This shows the interface and examples of the NVIDIA MIP-mapping tool.

an effective solution for some hardware, things are shifting over (due to technical reasons beyond me) to individual textures. That's great news to me—I find that texture atlases slow things down in the typical artist workflow.

As you build a game world, you create many textures to cover the many 3D objects in the world. When the game world is loaded and run in the game engine, the game engine has to access (call) each of those textures for each frame it renders. These calls slow everything down, so it is desirable to reduce the number of calls. There is a technique you can use called *texture packing* or creating a *texture atlas* that can accomplish this. Basically it involves taking a large group of textures that are related in some way (usually geographically close to one another in the game world) and putting them together to create one large texture. You can see a texture atlas of foliage created for a jungle level in Figure 1-5. You can create an atlas by

Figure 1-5 An example of an atlas texture.

hand or with a tool. Of course, NVIDIA makes such a tool (Figure 1-6). The primary benefit of a tool like this for the artist is the speed at which atlases can be built and altered. This tool creates the one large texture and with it a file that tells the game engine where each image is placed on the master image.

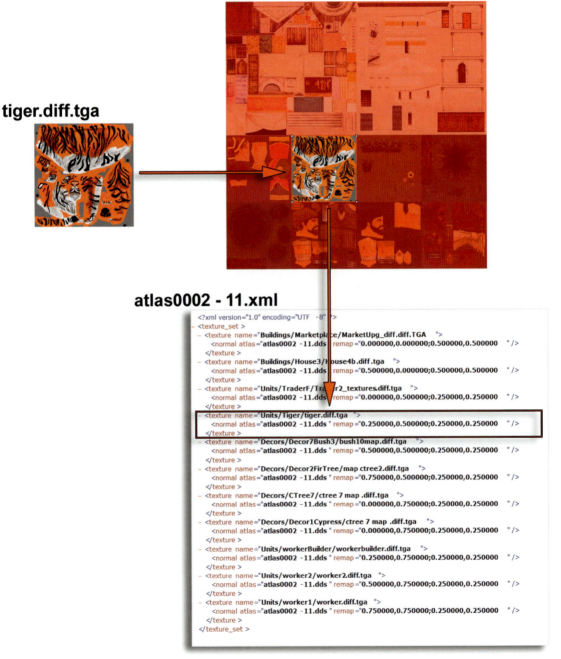

Figure 1-6 The texture atlas and accompanying index file.

UNLIT TEXTURES

An unlit texture is a texture that is unaffected by lighting and displays at 100% brightness—sometimes called a *full bright* or *self-illuminated* texture. Note that this not the same as a texture that uses an illumination map. When an illumination map is used, it must calculate lighting for a texture and take into account the grayscale illumination map. Since calculating the lighting for a texture can be one of the biggest resource hogs in a game, it can be much more practical to use an unlit texture, which renders much faster. Using unlit textures is a way to boost performance. This is easy to do with some materials such as water or certain signs, and in some game types or genres you can get away with using large numbers of unlit textures. Large forested outdoor areas can benefit from the use of unlit textures on the foliage. Figure 1-7 shows an example of a texture that is lit in one scene and then unlit in the next. Notice how the sign is at full brightness and remains unchanged by the lighting affecting the walls. Particle systems typically look better unlit and run faster as well (Figure 1-8).

MULTITEXTURING OR MULTIPLE UV CHANNELS

Increasingly in today's game engines you are not limited to one UV channel. This allows you to combine textures on a surface in real time. That in turn allows a great degree of variety from a relatively smaller set of assets. A grayscale image may simply define the dark and light areas of a surface, another map may define color, and another some unique detail. You can see an example of this method in Figure 1-9. The building mesh has a base-colored material applied; on a separate channel I applied dirt, and on another I added details such as posters and cracks. Multiple UV channels are also used to apply bump mapping and other shader effects.

LIGHTMAPS

Lightmaps are pre-rendered images that define the light and shadow on the surfaces of your world. Since lightmaps are created before the game runs and are saved as separate grayscale images this means that the total file size of your assets is increased. There are two things you can do to optimize lightmaps: lower their resolution or compress them. A smaller lightmap will result in a faster loading and running level, but lowering the resolution also lowers the quality (Figure 1-10).

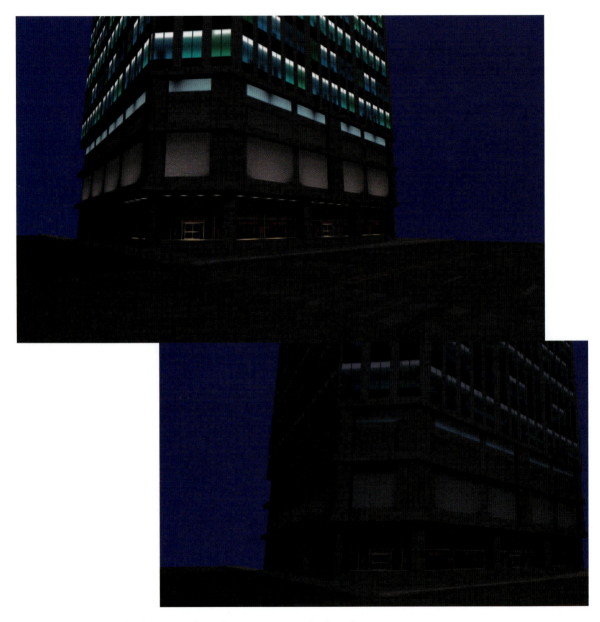

Figure 1-7 An example of a texture that is lit in one scene and unlit in the next.

Figure 1-8 Particles lit and unlit.

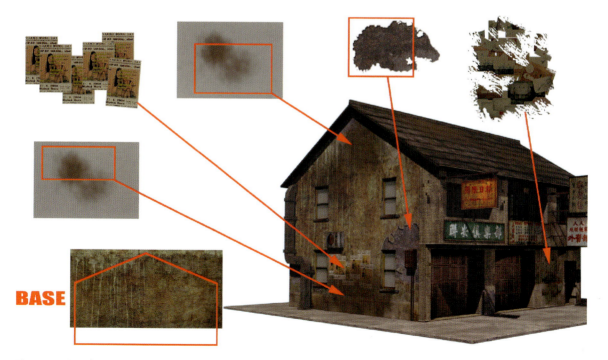

Figure 1-9 Multitexturing allows you to combine a relatively small set of assets in creating a large variety of surfaces.

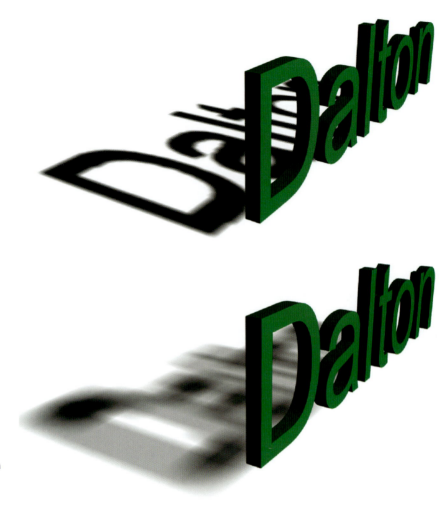

Figure 1-10 Lightmaps both large and small on the same area.

Note: For a great article on compressing lightmaps, go to Gamasutra (www.gamasutra.com, one of the largest game development sites on the Internet) and look up "Making Quality Game Textures" by Riccard Linde.

Usually you can opt out of using a lightmap or can determine at what size the lightmap will be created. This allows you to increase the resolution of the lightmap in those areas where the player can go and lower the resolution for less accessible, but visible areas.

MASKING AND TRANSPARENCY

When possible, it is preferable to use masking instead of transparency because masking renders more quickly. Take a look at Figure 1-11, as these concepts are much easier to grasp pictorially.

Masking typically uses a specific color that is designated the "clear" color, and this creates hard jagged edges (although newer hardware can handle larger-resolution textures and can post-process the images and smooth the edges).

Transparency uses a separate, additional channel, a grayscale image called the *alpha channel*, to determine the opacity of a pixel. The trade-off is that transparency looks better, but it requires more file space and more processing power. This is because while masking simply either draws the pixel or not, transparency must look at two pixels (the source image pixel and the on-screen pixel behind it), consider the grayscale pixel of the alpha channel, and calculate the color of the final on-screen pixel. Technically what you are seeing isn't real-world transparency, but rather a new image composed of a blending of two images that gives the illusion of transparency.

Of course, NVIDIA makes a tool that allows for the rapid adjusting and viewing of textures before outputting them (Figure 1-12).

TEXTURE SIZE AND COMPRESSION

You want to consider the size of each texture you create. A texture that covers most of the walls and/or floors in your world, and has to tile well while still holding up visually, needs to be larger than a texture that is displayed infrequently and is not subject to direct examination by the player. The other factor is compression. A compressed texture file can be significantly smaller than an uncompressed one yet still maintain visual integrity using the right combination of compression options. NVIDIA makes a plug-in for Photoshop that allows for the rapid and easy iteration through many compression schemes before final output of the file (Figure 1-13).

Remember that there are many factors to consider when determining texture size and compression. How close will the player get to the asset? How often will the asset appear in the world, and how many times is it

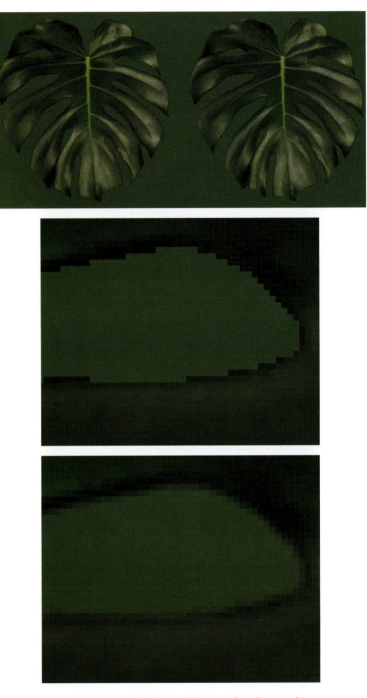

Figure 1-11 How the three methods discussed here work with examples.

NVIDIA dds Format (v7.83)

8:8:8:8 ARGB (32 bit) Save Cancel

Volume Texture

MIP Map Filtering... Sharpening...

Image Options... Normal Map Settings...

Fading MIP maps... Write Config...

Read Config...

*n*VIDIA.

Comments to SDKFeedback@nvidia.com

MIP Map Generation
- Generate MIP maps
- Use Existing MIP maps 6
- No MIP maps

2D Preview 3D Preview

Refresh Preview Preview Options...

Profiles

Set Profile Directory Save Profile

Load Profile

<no profile loaded>

Preview Options

- Alpha Blending
- Show Differences (magnified 10x)
- Enable Filtering
- Anisotropic
- ☑ Display MIP Mapping
- Disable MIP map generation
- Enable Lighting for Normal Maps
- Use Image

Select Background Image

C:\ArtDrive\testMapNew.jpg

Formats
- ☑ DXT1
- DXT1 (alpha)
- DXT3
- DXT5
- 16 bit RGB (4:4:4:4)
- 16 bit RGB (1:5:5:5)
- 16 bit RGB (5:6:5)
- 32 bit ARGB

Background Color

OK

Figure 1-12 The interface and various windows of the NVIDIA tool as applied to masking and alpha.

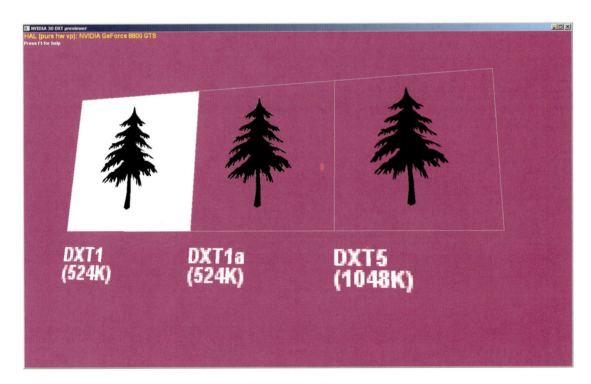

Figure 1-13 The interface and various windows of the NVIDIA tool as applied to the compression options.

expected to tile or repeat? Can you achieve the same effect with a more efficient solution? Can you use three small textures on multiple UV channels as opposed to one enormous texture? How much can you compress or reduce the resolution of an image and still maintain visual integrity? One of the most valuable but underappreciated skills a game artist can acquire is knowing not only the various ways of implementing game art solutions, but what methods and combination of those methods comprise the best solution.

PARTICLE SYSTEMS

Since we are not programmers, we can't optimize the particle code, but we can control many variables that will allow us to improve the performance of the particle system. A particle system displays an asset in great numbers (the asset is usually a small polygon—two triangles—with an applied texture that has alpha transparency on it). The system tracks the asset/particle in 3D space using a set of parameters that the artist can change. These parameters typically alter the rate, size, speed, position, and life span of the particle as well as telling the particle to shrink, fade, or always face the camera (which it usually does). Particles can even physically interact with the game world, colliding and bouncing off surfaces.

A particle system can be used to simulate a wide variety of effects, from smoke to a flock of birds. Traditionally, particle systems, with their large numbers of particles, have been a big drain on a computer, so the effects that game developers could achieve have been limited. But as software has become more complex and game hardware more powerful, smoke and fire and other impressive effects can be very effectively generated even while using a much larger number of particles.

The point at which the particles are spawned, or appear, is called an *emitter*. An emitter can be of any size. A small emitter with a lot of particles coming out in a spray may be what you would use for a garden hose, whereas a very large emitter high in the sky of your game world with a few particles falling from it might be used for rain or snow. Often special particle systems are written for specific uses. Specific particle systems that handle weather effects, for example, are commonly created because weather systems have a more limited function but cover a larger area compared with a typical full-featured particle system. These special versions of a particle system

allow developers to make them run more efficiently. This is achieved partly by simply dropping the features of a typical particle system that are not needed for a more specific-use particle system. Emitters and particles are typically represented by some sort of icon in the game editor but are invisible in the game—you only see the assets spawning at the emitter point and being controlled by the particle entity they are attached to. Usually the game artist, when placing an emitter, makes sure it looks as if the particles are coming out of something and not just from thin air.

While a simple particle system may only contain an emitter, a polygon, and a texture, more complex particle systems can contain multiple emitters and multiple textures and use 3D meshes as particles. An explosion is usually composed of a quick ball of fire and a spray of debris, followed by smoke that drifts from the blasted area and dissipates into the air. This is typically created using a blast decal and several systems, one for each effect: flash, debris, and smoke. Additionally, particle systems are usually associated with sound events. Sound adds a lot to the effect a particle system has. What would rain be without the rumble of thunder? How effective would a silent explosion be? When a fire crackles as you approach, it adds another level of realism and immersion to a game. In Figure 1-14 you can see some of the most common aspects of a particle system.

As far as optimizing particle systems, try the following:

- Use unlit textures. This should be standard for most particle effects.

- Use the most efficient asset possible in terms of resolution and file size.

- Use the necessary masking/alpha scheme.

- Turn off particle collision if possible.

- Have particles die or fade out quickly.

- Use only the necessary number of particles.

- Use the best asset for the particle (this is related to the previous point). A thousand little dots don't look as cool as a hundred great particles.

- Tweak! Take your time and you can make ten particles look better than a hundred. Ten particles that behave and display in an impressive fashion are generally much more pleasing than a hundred particles dropping in some slipshod default display.

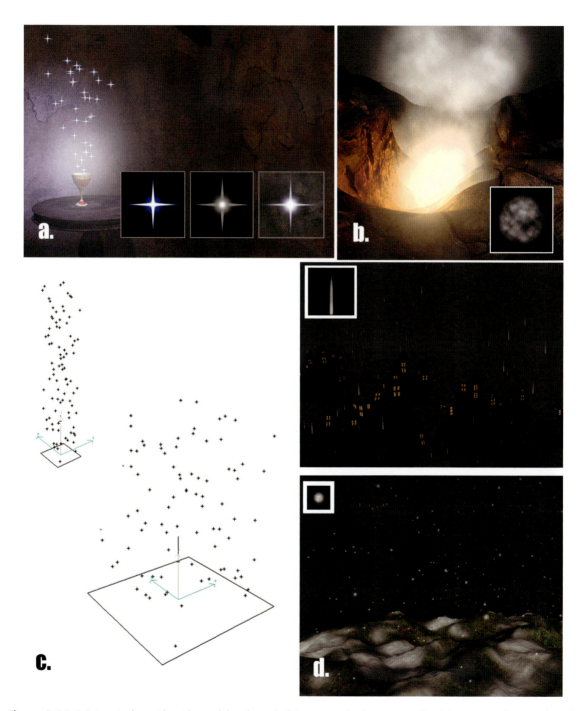

Figure 1-14 (a) A typical particle with an alpha channel; **(b)** a steam cloud using particles; **(c)** an emitter large and small with the same number of particles spawning from it; **(d)** a particle system used to create rain and snow.

FORCED PERSPECTIVE

Forced perspective is a trick used on stage productions and in places like museum displays to make an area look much larger than it really is. This involves simply taking what would be the real perspective lines of a scene and forcing them into a tighter angle. This takes up less space but looks the same—from the right angle. This technique has limited, but powerful uses. In Figure 1-15 you can see that the player can only view this scene from a limited angle, so this is a good use of forced perspective to make the game world look much larger than it actually is.

POLYGON OPTIMIZATION

Artists can manually delete any back, or unseen, faces on a mesh. They can also do a great deal to ensure stability and efficiency when building assets, by seeing to it that they have none of the following:

- Floating or single vertices

- T junctions

- Stacked or multiple faces

- Bad angles or sizes of polygons

And depending on the game technology, they can (and should) also ensure that:

- Sealed geometry or all unseen faces have been removed

- There are no polygons of a certain dimension or proportion

- There is a limited number of smoothing groups or none at all

Since polygon optimization consists mainly of removing polygons you cannot see and building your geometry in a way that uses as few polygons as possible, we will tackle this on a case-by-case basis. Several factors affect each decision: Can you use normal maps? Does the geometry need to be sealed? Does the polygon contribute to the visual quality of the mesh? How close does the player get to this mesh, and how important is it to the level?

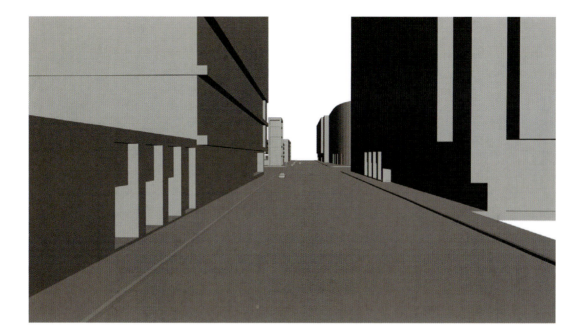

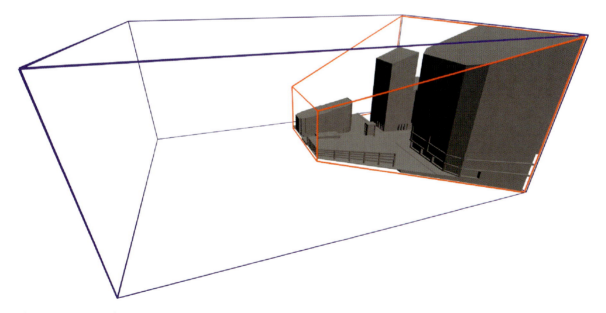

Figure 1-15 Forced perspective makes this city street look much longer than it really is.

LEVEL OF DETAIL (LOD)

Level of detail (LOD) works on the same principle as MIP mapping. Up close, you benefit from a high polygon model, but when the model is far off in the game and is displayed using far fewer pixels, you don't need to draw the high polygon model; instead you can swap it for a much lower polygon model. As with MIP maps, not only is the swap undetectable, but often the smaller asset looks better because it was created to be viewed smaller.

There are two basic ways to utilize an LOD system. You can build several versions of the model, each getting progressively smaller in poly count, and these models will be swapped by the game engine; or you can auto-generate these models. In my experience auto generation usually doesn't look as good as doing it by hand.

COLLISION-BASED OPTIMIZATIONS

Collision is another area where programmers have a huge task before them. (True, I say that about every programming task—AI, sound, whatever; it's all complexity that eats resources.) Collision, to an artist, simply means when stuff runs into other stuff. Yet collision is actually a difficult task to pull off and a resource hog when it happens. So we need to understand how we can get fewer objects hitting other stuff so things happen faster. Fortunately, when you collide with an object in a game, unlike in the real world, you aren't necessarily hitting what you see. Collision is usually determined by entities that are invisible to the player, so even though you see a model of a highly detailed car in Figure 1-16, the player is just inter- acting with an extremely low polygon object you can't see in the game. That unseen object is typically called a *collision hull* or *collision mesh*. Another non-real-world advantage we have is that we can determine *what* collides with a particular surface and how (meaning what computational method is used). In general, the more accurate and comprehensive the collision, the more expensive it is.

COLLISION OBJECTS

There are several ways you can set up your world, and the objects in it, for collisions. You can use simple generic collision solutions that detect

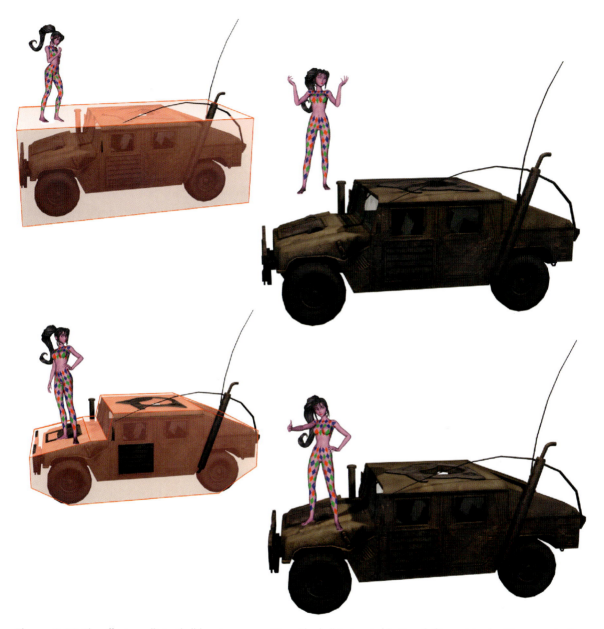

Figure 1-16 The effect a collision hull has in a game. **Top:** The hull is too simple (**top left**), and the book's mascot looks like she is floating when on top of it (**top right**). **Bottom**: The hull is a little more complex, but a lot more effective (**bottom left**). The figure looks like she is actually standing on the car hood (**bottom right**). Note that the collision hull might be even a bit more detailed (depending on the game), so players can crawl under the vehicle or interact with it in an even more refined manner.

collisions in a simple primitive shape such as a cube, sphere, or cylinder. You can let the actual geometry of the world object be the collision hull and detect collisions on every polygon, or you can build a low poly collision hull specifically for the asset. Remember that collision hulls are invisible to the player, but the effect they have on the world is not. A simple primitive may be a quick solution to implement for collision detection and may run very efficiently in the game, but may also net terrible results. Using the actual mesh as the collision hull is highly accurate but also extremely inefficient, especially since polygon counts have gotten much higher in games. You can use automatic collision hull generators, but I rarely use them as I find the results are usually poor. It is always faster for me to build a hull from scratch than mess with the auto-generated one.

The best solution is usually to build a hull. This is fairly easy, and you only need to know a few things. How will players interact with the geometry? Will they be able to jump on it, or are they supposed to be totally blocked by it? (See Figure 1-16.) What collision events are tied to the hull you are creating? Is this only for the player to bump against? Does this hull determine where bullet impacts are drawn? Sometimes you create one simple hull for player interaction and a more complex one for the detection and display of impact events (Figure 1-17).

COLLISION TYPES

There are many things that can potentially collide in a game world, and these all produce various results (block player, start or end an event, display an effect). But we don't want to check for every possible collision and result every time an object collides, as this would be a very big burden on the processor. We must check for different collision events for different entities and assign different responses. Take, for example, a game with players and AI bots in the same world space. If you are on a high narrow bridge with no rails spanning a lake of deadly molten lava, it is part of the game play challenge that you stay on the bridge and not fall in while fighting the enemy. The enemy, however, is usually a dim-witted bot who would walk into the lava and die if we let him. The programmers could code a "do not walk in lava" or "detect edge that leads to danger" routine *or* we could throw up a simple collision wall that only blocks the NPC (non-player character or computer controlled character) and not the player.

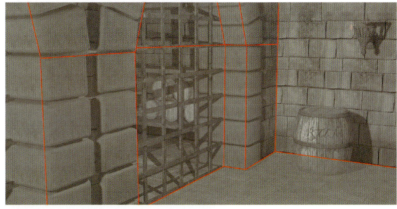

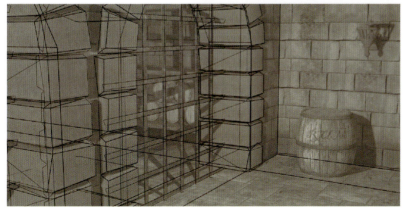

Figure 1-17 Top: The higher polygon visual scene. **Middle**: The collision hulls for player interaction. **Bottom:** Impact event detection and display hull.

We are given many options when dealing with collision. In addition to the collision detection solution (simple solution or custom-built hull), we also have a lot of input into what collides with what and what happens when a collision is detected. A great example of this is weapon impact. When a player shoots a wooden door with a shotgun, it would be reasonable to expect a shower of splinters. If he shoots a large pane-glass window, a crash and a shower of glass shards should result. When shooting a creature, one would expect a shower of blood and guts. Players would probably notice (and be disappointed) if every time they shot something the same thing happened. Every surface in a game has a set of sound effects, decals, particle systems, and so on associated with it for every different impact event. A shotgun hitting dirt is going to look and sound different than a shotgun hitting metal or glass. A thrown knife hitting metal will sound different than the shotgun hitting metal. It is usually someone's job to track all this and make sure that as assets are introduced into the game, the correct properties are assigned to it. Often a spreadsheet is developed for every weapon, projectile, and surface type in the game to ensure that everything is accounted for during production. You need to know what sound effects, decals, and other assets need to be produced and what sound effects and other events must be assigned to each surface in the world.

You can also control aspects of collision such as distance. If an object is very far away, you can decide not to detect any collisions on the object, as this is more efficient. If an object is close but unreachable by the player, you might want to detect for bullet collisions so the bullet effect can be displayed, but not detect for player collisions.

OCCLUSION-BASED OPTIMIZATIONS

Occlusion and Culling

The word *occlusion* means that one object is blocking another from view. The word *cull* generally means to remove an unwanted or unproductive member of a group. So in the context of a computer game, the simple explanation for occlusion and culling is that you don't draw (or cull) what is not seen (or occluded). The programming involved in fast and effective occlusion and culling is very complex, and there are numerous methods and algorithms involved. The reason you as an artist need to understand this is so you can take optimal advantage of the technology and design the

world or level in the manner that most effectively executes (and avoids the weaknesses of) the occlusion and culling methods your game engine utilizes. And you will also have some degree of control over how the occlusion and culling methods are utilized in the world.

Optimizing the usage of occlusion and culling is where you can get some of your most significant performance gains. To assist you in this, most game engines have some sort of tool that allows developers to examine the level in detail. You can usually view the game world in various modes and see what is being drawn, and gather data on what is making things run slowly. Quite often you will discover that objects invisible to a player in a normal game mode are being drawn anyway. But even when your level is running great, if you can make it run faster you can add more stuff to it and make it look better; or you can free up frame rate for another area of the game to use. There are various forms of occlusion, ways for you or the game application to tell the game engine what not to draw. The occlusion and culling devices most commonly used by artists include:

- View frustum culling

- Cull distance

- Backface culling (manually)

- Cell and portal occlusion

- LOD (level of detail)

- View frustum

The frustum is the area of the world visible to the player, or camera view. The frustum is a pyramid that starts at the point of view of the player and extends off into infinity at a determined angle (Figure 1-18). Like a camera lens, the wider the angle, the more fish-eyed the view. In Figure 1-19 you can see two images; both were rendered with a camera in the exact same spot. The only difference is the camera angle. The camera on the right has a wider angle lens than the one on the left. A wider angle allows us to see more of the world, but the image is greatly distorted.

You can determine where the frustum begins to draw objects and where it stops drawing objects. These settings are called the *near* and *far clipping planes*. The plane closest to the camera is the near clipping plane, and the plane farthest from the camera is the far clipping plane (Figure 1-20).

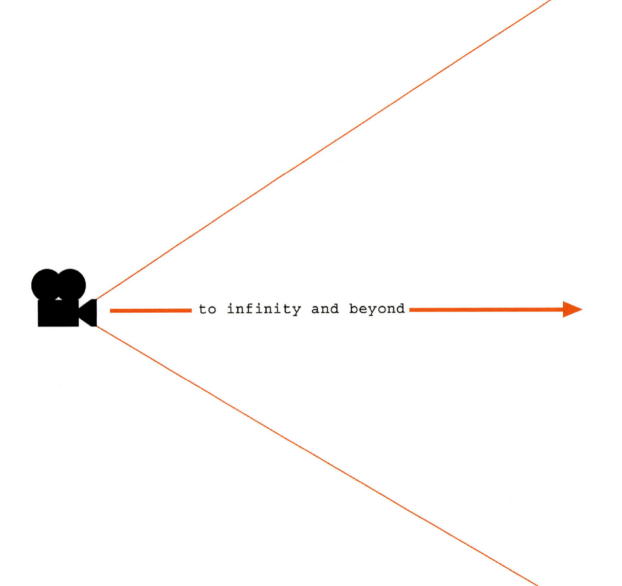

to infinity and beyond

Figure 1-18 The view frustum.

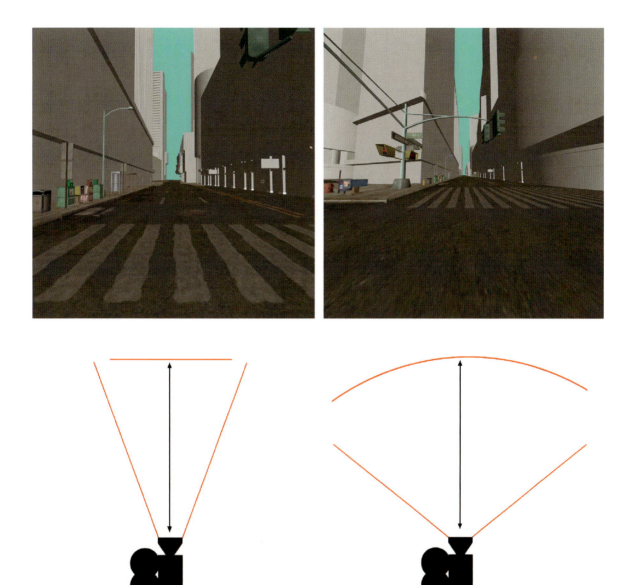

Figure 1-19 Like a camera lens angle, the angle of the view frustum affects the distortion of the scene.

All of the six planes of the cube that comprise the viewable world have names: near plane, far plane, left plane, right plane, top plane, and bottom plane. The frustum is used in a process called *frustum culling*, which at its simplest is the process of determining which objects are visible to the player so the game engine doesn't have to draw them. While the clipping plane

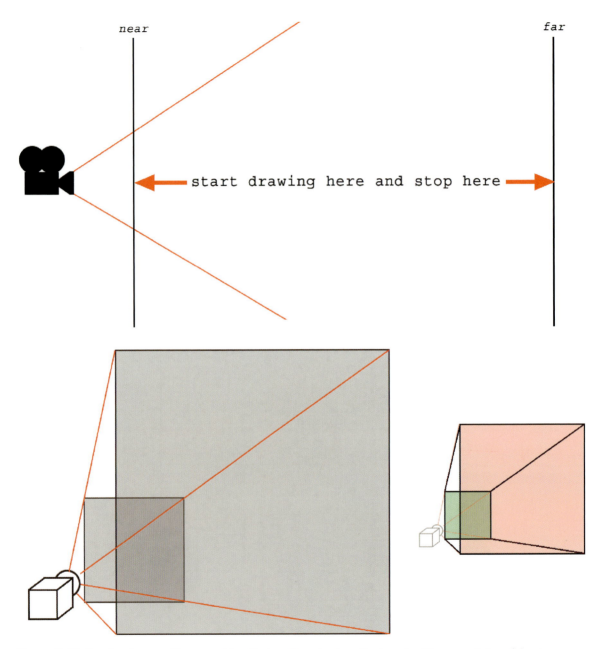

Figure 1-20 The view frustum with near and far clipping planes in place (**top**), and a 3D representation of the view frustum. The **bottom right** further clarifies the 3D space drawn in the game world.

can greatly speed up a game level, a major drawback to its use is that you can see objects pop in and out of existence. One method to remedy this is distance fog.

Distance Fog

As just mentioned, distance fog hides the popping in and out of culled objects (objects that suddenly disappear as they pass beyond the far clipping plane). But distance fog can also be used to increase the sense of distance, atmosphere, mood, and setting, through the use of color and other adjustable parameters.

The simplest form of distance fog works by tinting the pixels in a scene a selected color, based on how far they are from the camera (Figure 1-21). As with near and far clipping planes, you can assign a point at which the fog starts to tint the pixels and a point at which the pixels become completely the selected color. This is usually called the *minimum fog distance* and the *maximum fog distance*. You use distance fog to prevent objects from popping out by setting the far clipping plane just beyond the maximum fog distance. Some game engines will automatically set a clipping plane if distance fog exists. While distance fog can be used to speed up a level, you should be cautious because there are many other forms of fog that are very expensive computationally and will slow things down.

Other types of fog in a game world are volumetric and controllable in nature. Some types allow for the horizontal layering of fog, and still others can fill a specified space or volume. More complex forms of fog can change colors depending on certain circumstances. If you are outside on a bright snowy day looking into a dark dungeon opening, you would want the world distance fog to be white and the dungeon's distance fog to fade to black. If a character ran away from you on the outside of the dungeon, she should be affected by the exterior distance fog and fade to white, but if she ran into the dungeon she should fade into black.

Cull Distance

Cull distance is an optimization that simply tells the game engine not to draw an object if it is a certain distance away (Figure 1-22). Whereas the clipping plane determines the point at which no objects are drawn, the cull distance is a unit of measure assigned to a specific object in the world. This

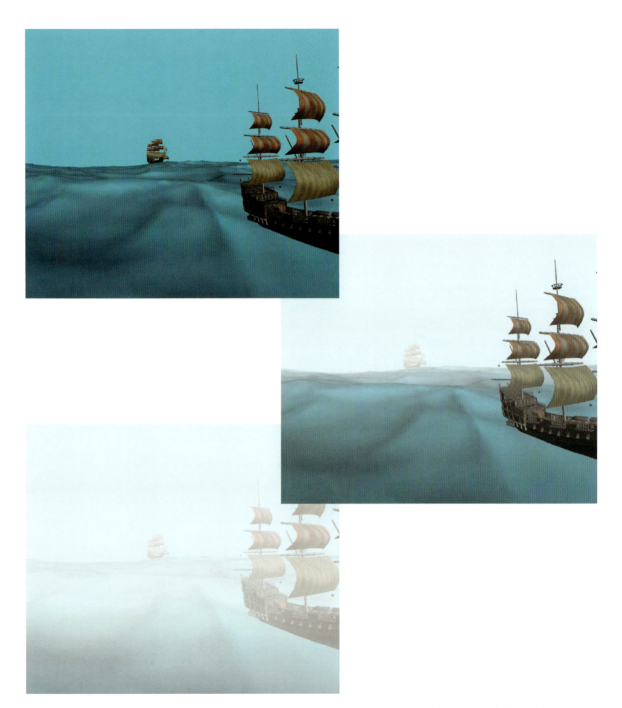

Figure 1-21 No distance fog; distance fog starting away from the camera and ending far away; and distance fog starting close to the camera and ending far away.

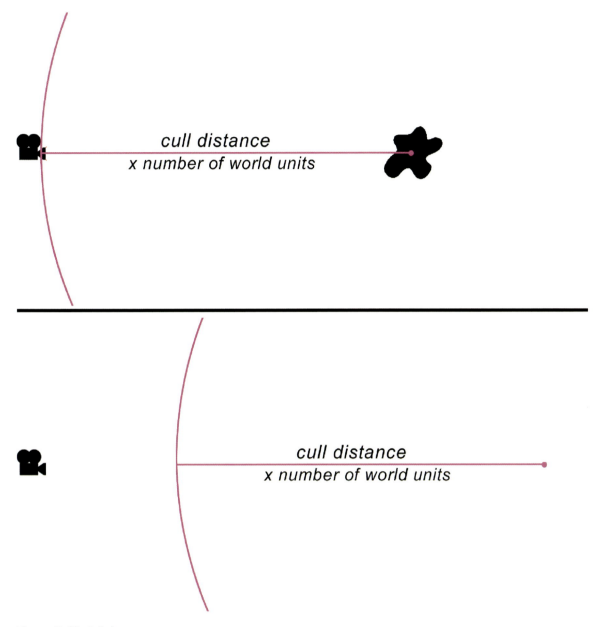

Figure 1-22 Cull distance.

can be useful when certain visibility schemes draw objects you can't see and you have to tell it to not draw the object. Some game engines allow for additional functionality, such as the ability for a mesh to fade in and out and shrink and grow with distance. This helps smooth the transition between drawing and not drawing the object. Most game engines today have built-in systems for foliage and decorations that allow for the controlled placement of these objects and manage their fading in and out and other similar behaviors. Quite simply, cull distance is a defined distance at which the game engine will not consider rendering (or drawing) an object.

Note: Culling distance also applies to collision objects. You can tell the game engine to stop tracking various collision types at various distances. For example, you may want to stop tracking player collisions on an object across a room from the player, but you will still want to track projectile collisions in case the player shoots the object from across the room.

Cells and Portals

Another way to optimize a game world is by using cells and portals. This is basically the assemblage of rooms (*cells*), and a door to each room called a *portal*. When a player is in a room (cell), the engine looks at which other cells are visible through the doors (portals) leading out of that cell. This quickly eliminates a lot of the world that doesn't need to be rendered. Some common setups between cells can be seen in Figure 1-23 . There are many other creative setups to prevent the player from seeing too much of the world all at once.

PLANNING

Of course, the best optimization of all is planning your level to be efficient using the best combination of the tools you have available. In general, you will want to occlude the transition between two large areas, if at all possible. Balance the complex with the simple. You don't have to have every inch of the world covered in high detail—in fact, that is confusing, ugly, and actually reduces the impact one nicely detailed area can have. Use composition and drama over more assets! Take the time to polish and tweak everything you can. Ten well-orchestrated particles can look better than a hundred that were implemented quickly using default settings. A smaller,

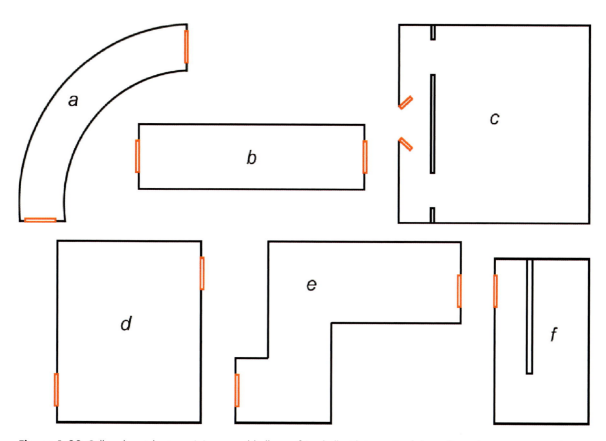

Figure 1-23 Cell and portal setups. (**a**) a curved hallway; (**b**) a hall with two sets of doors that only open one at a time; (**c**) and (**f**) doors open into a wall that occludes a larger room or separate area; (**d**) and (**e**) offset doorways.

well-painted texture can look better and actually have more detail than a sloppy, large texture. Ask yourself whether there is a better and more efficient way to achieve any objective you may have. Keep track of all that you come up with, and develop a checklist of things to do to an asset before considering it complete. At one studio we actually designed and developed a plug-in for Max that ran a series of checks on a mesh before we considered it final. We also met regularly and compared notes.

The importance of designing, planning, and just plain iterating through your level cannot be underestimated. So far, almost every level I have worked on has been a special case to some degree. There are always numerous opportunities in any game world to achieve greater or lesser optimizations and visual quality. The sheer number of choices you are given when

building a game world allows for an almost unlimited combination of approaches to any given situation. Take time to ponder the best solution, then experiment and collect data. If you do this early on, the rest of the game world will come together more quickly and allow you to devote more time to the actual visual polishing of the world.

CONCLUSION

That was a quick overview of the most common artist-accessible game optimizations. As we progress through the book we will use some of these optimizations in the projects so you can see how they might be implemented in an actual game development scenario.

CHAPTER 2

3D Concepts

INTRODUCTION

This chapter is only an introduction to the concepts of 3D modeling you will most likely be working with. Once you understand these concepts, you can more easily use the tools at your disposal to create the art in this book. For the details on how to do any of the specific functions for any given 3D application, you need to consult the documentation for that application. The good news is that as game artists we work in both 2D and 3D, but at a pretty basic level of functionality, so that you can easily achieve these results in virtually any 3D package.

A note on texture and polygon budgets: In environmental (and all game) art we still need to control our asset budgets. Even though we are able to use much larger assets (poly counts and textures), we don't want to use a high poly model if it is for a simple background world prop. By definition, environmental art is still easier and more basic than modeling characters, vehicles, or weapons. This is true for a few reasons. Environmental art needs to tile and be efficient. It cannot overshadow the characters and important features of the world. It's like formatting text. If every word in this book were bold and underlined, it wouldn't mean anything, it would only be annoying to read. Bold and italics are reserved for **special** words, very, very **special** words. So too must assets be reserved for special places and events in the game. The front of a castle may require more textures, polygons, and just plain artistic attention than the empty hut down the road. Likewise, a racing game is going to focus assets on the cars and not the buildings blurring past in the background. This is not to say the buildings are not created to the same standards as the cars, simply that the car will require more resources to achieve the required level of detail.

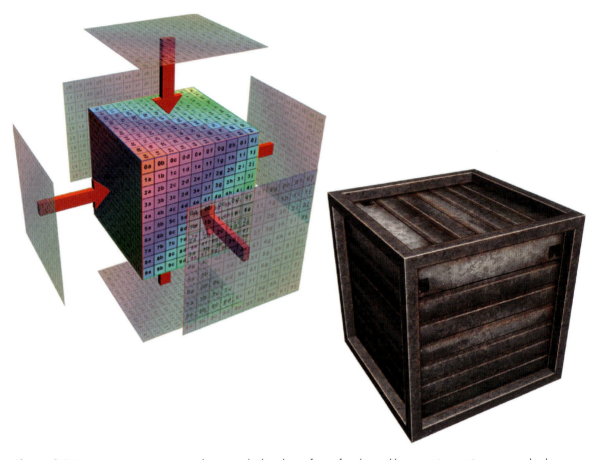

Figure 2-1 A texture map is an image that is applied to the surface of a shape, like wrapping a picture around a box to make it look like a crate in this figure.

TEXTURE MAPPING

Although creating the texture is a 2D process, texture mapping—the process of applying 2D art to the 3D objects in the world—is part of the 3D process. Textures add a huge amount of detail and richness to a 3D model. A texture map is mapped (applied) to the surface of the shape in various ways, like wrapping a picture around a box to make it look like a specific object—a crate, for example (Figure 2-1).

In environmental art we create a lot of 2D and 3D assets. Here we will look at the most often used 3D concepts you need to be familiar with. We will create the 2D art as well, but for a deeper education on 2D art creation, please refer to my book *3D Game Textures* (Focal Press, 2006). We will

Figure 2-2 The process of UV texture layout and mapping.

address texture creation on a simpler level in this book, and we will turn our focus to the application of textures to the mesh. In *3D Game Textures* the emphasis was strictly on 2D art and texture creation, but here we learn how to map the textures to the 3D assets we create and to use shaders. The creation of textures for the models in this book will be addressed on a case-by-case basis as we create them for each project. This includes the creation of the UV template and the application of the texture to the model (Figure 2-2).

Note that there is a distinction between a texture and a skin. A skin is the art that goes on a more complex model such as a character, monster, or weapon. Skins are generally not tileable and are created for a specific mesh. A texture is generally the art that covers the game world surfaces: grass, floor tiles, walls, and the like, and UV-ing these surfaces is much simpler than skinning an organic model.

MAPPING TYPES

When applying textures to a mesh in a 3D program, there are some tools that will apply the textures rapidly in a set fashion with the push of a button. While these tools are useful and quick, they have drawbacks that

make them useless in some applications or, at the least, produce results that must be cleaned up. Such pushbutton tools assume that the mapping type is applied to the entire mesh. However, mapping types become more useful when used on a face-by-face basis. We will get to that level of mapping in the projects when we actually start laying out UVs. Right now we will look at the pushbutton mapping types, since they are the basis for more complex mapping. They are as follows.

Planar

Planar mapping works like a projector. The texture is projected onto the 3D surface from one direction. This can be used on walls and other flat planar surfaces but is limited and can't be used on complex objects since the process of projecting the texture in one direction also creates smearing on the sides of the 3D model that don't face the planar projection directly (Figure 2-3).

Box

Box mapping projects the texture onto the model from six sides. This works great on boxes! Used on a more organic mesh, there will be seams and smearing on portions of the model (Figure 2-4).

Spherical

Spherical mapping surrounds the object and projects the map from all sides in a spherical pattern. The drawback to this mapping type is that you can see an edge where the textures meet unless you have created a texture that tiles correctly. Also, the texture gets gathered up, or pinched, at the top and bottom of the sphere and needs to be dealt with in the texture. Spherical mapping is obviously great for planets and other spherical objects (Figure 2-5).

Cylindrical

Cylindrical mapping projects the map by wrapping it around in a cylindrical shape. Cylindrical mapping can be used on tree trunks, columns, and other cylindrical objects (Figure 2-6).

Figure 2-3 Planar mapping projects the texture onto the 3D mesh from one direction.

Figure 2-4 Box mapping.

UV EDITING

These mapping types are all limited in their uses. Later on we will start the process of editing the UV coordinates for a model. This is the process you will use most of the time when mapping a texture to an object. It is a face-by-face process that can be tedious, but is extremely important for the efficiency and the quality of the assets.

Multitexturing

Multitexturing is the process of laying multiple textures on one mesh. This is powerful because you can mix and match many smaller, simpler textures over a surface to get a very wide variety of looks on your meshes. (See

Figure 2-5 Spherical mapping.

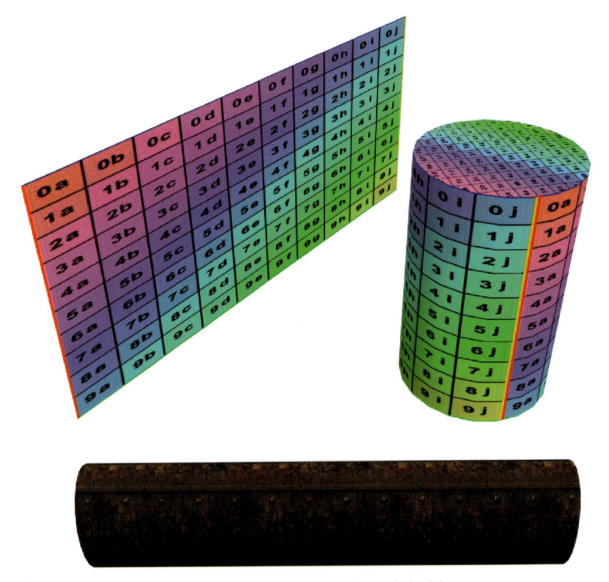

Figure 2-6 Cylindrical mapping projects the map by wrapping it around in a cylindrical shape.

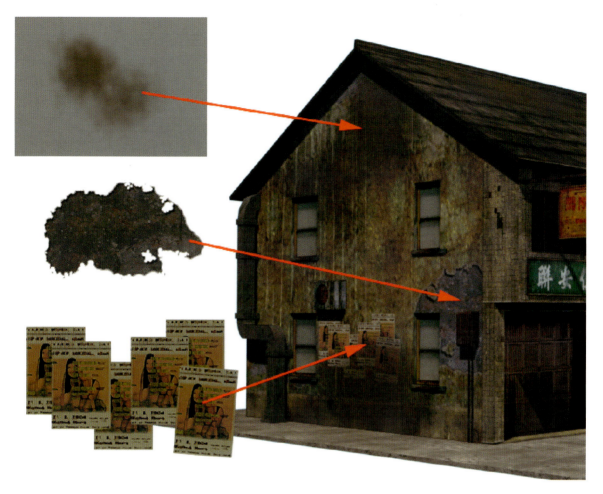

Figure 2-7 Multitexturing.

Multitexturing or Multiple UV Channels in Chapter 1 for a detailed explanation of multitexturing.) Figure 2-7 shows a simple example of multitexturing.

3D

The very basics of 3D start with the vertex. The vertex is represented by a dot on screen, but in reality it is a mathematical location in 3D space defined by three numbers, or the xyz location. Three or more vertices connected to each other is a polygon. Many polygons together create a mesh (Figure 2-8).

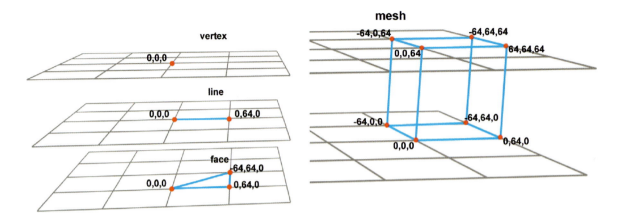

Figure 2-8 The creation of a 3D object.

You can edit 3D objects at many levels, from an individual vertex to an element. The basic parts of a mesh are as follows (see Figure 2-9):

- Vertex

- Edge

- Face

- Element

3D SPACE

When working in 3D on a computer, we are actually looking at 2D images that update fast enough that we feel as if we are actually looking at a 3D object when we move about it. That being the case, we need to utilize many tools and functions to help us overcome these limits. First we will look at the little window into our 3D world, which is usually called a *viewport*.

Viewports

Viewports are like the portholes of a ship: tiny, restricted openings looking into to a much larger world. To overcome this restriction we need to use any trick or tool we can. First off, buy as many big monitors as you can afford and your system can support. With the drop in the cost of flat screen monitors and video cards, it can be feasible to make this upgrade. You can put all your menus on one screen and work on art on another. I usually have my 3D application on one screen (say, on my left side) with all the

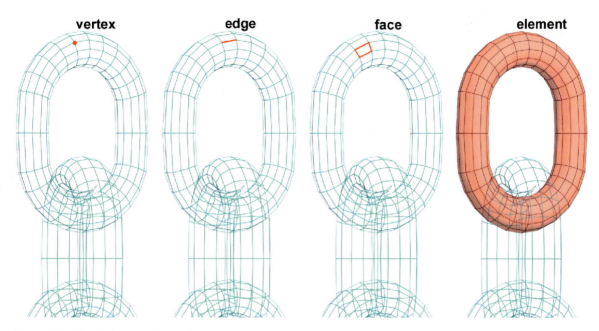

Figure 2-9 The basic parts of a mesh.

menus on the other (on the right) and Photoshop in the reverse order so I can quickly switch between the two applications.

Here are some other tips for working efficiently:

- Get used to working in one viewport at a time rather than four at once, if possible. This gives you a larger view of the world.

- Use hotkeys and shortcuts so you are able to gradually remove menu bars, your goal being to work in "expert mode" as often as possible where there are no menus on screen.

- Create custom menu bars if you need to use menu bars. Applications often come with bloated menus for many functions you may never use; these take up a large amount of screen space.

- Get used to switching viewports using hotkeys, so if you need to line something up using a specific viewport you can do so quickly and in full screen.

- Learn and use the zoom functions. This will allow you to quickly zero in on an object or back completely out for a bird's-eye view of the world.

- Learn viewport navigation, that is, the modes of moving around the viewports in the fastest, most efficient way. Some 3D programs have accelerator hotkeys that allow for a larger movement across the world when held down. For example, holding Control when moving your view across the world may move you × times (× being any multiplier such as 4× or 10×) farther per mouse movement.

- Don't forget the right-mouse click, or pop-up, menus. These can usually be customized as well.

Player Perspective

Most 3D applications offer a walkthrough mode, or at the very least the ability to set up a camera to look at the world from the position and at the focal angle the player will see it in the game. After flying around the world you are modeling, you may be surprised at how much you can or can't see at the player's level. The world will often appear much larger when you are taken out of the sky and put on the ground at the player's eye level. The focal length of the camera alone will have a dramatic effect on how large the world appears. It is common practice to give the game camera a slightly fish-eyed view to compensate for the limits of the monitor.

Shortcuts and Hotkeys

Learn to use shortcuts and hotkeys! We all know what they are by now. Pressing a key or using a set of keystrokes is far faster than navigating the menus. Do anything you can to speed up your work. Learn to create macros, actions, and custom menus, and learn a new shortcut or hotkey combo every so often. An added benefit to this efficiency is reducing stress on your fingers and wrists. If you work at a computer all day, the number of clicks and mouse movements add up. The cumulative wear and tear is tremendous when you start doing the math.

Units of Measurement

When setting up to model items for a world space, you need to know the units of measurements in that world. What unit is used to communicate the size of an object: feet, units, meters? And how do these units translate in the game? Later we look at world scale and measurement in more detail

and examine what we need to know in order to determine what our units of measurement are and what they mean.

It is common in most games to use generic units as a measurement, and those units tend to be powers of two (16, 32, 64, 128). Units of measure are important for consistency, accuracy, and technical efficiency. If you create a model and a texture for a game world using all the same units of measurement, things will come together much more smoothly. But what does a generic unit equal? It could be a foot or a mile—that will be determined as you develop a game.

Grids and Snaps

The grid and the snap settings are related to the unit of measurement. Grids are just that—a grid of lines spaced evenly apart. You can set the spacing of the grid. This is handy when used in conjunction with snaps. A snap is a setting that controls how strongly your cursor will snap to a specific point. A strong snap setting will grab your cursor when you are close to a certain object and snap it precisely in place; a weaker snap allows you to get closer to the snap position before grabbing the cursor from you. That place can be defined by you, and usually you want your cursor snapping to the intersections of the grid or the nearest vertex. This is very helpful when creating world art, since you can snap a line or shape to a precise size on the grid and that precisely sized object will easily fit a precisely created texture and then into a game world based on the same settings. This also speeds things up. Imagine trying to drag a shape out to a precise size or hand entering the sizes for every primitive you create. Some of the common snap types (Figure 2-10) are:

- Edge—Snaps along an edge

- Edge Midpoint—Snaps to the middle of an edge

- Endpoint—Snaps to the end point of edges on a mesh

- Face—Snaps to the surface of a triangular face

- Grid Line—Snaps to any point on a grid line

- Grid Point—Snaps to the intersections of a grid

- Pivot—Snaps to the pivot point of an object

- Vertex—Snaps to the vertices of a mesh

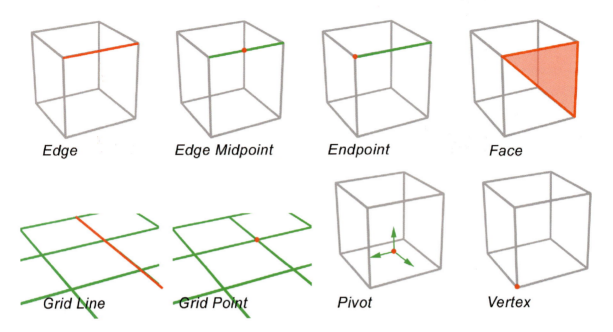

Figure 2-10 Various ways to precisely snap objects together.

Note: In 3D applications snaps can operate in different ways. Some modes offer a two-dimensional snap that only snaps to a specific grid or plane, or a three-dimensional snap where the cursor snaps to anything that is set for snapping on any plane. 3D snapping lets you create and move objects in all three dimensions.

Snap is also available to transforms as well. You can set the rotation or scaling to snap at certain angles or percentages.

Hide/Unhide

You can also hide objects if you wish, and that makes working much easier. Not only is the scene clearer, but there will be a smaller load on the computer too. If you are experiencing poor performance, you can hide objects to speed things up. There are usually multiple ways to hide and unhide objects: using groups, selections, or entity types (lights, objects, and so on).

Freeze

Freeze allows you to freeze an object so you can't interact with it, but it is there for your reference. This can make life easier, as you won't be selecting unwanted objects as you work.

Drawing Modes

You usually have options as to how the objects are drawn on the screen, meaning you can look at your world in wire frame, flat shaded, textured, textured and lit, lighting only, among others. This is useful for many reasons; for instance, it allows you to examine the soundness of your geometry, see how the textured model may look in the game, or see what face you may have selected at the time (Figure 2-11).

Grouping

You can group objects together, which is very useful for scene management in large scenes. I strongly suggest that you name your groups well. As a scene becomes more complex, you can hide, select, and deal with a grouping of objects much faster than you can a bunch of individual items. For example, you may have a large factory with control panels, several different piles of crates, gun racks, and other groupings of items in a large area.

Selecting

When you work in 3D, especially in a game world where multiple meshes or entities can occupy the same exact location as several others (in the case of collision and detail meshes), you need to learn to find what you are looking for quickly, isolate it, and leave everything else so others can find what they need when they work in the same space. For this there are many tools that can help you. For almost any 3D application or world editor, you should have the tools to hide or unhide items quickly; freeze items (you can see them but not alter them, or they can't be unhidden but must be specifically unfrozen); and select items by name, mesh color, material, alphabetically, or by many other attributes. When you are working in a game world, as opposed to working on a 3D scene that contains only the art, you will have many other items potentially in view. These can include (but are not limited to) AI paths, event trigger markers, and many other game-related events such as power-ups, switches, particle effects, and player spawn points. When looking from any given view at your world, you will see hundreds or thousands of crisscrossing colored lines, and that is nothing but confusing. When working on your own, it is a good idea to get used to naming your meshes and groups at the very least; and when working on a development team, it is very important to learn the naming conventions and other organizational conventions set forth by the developers.

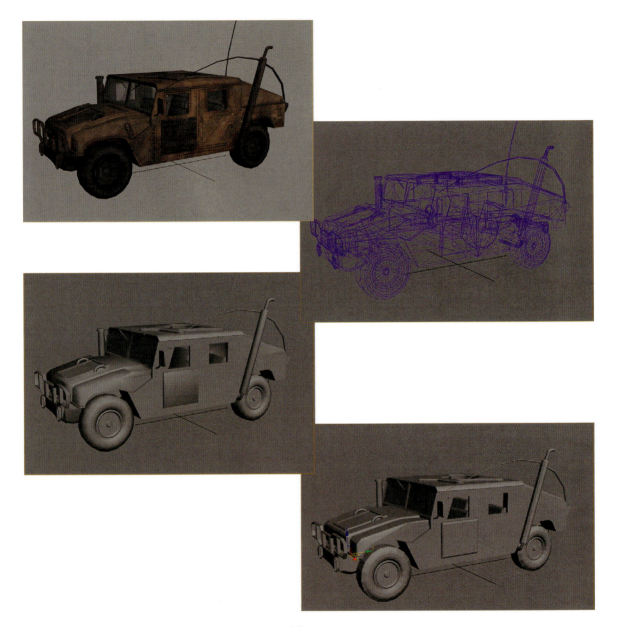

Figure 2-11 Drawing modes let you look at your 3D world in various ways.

Cube Cone Tube Torus Pyramid Cylinder Sphere

Figure 2-12 Basic 3D shapes.

3D CREATION

Now we get to the concepts for the actual creation of 3D assets. There are numerous paths to the completion of a 3D model. As you learn these tools, you will get better at knowing what path to take. Some methods may take longer or create messy geometry while being the perfect solution in another case. We start with basic shapes, called *primitives* in 3D modeling. These shapes are so basic and common that there are dedicated methods to their creation. These shapes are usually the following (Figure 2-12):

- Cube or box

- Cone

- Tube

- Torus

- Pyramid

- Cylinder

- Sphere

Mesh Editing

Some of the most common functions you will use in game modeling involve working with vertices, edges, and faces. For vertices, we can weld them together, break them apart, align them, and use a function called *soft select*. Soft select has a gradually lessening effect on the vertices surrounding the selected vertex. This is based on parameters you set and is very useful for forming or tweaking terrain. Edge functions include chamfer and bridge, among others. And face functions (we will use them a lot) include extrude,

bevel, inset, outline, and hinge from edge. Figure 2-13 illustrates some examples of various mesh editing functions.

Axis

The axis shows the direction the coordinates are running in the 3D window. What this means is easier to understand if you know what the Cartesian coordinate system is. The Cartesian coordinate system is a method that determines where a point is in 3D space using three bits of information— the x, y, and z coordinates. The standard locations for these are:

- x = left to right

- y = up and down

- z = front to back

Using the grid makes it easier to navigate 3D space. The starting (origin) point is 0,0,0. Any movement away from this point will result in a negative or positive value in one of the x, y, or z values (Figure 2-14).

There are many ways to view a coordinate system (Figure 2-15). A few of the most common are:

Object Space or Local

This uses the xyz coordinate system of the selected object. An object's coordinate system is held by its pivot point. You can actually edit the local coordinate system, moving and rotating how the axis points are orientated.

World Space

This system is fixed, centered in the world despite your view or the objects involved. All vertex data is based on the coordinate system of the world, which originates at 0,0,0.

View Space

The coordinate system dynamically moves as the view or camera moves.

Pivot Points

An object's pivot point is the location at which the object rotates. In (Figure 2-16) you can see some examples of how moving the pivot point affects

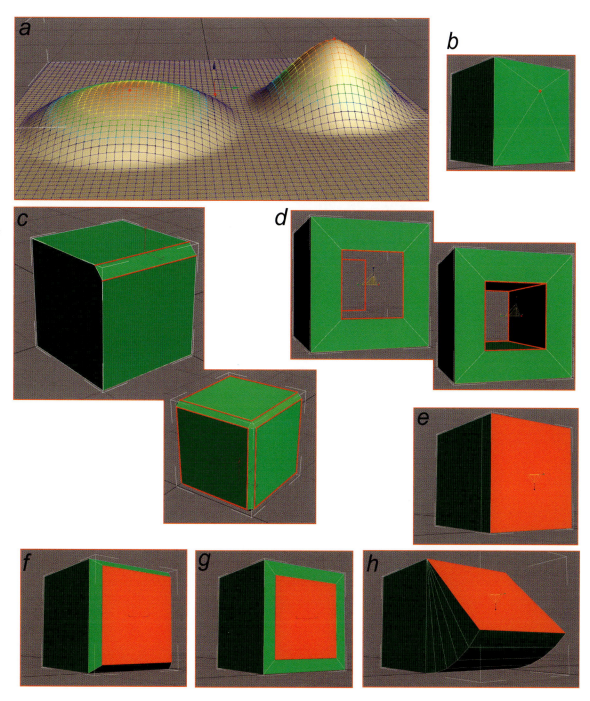

Figure 2-13 Mesh editing functions. (a) vertex soft select, (b) add vertex, (c) chamfer edge, (d) bridge, (e) extrude face, (f) bevel face, (g) inset face, and (h) hinge from edge.

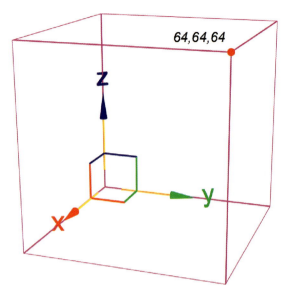

Figure 2-14 Coordinate system.

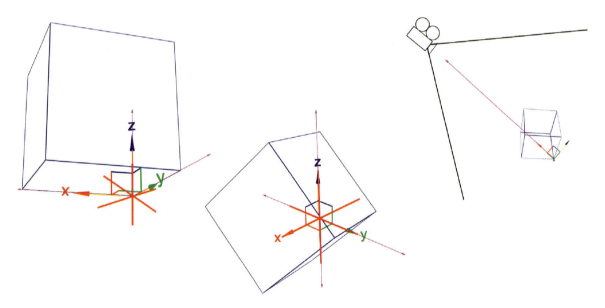

Figure 2-15 Local space, world space, and view space.

Figure 2-16 An object's pivot point is the location at which the object rotates, you can see how moving the pivot point affects the movement of an object.

the movement of an object. The pivot point can also influence how modifiers and transforms affect a mesh (Figure 2-17). It is easier to see the effects in the 3D application where you can see the changes in real time.

2D Shapes

You can draw a line in a 3D space and create a 3D object from it. This is a great way to start odd shapes. There are 2D primitives as well, just like 3D primitives. You can start with a predefined shape or a shape created from a line. Most splines are controlled at their vertices in four ways (Figure 2-18).

• Bezier Corner—Each handle operates independently, resulting in a peak between curves.

• Bezier Curve—Handles will operate together to create a smooth curve.

• Linear—No handles; this is a straight, linear corner.

• Smooth—No handles; this is a smooth curve of predetermined angle.

The great thing about splines is their editability. You can convert between the corner types, add and delete points, and even perform Boolean operations on them.

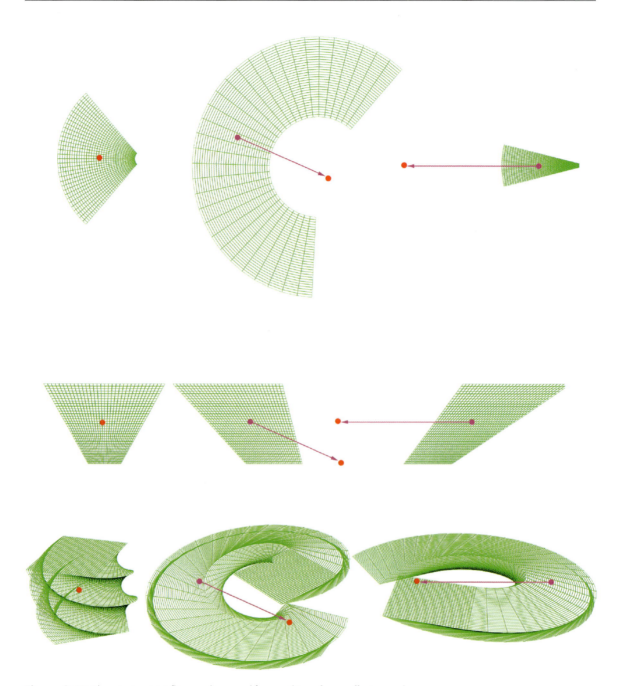

Figure 2-17 The pivot point influences how modifiers and transforms affect a mesh.

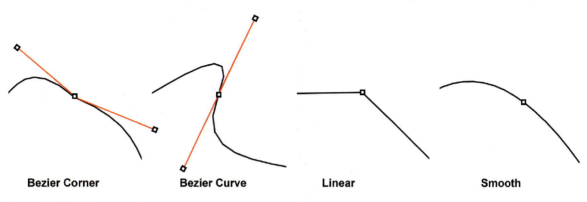

| **Bezier Corner** | **Bezier Curve** | **Linear** | **Smooth** |

Figure 2-18 Spline control.

CREATING 3D OBJECTS FROM 2D SHAPES

After you have created your spline path, you can perform several procedures on them to create a 3D shape. These include extrude, lathe, and loft.

Extrude

Extrude adds depth to the 2D shape (Figure 2-19).

Lathe

The concept of lathing is from woodworking. A lathe is a tool that rotates a block of wood very fast while a sharp tool is placed against the wood. The carving action creates radial cuts in the wood. You can use a lathe in 3D to create goblets, vases, and other symmetrical geometry. We will use Lathe to create the body of a fire hydrant in the coming exercises (Figure 2-20).

Loft

Lofting is like extruding a shape, except that it follows a spline path. In games this is great for pipes and hoses (Figure 2-21).

Transforms

As you would expect, transforms transform an object. You can alter the size and position of an object by moving, scaling, or rotating it. See Figure 2-22 for some visual examples of transforms.

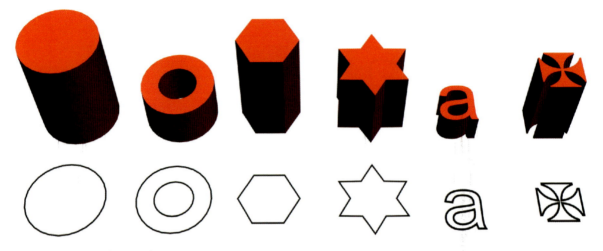

Figure 2-19 Extruding 2D shapes.

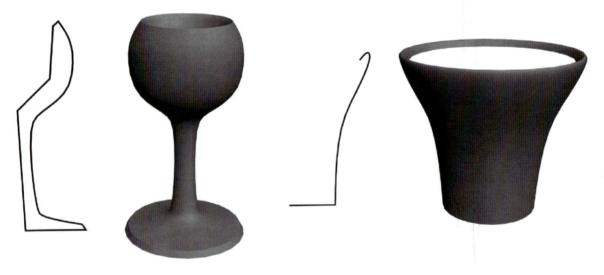

Figure 2-20 Lathing.

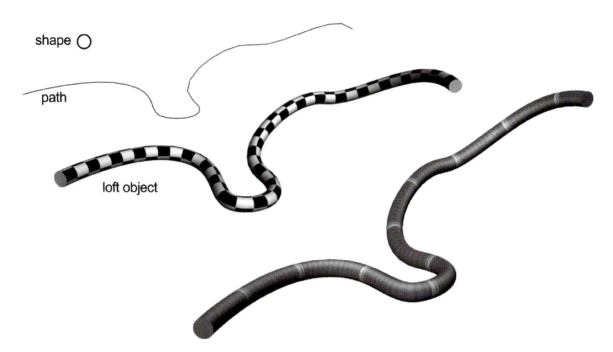

shape

path

loft object

Figure 2-21 Lofting.

Finally there are numerous ways to copy and align objects. In addition to the basic transforms, you will probably use mirror and align functions a good bit. Mirror flips an object on a set axis. If you model a car, you don't model the entire model; you model half of it and mirror it and attach the two halves together (Figure 2-23). Alignments combined with copy functions can create a perfectly spaced row of columns or a rabble of stones across a ground surface.

Deforms

Deforms alter or deform a mesh. You can bend, twist, taper, ripple, and even freeform deform a mesh. There are many deforms for meshes. See Figure 2-24 for examples of deforms and their effects on a mesh.

If you understand these basic concepts you can quickly learn how to accomplish them in your 3D application of choice. Once you know that, you will be able to create most simple game art and will have a solid base from

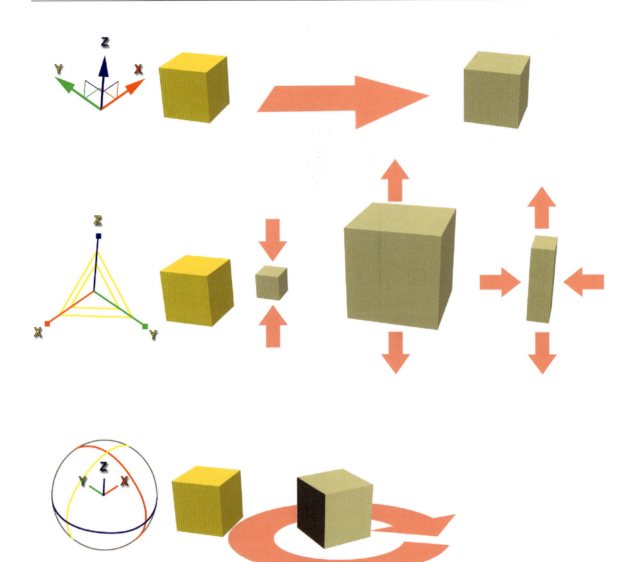

Figure 2-22 Transforms.

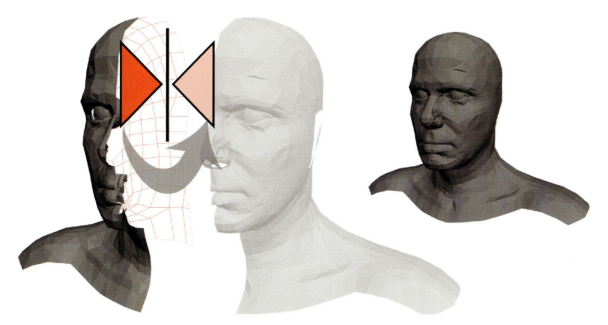

Figure 2-23 Mirroring.

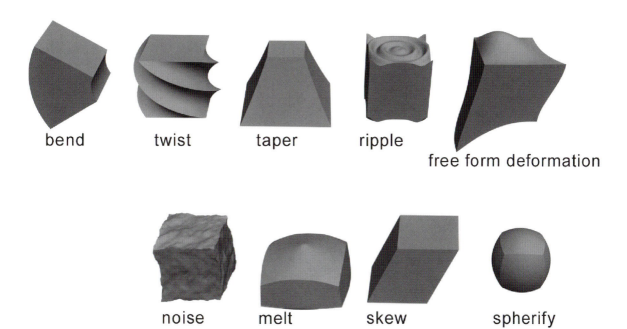

bend twist taper ripple

free form deformation

noise melt skew spherify

Figure 2-24 Deforms.

which to further learn on your own. In the coming chapter we will look at shaders. Shaders are an exciting topic, as they add so much visual depth and immersion to a scene. Although shaders can get complex, the basics are easy to learn and implement and have a huge impact on the visuals of a game world.

CHAPTER 3

Shaders and Materials

INTRODUCTION

Shaders allow for a level of realism in games that is stunning and getting better all the time. In Figure 3-1 there are some screenshots provided by NVIDIA. As I write this, the latest crop of DirectX 10 cards is out, and the quality of the graphics is amazing. Simply put, a shader is a mini-program that processes graphic effects in real time. For example, the reflections on a surface can move in real time instead of being "baked" or permanently painted into a surface. Shader effects are very powerful visually, even if viewers are unaware of what they are seeing. That is, the average player would have a hard time defining why the game he or she is playing looks so good. It may be the real-time reflections, normal mapping, or the specular mapping being processed in real time.

Ever since these technologies started rapidly advancing, there has been talk that procedural textures and advanced technologies would one day replace the artist. This will never happen. As awesome as the technology is, it still takes an artist to make these technologies produce the best visual results. In fact, the artist has become more important than ever as technology has become more complex. While programmers give us awesome new technologies, the artist still needs to create and control the input and output of those systems.

There are two main types of shader on modern graphics processors (GPUs): vertex and pixel shaders.

- Vertex shaders manipulate geometry (vertices and their attributes) in real time.

- Pixel shaders manipulate rendered pixels in real time.

The ability to manipulate an individual pixel or vertex in real time is what makes shaders so powerful and also what makes them so processor

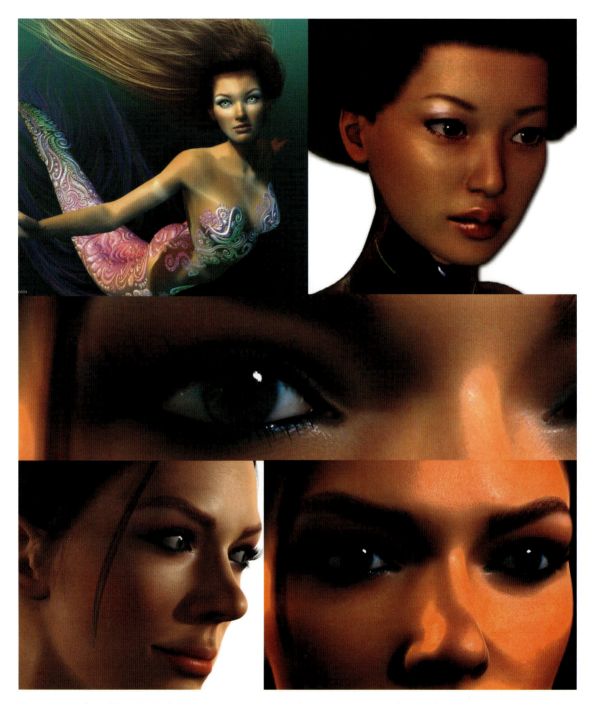

Figure 3-1 A few of the absolutely awesome images rendered on an NVIDIA graphics card.

intensive. On one hand, we can simulate virtually any condition using shaders, but on the other, they devour resources. For each frame displayed, all the shader effects for that frame must be processed (or rendered), and this takes time. Although the time is miniscule, it adds up, since millions of individual pixels and vertices are being processed. Shaders can be used for many complex material appearances and image effects: hair, fire, shadows, water, reflections, and so forth. Shaders are so flexible that the list of possible effects is almost endless—a shader programmer can write almost any imaginable effect. Interestingly, while it has been only very recently that consumer-level hardware could handle the intense demand that real-time shaders puts on a system, the knowledge of these processes has been around for decades. In fact, many of the techniques you will read about here are based on algorithms named for well-known mathematical geniuses; Phong and Blinn are recognizable names if you are a 3D artist.

Remember that the ability to manipulate an individual pixel or vertex in real time is what makes shaders so powerful. Very recently, real-time lighting began being calculated per vertex and not per pixel—that is, lighting is now often calculated for an entire face of a polygon as opposed to for every pixel. This is significant because it not only adds a great degree of detail and smoothness, but also allows for shaders such as normal maps to function. But how does all this work? That brings me to the large fuzzy overlap between programming and art. Granted, these are two very different activities, and there is a line between how much art a programmer needs to understand and how much technology an artist needs to understand. Exactly where that line is, no one can say precisely, but when it comes to shaders you should understand the basics of how the technology works. Wait! Don't fling the book across the room just yet. You don't need to know the math behind it all, just a simple explanation of how it works.

SHADER BASICS

Shaders, from the artist's point of view, are often a bit of a black box. Our involvement usually requires that we generate input for a preexisting shader—set parameters and/or assign textures, and then look at the end result. Since the artist's role is mostly confined to creating input and judging the output of the shader, we often have nothing to do with the code. In some cases shader code is written or edited by an artist, but most newer

shader-creation tools are more like the material systems in Max and Maya, requiring no programming knowledge. Figure 3-2 shows a diagram of how a material shader works from the artist's point of view.

Shaders often require the use of 2D assets as input, and the artist is usually the one tasked with not only creating those assets, but also understanding, creating, and implementing the shader to some degree. So, while shaders can replace much of the work an artist would do on an asset, they may also increase our workload. Already there are effects in games where the artist is no longer painting a texture as an isolated entity but is creating a series of textures that must all work together for a desired effect. Using shaders requires more planning, a different way of thinking about creating the art, and more organization. The artist needs to learn the shader tool, organize more assets (assets that may be linked to one another and are therefore more rigid in their mobility after a shader is in place), and learn the mental discipline of creating assets that are not the end result but component parts of a final result.

We have to get accustomed to painting textures devoid of certain properties that will later be processed in real time. One reason we need to understand the fundamentals of light and shadow, or to develop the skill to see the base material of a scene behind all the dirt, reflections, and other surface properties, is that we may soon be building textures starting with a very plain surface (even a pattern) and building a complex organizational tree of maps and effects to create a final surface (much like we already do in 3D programs and how some texture generators work). For example, the highlights on the armor in Figure 3-3 are controlled by a shader. With no specular highlight, a surface can look flat and dull. With a generic specular highlight applied evenly to the surface, things will often look plastic and fake. Using a map to control the specular highlight, we can make a surface look much more realistic. While shaders can make our lives easier in some respects, and definitely can make our games look better, they can also be a bit complex to understand at first and require a greater degree of organization.

Some of the most common shaders today require images easily created and manipulated in Photoshop. The most common of these are the color map (or diffuse channel), the bump and normal maps, specularity maps, illumination maps, and opacity maps. In general, a game artist creates textures meant to be tiled over an area or mapped to an object. When the texture

TEXTURE MAPS

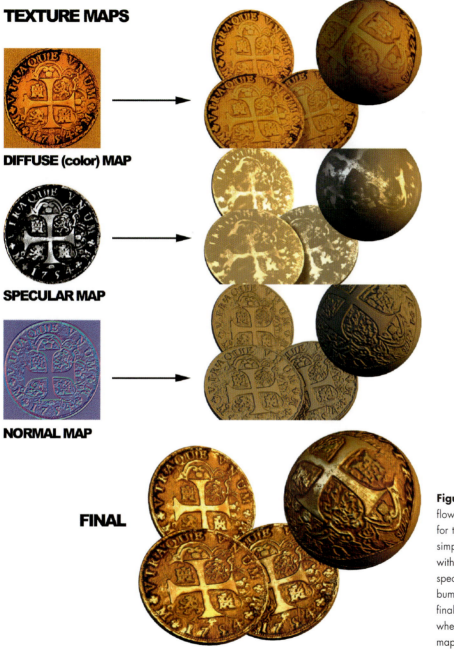

DIFFUSE (color) MAP

SPECULAR MAP

NORMAL MAP

FINAL

Figure 3-2 Here is a simple flow of how one shader works for the artist. The coin, a simple cylinder, is mapped with a diffuse or color map, a specular map, and a normal bump map. You can see the final result at the bottom where the effects of all three maps are combined.

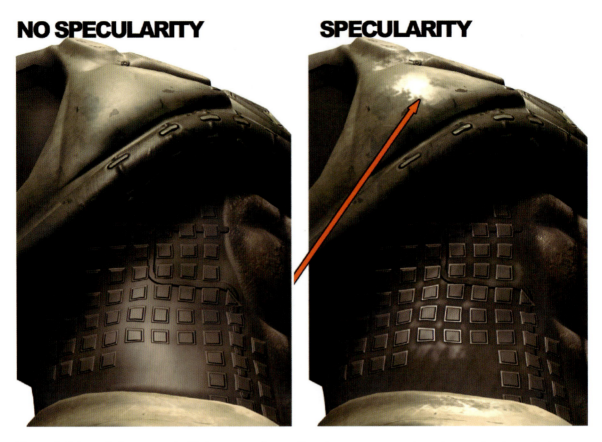

Figure 3-3 Instead of painting a highlight onto a surface in Photoshop, you can now leave it out and assign a shader.

is to be mapped to an object, the artist starts the creation of the texture with a template. Whether a complex character skin or a simple prop, this template is generated from the UV coordinates that have been mapped out onto the 3D model. After the basic color information has been put into place, the other shader maps are often created from the initial color map, the 3D model itself, and even some hand painting. The UV map represents the exact way in which the 2D art will be mapped, or wrapped around, the 3D model. In Figure 3-4 you can see how the template was created from the actual face model and the simple prop and then used as a guide to paint the textures. We will be working with these templates later in the book.

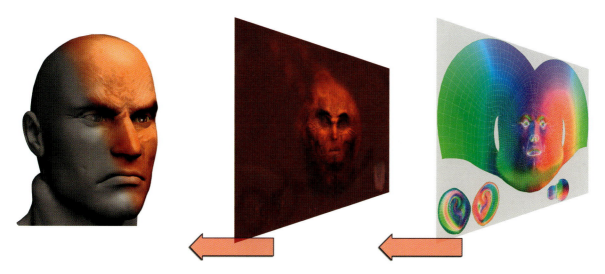

Figure 3-4 From right to left: The UV template, the diffuse map created from the template, and the model wrapped with the texture. The left side of the face was left unmapped so that you can see the original mesh.

COMMON SHADER EFFECTS

Like most things dealing with computer game technology, shaders are a vast and complex topic riddled with new vocabulary, concepts, and technological requirements. In addition, each game engine and each game project will have its own vocabulary, process, and subtle nuances in dealing with shaders. But you will always deal with some basic shader effects, and here are some samples of them. You may notice that these shader effects are very similar to filter effects in Photoshop, materials in Max or Maya, and many post-video effects. Post-video effects are effects inserted into a film or video after the footage is shot, during the editing process.

In this chapter we look at not only what these shaders can do in a cursory sense, but also some of the ways you can get various effects with these shaders. Throughout the book we examine each of these shaders in detail as they pertain to game development both creatively and technically. The following is a list of basic shaders and material types you will most likely work with in game development:

- Diffuse (color maps or textures)
- Blend
- Detail mapping

- Depth of field

- Heat haze

- Specularity

- Bloom (glow or halo)

- Masking and opacity

- Illumination (emissive)

- Reflection/cube mapping

- Pan/rotate/scale

- Normal, bump, and parallax mapping

Diffuse (Color Maps or Textures)

The term *diffuse map* has many meanings, depending on what software you use and what your educational background might be. I will spare you the technical and scientific definition and simply tell you that the diffuse map in the game industry generally means the color map or texture, an image containing only the color information of a surface. This is not to say it is devoid of all detail. Since game engines still don't reproduce the visual world 100% accurately, we still need to fill in the gaps. We can do this with subtle detail in the color map that is supported by the other maps. Areas in the texture where light would be noticeably brighter or darker can be defined to some degree. The spaces between metal panels and wood planks are examples of where some darkness could be painted in with good effect. In Figure 3-5 you can see the diffuse map for an old pirate. There is probably a bit too much light and shadow information in the texture. The prominent highlights and shadows on the veins and wrinkles are especially noticeable, and I would take them down and replace them with a normal map if this were to be used in real time. There is a normal map on this mesh, but I relied on the color map a bit more since I created this mesh for a specific use at a fixed angle and the normal map didn't need to behave perfectly.

Cracks and seams are places where dirt is most likely to collect, which would further add to the darkness of such parts of the texture. Technically you can handle these cracks with the normal map and other effects, but I

Figure 3-5 The diffuse color map can contain much information, but presently the use of per-pixel lighting makes this unnecessary and often undesirable.

find that relying too heavily on one map type often results in plastic-looking materials.

Originally game artists had only the diffuse channel to work with, and essentially what you created in Photoshop was what you saw in the game—all shadows, highlights, and details were contained on the color map and were static. This image was typically of low resolution and color depth and was wrapped around a low polygon model—presto, you had a game model. This process has changed quite a bit in the last few years. With the advent of new technologies that require a slightly complex separation of visual components into a series of separate assets that are processed together to create the final effect, the color map has become much more simple and subtle. That is, it's simple and subtle in terms of other information aside from the color itself, but richer in color detail since we can now use images that have much larger resolutions. In some ways this method of asset creation is harder to grasp and execute, but in other ways it is actually easier, especially for a trained artist who already understands how the visual world works.

The color map in Figure 3-6 contains the base color of a character's skin. In addition to the skin tone, however, the color map also must convey subtle details that either can't be depicted by the technology or are simply so subtle it may be quicker to paint them into the color map than try to reproduce them technically. Human skin is so subtle yet complex that often the qualities of skin (such as age and condition) and the details of skin (such as small veins, creases, spots, freckles, and pores) are best portrayed on the color map. Human skin is not one smooth color, but rather is composed of many colors and interacts with light in a most unique way. Such a map can take a long time to produce, as it requires a balance between subtle but clear detail. Too much contrast, saturation, or other attribute, and the character starts to look diseased; not enough and he looks like a mannequin.

Blend

The blend shader blends two textures together; depending on what software or game engine you use, it may blend in a default fashion or offer various modes very similar to the blending modes in Photoshop. The blending usually occurs between a base texture and one or more textures on top of this. Each layer has its own set of UV coordinates, so you can have one

Figure 3-6 The diffuse color map of human facial skin. Even with complex shaders, the skin on a human face is so full of subtlety and detail that we still need to have some detail in the color map.

small tileable texture that repeats as your base and blend other textures on top, such as stains, cracks, and other details. This method not only takes up less texture memory, it also allows for a great deal of variety since there are so many options when blending numerous textures together. The basic blending modes follow and are displayed in Figure 3-7:

- Average

- Additive

- Subtractive

Figure 3-7 Various blending effects using the blend shader.

Average

Average blends the colors of the base map and the new map evenly. If you don't want either texture overpowering the other in any way, use average. This is appropriate for creating an entirely new texture from two separate textures or, in conjunction with grayscale base maps, for coloring the base map.

Additive

The additive color model brightens the base map. Black becomes completely transparent.

Subtractive

The subtractive color model darkens the base map with the new image. White becomes completely transparent.

Detail Mapping

A detail texture is a layer laid on top of a low-detail color texture. Players can see the detail texture from their point of view, but the detail texture is fading in as they move. This allows the texture (the ground, for instance) to look very detailed. Detail textures are usually grayscale images that add detail to the color map below it, using one of the blending modes discussed previously. Detail textures can be used to add detail to stone, metal, wood—any surface in the world (Figure 3-8).

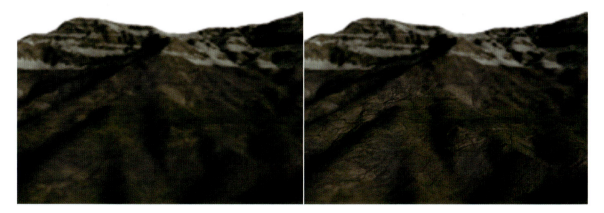

Figure 3-8 Players can see the detail texture from their point of view, but the detail texture is fading in as they move.

Depth of Field

Depth of field in photography is the distance in front of and beyond the subject being focused on and photographed. A shader can create the illusion that objects in the background are far off by blurring them, thus causing a depth of field effect. You can adjust the depth of field, just as you can in photography, so that the area in focus can range from infinite to very narrow or shallow. A shallow depth of field means that objects are only in focus in a very small area. Depth of field can be so shallow that a very close-up picture of a coin can have one side of the coin in focus and the other totally blurry. Figure 3-9 shows an example of depth of field.

Heat Haze

Heat haze creates the shimmering effect you can see emanating from very hot objects, or the ground, on hot days. Figure 3-10 shows the effect applied to the exhaust pipe of a vehicle.

Specular Highlights and Glossiness

A specular highlight is that bright spot that appears on most surfaces when light hits it. That spot can be small and bright or large and barely noticeable, depending on the quality of the material the light is hitting. A specularity map allows you to control this effect, and you can even use a mask to control how various parts of the same surface display the specular light differently. A good example is beat-up metal armor. You may have a layer of old paint and dirt that will not be highly reflective and areas where this has been worn away to reveal reflective metal, metal that has been polished by constant wear and tear (Figure 3-11). Sometimes glossiness is separated from the specular highlight; the distinction is that glossiness determines the size of the specular highlight, and specularity controls the intensity of the highlight.

A specularity map controls what parts of the surface are shiny or dull based on the grayscale value of the specularity map. You can see that the armor has no specular control on the left, and the middle and right have two different specularity maps. Specularity maps are generally created from the color map. In Photoshop you simple desaturate a copy of the color map and adjust from there. You can see the exact spot where the grayscale image is affecting the specularity on the model (Figure 3-12).

Figure 3-9 This shader creates the illusion that objects in the background are far off by blurring them, thus causing a depth of field effect.

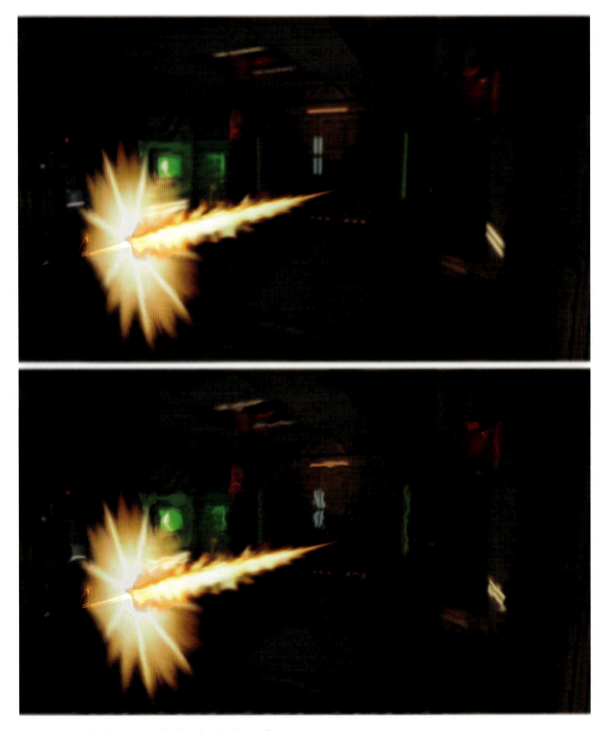

Figure 3-10 The bottom muzzle blast has the heat effect present.

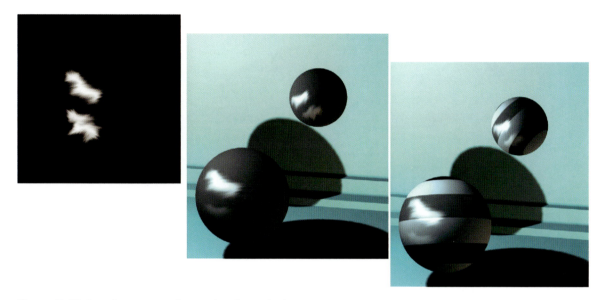

Figure 3-11 Specularity map and examples of specular basics.

Bloom (Glow or Halo)

Blooming makes a light source appear brighter than it really is by taking the light source and spreading it out over the edges of the object it is on. A bright light will appear to bleed over onto objects around it, both in front of and behind the object. Usually this effect is achieved by creating a glow around the light source that is blended with its surroundings, but sometimes the engine actually processes the entire screen. Using several render passes, it will multiply the frame (like the Photoshop blending mode, this lightens the lighter areas and darkens the darker areas), blurs the image, and then draws it on top of the original screen. Blooming helps create the illusion that a light source is brighter than it can actually be displayed by the monitor. See Figure 3-13.

Masking and Opacity

As discussed in Chapter 1, masking typically uses a specific color that is designated the "clear" color and is more efficient than transparency. Transparency uses a separate channel or grayscale image to determine the opacity of a pixel. The trade-off is that transparency looks better, but it requires more file space and more processing power. Masking can significantly speed up a huge scene with tons of overlapping elements with transparency on

NO SPECULARITY **SPECULARITY** **SPECULARITY with MASK**

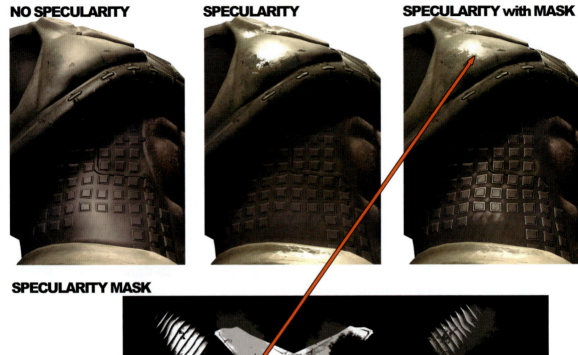

SPECULARITY MASK

Figure 3-12 Specularity map.

Figure 3-13 Bloom shots. Light glow, with full-frame processing.

them, such as a forest or jungle. In Figure 3-14 you can see examples of masking and transparency. In Figure 3-15 you can see the interface of the NVIDIA tool that allows for the rapid adjusting and viewing of textures before outputting them.

Opacity maps determine if an image is solid or transparent, or somewhere in between. Opacity is generally best used when there is a need for transparency, as on windows, and/or subtle ranges in opacity such as we see in smoke and fire. While masking can do the job for tree leaves, fences, and grates, opacity is better for in-game effects such as explosions, fire, bullet holes, smoke, and particles like rain and magic sparks. In Figure 3-16 you can see various examples of such effects.

Illumination (Unlit, Emissive, or Full Bright)

An unlit texture is a texture that is unaffected by lighting and displays at 100% brightness, sometimes called full bright or self-illuminated textures (Figure 3-17). In Figure 3-18 you can see an example of an unlit texture on a particle that looks better unlit as well as runs faster. Be aware that when you add an illumination map (grayscale), you can control what portions of the texture are lit and to what degree, but now additional calculations must be done and additional resources used for controlling the lighting on a texture this way.

Reflection

The reflective nature of a surface can be like a mirror (100% effective) or completely matte—a rough wood may have no reflection at all. Real-time reflections can be very draining on the computer, so there are ways to fake reflections using environment or cube mapping.

There are many ways to generate reflections in a game, but the most common and easiest to implement is the cube map. A cube map is a series of images that the environment map uses to fake the reflection on the surface of an object. Cube maps are so named because the reflections you see are actually six images arranged in a cube and projected back onto the reflective object. These images are rendered from the location of the reflective object so the cube map reflects the objects' surroundings accurately. These six images cover all directions: up, down, front, back, left, and right. Ideally they all line up, meaning the images meet at the edges so the reflection is seamless. The images of the cube map are most commonly static,

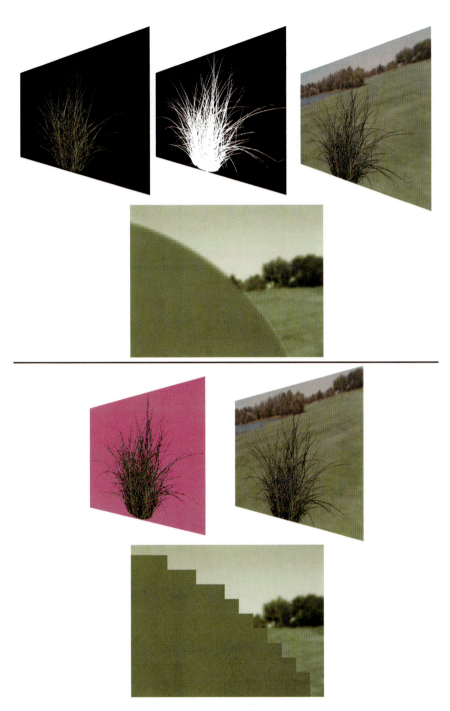

Figure 3-14 The **upper portion** of this figure shows an image of some grass with an alpha channel and the **lower** a color mask. Notice that the images from afar look virtually identical; it isn't until we are very close that we can see the jagged edge.

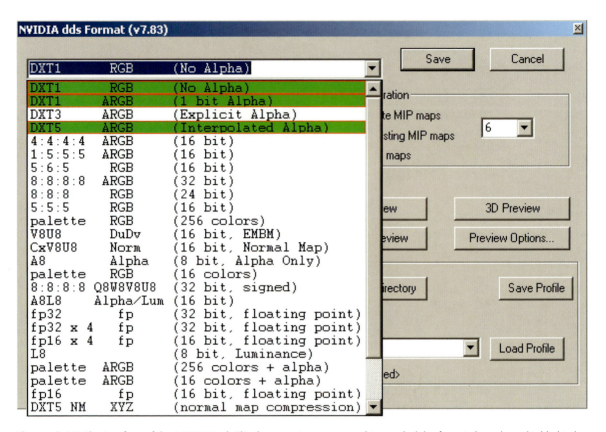

Figure 3-15 The interface of the NVIDIA tool. The three most common masking and alpha formats have been highlighted.

meaning they are always the same. If you are looking into a reflection created by a static cube map, you won't see yourself (or in-game character). This is the most efficient way to handle cube mapping, but there are also other techniques for generating real-time reflections. One of those techniques is called *dynamic cube mapping*. This method redraws the six images in the cube map every frame. If the object mapped with the environment map moves, or something in the environment around it moves, the cube maps are updated to render an accurate reflection in real time.

Figure 3-19 shows how the (static) cube map was created for the pitcher. Notice the maps arranged as if the cube were folded open like a box. The six images that form the cube map were rendered from the location of the pitcher, so the metal looks as if it is reflecting its surroundings from the proper position. You can even use a simple cloud image as a cube map and get some great results (Figure 3-20). I did nothing more than use cloud

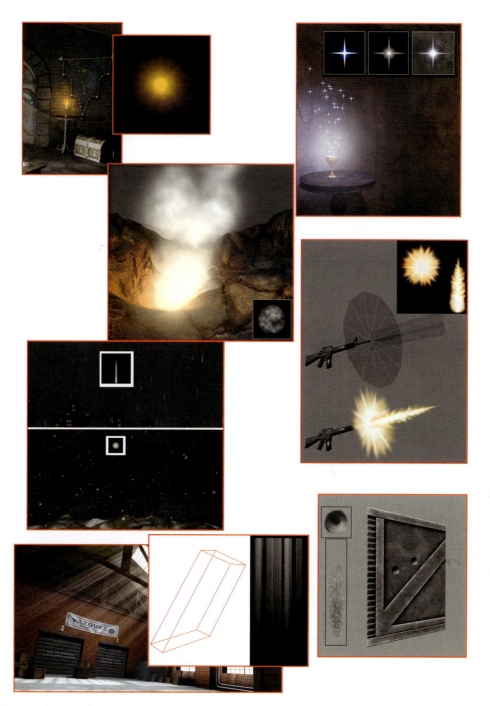

Figure 3-16 Particle examples.

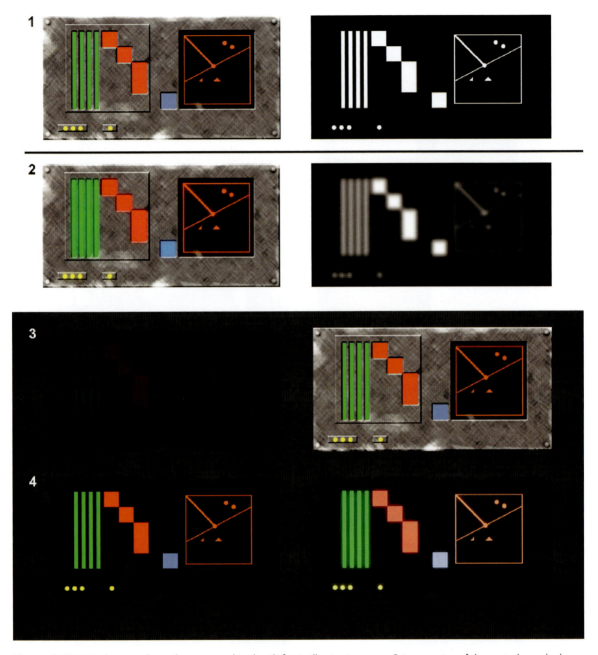

Figure 3-17 1 is the control panel texture, and to the **right** its illumination map; **2** is a version of the control panel where the lit parts are slightly blurred and the corresponding bright parts on the illumination map are as well. In **3** you can see the control panel in a darkened setting and the control panel unlit (or full bright), and in **4** the illumination-mapped versions. By blurring the portion to be lit in the color map and the illumination map, a glow effect is simulated.

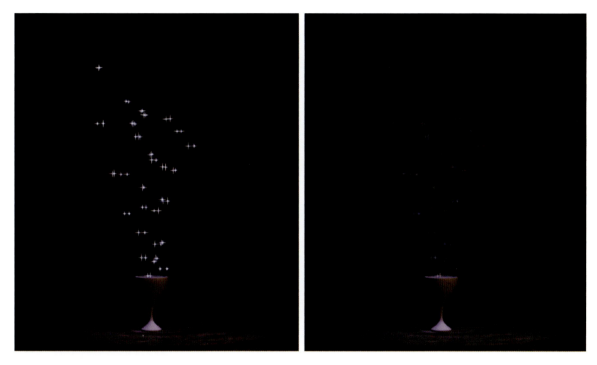

Figure 3-18 Magic particle unlit and lit.

images for each face of the cube map, and the armor looks like it is made of silver. The neat thing is that in a game, those reflections would move with the armor and look so much more convincing than a static image of a reflection.

Pan/Rotate/Scale

Often shader systems give the artist the ability to pan, rotate, scale, and otherwise move a texture in real time. This can be useful to convey the movement of elements on a computer screen, fluid through pipes, or to create a moving walkway. It has been used to animate waterfalls and rotating fans. In Figure 3-21 you can see the simple concepts of pan (moving vertically or horizontally), rotating (turning), and scaling (larger or smaller). You can also see that to make a wheel look like it is turning, we must pan and rotate the texture. You should be aware that although this illustrates the concept, chances are that in a 3D game the mesh the texture is on would turn and move, and not the texture itself. I have used a scrolling

Figure 3-19 This cube map was created for the pitcher. The metal looks as if it is reflecting its surroundings from the proper position.

Figure 3-20 With a simple cloud image as a cube map, this armor looks as if it were made of silver.

and panning smoke texture over a simple laser light texture with a great "dust in the laser beams" effect (Figure 3-22).

Bump, Normal, and Parallax Occlusion Mapping

These shaders add 3D depth to an otherwise flat surface. While bump maps are grayscale and display the most limited 3D effect, the others add depth using a color map with lighting information encoded in it. These shaders are all similar in what they accomplish but, depending on the exact code of the shader and the supporting hardware, the effect can range from really cool to absolutely awesome. A basic normal map adds a level of depth deeper than the bump map, but more advanced forms of these shaders add details and behaviors such as self occlusion, silhouetting, and self shadowing. Figure 3-23 is a simple visual demonstration of how the shader operates. Because we can calculate the light of the surface for every pixel, we don't need to include geometry to create shadows and highlights as we did when we lit per polygon. We can now tell the 3D application to treat each and every pixel as if it were reacting to light, as it did when it was on the high polygon model.

Have you every seen a mural or painting that looked real but when you changed your viewing angle, you could suddenly see that it was fake, a flat

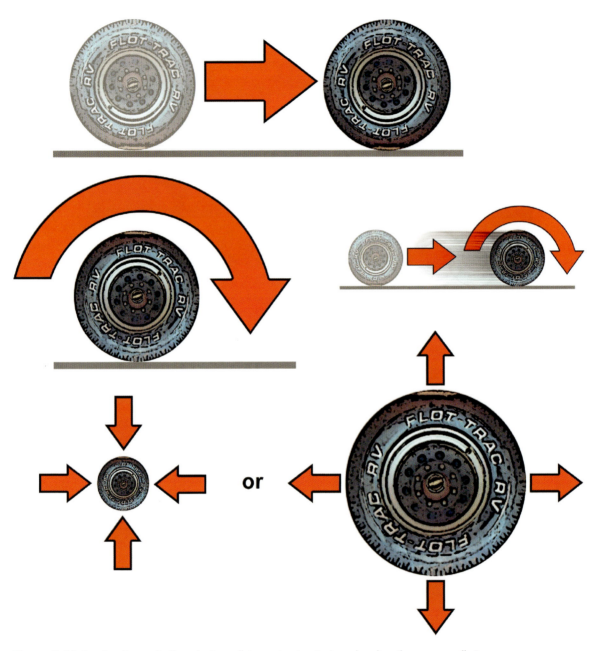

Figure 3-21 Pan (moving vertically or horizontally), rotating (turning), and scaling (larger or smaller).

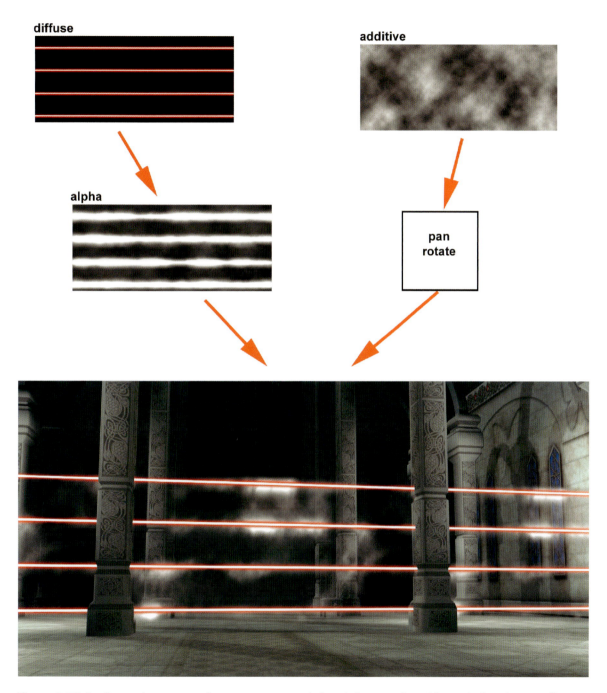

Figure 3-22 Scrolling and panning smoke texture over a simple laser light texture for a "dust in the laser beams" effect.

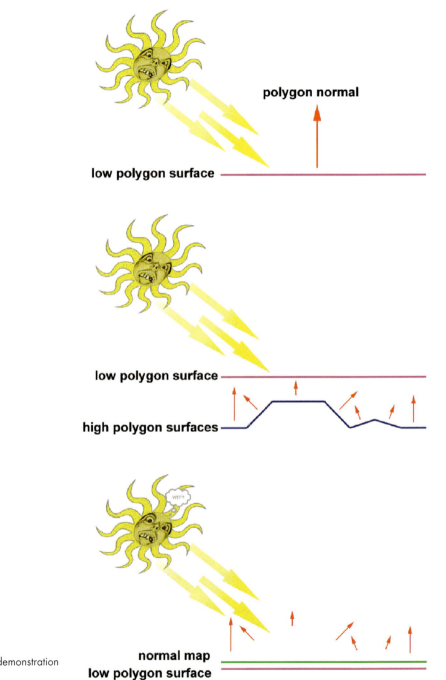

Figure 3-23 A simple visual demonstration of how the shader operates.

2D image? The light and shadow didn't move. The artist painted it to be viewed from that one angle, so it only looks good from that one angle. Imagine if you could create a painting that quickly repainted itself every time you moved, so it looked as if you were seeing a real three-dimensional scene. That is essentially what a normal map is doing as it calculates light and shadow in real time.

In short, a normal map is an RGB image that records all of the light and shadow detail from a high polygon model. When this map is applied to a low-resolution model, the light and shadows are calculated as if the light were hitting the high-resolution version of the model. The idea is actually simple to understand (of course, my standard disclaimer of how tricky this is for a programmer goes here, but seriously, we have the fun part of all of this).

We still need to maintain the silhouette of the model as best we can. Using a present-day vanilla normal map allows us to focus more polygons on the silhouette of the model, which is a benefit. But there is also a drawback to this: it means that the normal map cannot change the silhouette. Back to the painting analogy: Even if a painting can be repainted so quickly it looks real, there is a limit to the effect. When you move too far off on an angle, you will see that it is just a flat 2D painting that is updating in real time. That is how a basic normal map works. But there are versions of normal maps under development now that can actually move the pixels in real time and change the silhouette when viewed from the side; this would be like the canvas of the painting actually pushing out to form the detail painted on it.

Although the best normal maps are typically generated from very highly detailed 3D models, you can get a free Photoshop plug-in from NVIDIA that will generate a normal map for you from a 2D image. There are many other tricks for creating normal maps entirely in Photoshop, and we will use them later in the book. This method is especially easy when creating environmental art, since the surfaces we work with tend to be much simpler than the surface of a character. In Figure 3-24 the surface was built up using images created in Photoshop; even the normal map was created as a black-and-white map and exported as a normal map. You can see the grayscale image used to create the normal map and the surface with nothing applied to it. Then you see the color map only, and the normal map only, and finally the surface with all the maps applied. We look at normal

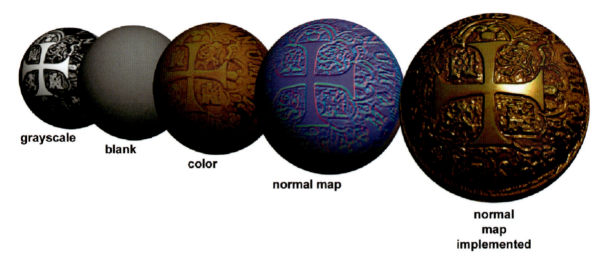

Figure 3-24 A surface built up using images built-up in Photoshop.

mapping in much greater depth later in the book and actually create normal maps using a few different methods.

CONCLUSION

That was a quick look at what shaders can do. We will implement all of them in the coming exercises to create various effects. Our implementation will be generic, meaning that we will create the assets for the shader based on the most basic parameters. If you are using Max, Maya, Unreal 3, or any other shader system, these basics will translate easily into those systems.

Planning the Low Polygon Urban Environment

INTRODUCTION

The large urban environment is a pretty common setting in games. Driving is a primary activity, along with stealing cars and running over pedestrians. Large city areas offer some unique challenges, but for the most part they can be the easiest to deal with in terms of creating environmental assets. From a programmer's point of view, it can be demanding to code the environment for driving in a very large area where the player can see distant buildings and drive for miles—that is, in terms of the textures and models needed to fill the city. These elements tend to be repetitive by nature and inorganic. In this chapter we will establish general information so we can start creating the world. Then we will follow with chapters on 3D modeling and texture creation.

If you are able to drive a vehicle in a game, chances are you are playing in a large, open environment. We will discuss large forested areas that use hilly terrain later in the book; in this chapter we will cover large urban areas. Large urban areas are also used in large-scale massively multiplayer online games (MMOs) as well as in driving games and team shooters. Sticking with the focus of this book, we will create a pretty generic (technically speaking) set of assets for a large urban environment, but one that can be expanded on (or reduced) depending on the situation you find yourself in. Before you begin building assets for any space, you need to answer a lot of questions. We will explore these basics before moving on to asset creation:

- Development technology

- Platform technology

- Game perspective

- Game theme

- Game genre

- Game fiction

- World maps

- Concept art and/or reference

- The asset list

TECHNOLOGICAL ASSUMPTIONS

The first thing we have to know is what we need to develop the game: 2D and 3D programs, game tools, and what platform or machine configuration we are shooting for. As discussed in the introduction, for the scope of this book we don't need to look at budgets or specific brand names for our development tools and user platform. The purpose of this book is to examine the task before us in universal terms that will plug into any situation in which you are working. At the basic core, you can use almost any commercial 2D and 3D software to create the needed assets for any one of a large number of the commercial game engines. In practice, there are large gulfs between the cost of one commercial product and another, as well as between the results of various products, but essentially they are all doing the same basic thing. This book gives you the foundation to more rapidly learn the basics of any set of tools you may end up developing with. This book is also limited to the creation of world assets and not the specific implementation. Over the course of my career I have developed on at least ten different 2D and 3D engines and never had much difficulty moving between them. A polygon, a pixel, distance fog, occlusion—these things are the same in every engine. So our assumption here is that we can produce the needed 2D and 3D assets with tools easily obtainable.

Note: Remember that although specific game tools are not the focus of this book, to obtain a job you will want to know at least one commercially successful game development tool really well.

POINT OF VIEW

It is assumed that this large urban space is being set up for a driving game. The perspective will be a third-person view. The camera will have move-

ment and will move closer to the vehicle the slower it goes and will pull back at higher speeds. Like most games that have high-speed driving as the main activity, the environment is not meant to be explored close up. The assets tend to be lower quality in relation to the cars. Most driving games, even today (and rightly so), put the greatest focus and resources into the cars. Notice that in most games the car will have opacity on the glass, reflections on the paint, and high detail in terms of polygons and textures, but the buildings are lower in polygon count, texture resolution, and have virtually no shaders on them. It only makes sense that a building you are blazing past at 150 mph (240 kph) will have less detail than the car you are constantly looking at (and trying not to wreck)—because the building needs less. So, we will not detail the world too much and not burden the game engine with an abundance of shaders, effects, and large assets.

THEME

This is a basic New York–type setting that can be dressed to look like almost any city in almost any recent or near-future time period. In our special projects we will look at three common variations of the urban setting: a different or foreign city, a grungy city, and a bombed-out city. For the generic New York urban look I went online and searched for images of the props and the city streets I wanted to create. From this I was able to break down an overall look and feel I wanted and a list of the assets I needed to create.

GENRE

This is a high-speed driving game. Whether you are racing professionally through the streets or running from the cops, you are expected to be driving really fast. There are many more questions that need to be asked and answered in an actual development scenario, but for this exercise we focus only on the environment and ask those questions pertaining to the creation of the environment. Some of the questions you need answers to are:

- How close does the player get to the buildings, and how much is he expected to examine them?

- Does the player get to leave the vehicle and explore the world? Can he jump high, fly, climb walls, fly a chopper? Where the player can go and how he can travel are very important to know at the outset.

- Are there alternate routes or choices the player can make, or are they limited to one path?

Usually these questions will have been asked and answered, and you will work from sketches, concept art, and other materials. But there is always the chance you will be in the situation where you have to ask these questions. For this exercise we will restrict the player path to the street. That being the case, we know now that the upper parts of the buildings do not need high detail.

WORLD SIZE

The technology (game engine) that runs the game and the game design will determine most of what you can and can't do in your game world and what compromises will be made in order to make the game look good and run well. In games like Grand Theft Auto (GTA) and True Crime you can go through all the streets and into many buildings. It's possible to jump rails and end up in water or on a rooftop. You can get out of the car, and your character can run around the city. This type of massive world will probably have lower poly count models than a racing game where your primary objective is to outrun the other cars on a closed track. No matter how many buildings there are and how big the city looks, you can't get out of your car and interact with the world. You are limited to driving on a track. In a GTA-type game the designers and artist have to make sure there are no holes the player can fall through, whereas the driving/racing games can have buildings floating in space, as long as you can't see the base of the buildings.

Although we aren't designing and building for a specific technology, we need to make some assumptions. In general these types of games use texture atlases, sheets, or T Pages, and contain either tileable textures or a texture packed with details that are used to make a more detailed structure. Since we are working with power-of-two textures, you can create the atlas textures easily if you need to. For this exercise we will create all of our textures as separate entities.

The 3D assets must contain as few polygons as possible, so unseen polygons should be removed. Note that some of the next generation technology uses lighting models that require sealed geometry, and more polygons are required to create sealed geometry; but polygon optimization techniques

are important, even if you can render a gazillion of them. It is also often more efficient to leave the backs of buildings on and, if you can, to model each side to look like a different building. This way you can use one model in various positions and make it look like several different buildings.

Note: Keep in mind that in the final game there will be more going on than the rendering of your world assets. Another target assigned early on is a frame rate goal. A fully operational game will be processing characters, UI, physics, sound, and more, and all of this eats frame rate. If you are running at the predetermined frame rate before the entire game is up and running, then expect the frame rate to drop dramatically when the rest of the game systems are integrated.

We can't set meaningful asset budgets, but we should have some guidelines. Although I do not mention frame rate (we are not going to integrate these assets into a game engine to see a frame rate), frame rate is actually the most important target to reach. In general, a world this large, with all considerations made, will have low polygon world models that use small textures and no shaders, if at all possible.

GAME FICTION

Game fiction is very important. The back story of the game world will determine a great deal of what the game will look like. A utopian future will look very different from a post-apocalyptic world. Think of the future world as portrayed in *I Robot* versus *The Terminator* movies. Although the look of the game will be determined by the designers, producers, and art director, it is wise to know as much about the world you are building as possible. Not only will that help you be a more effective artist, you may be given leeway to create the props or settings as you see fit. If and when that happens, that is your chance to shine as an artist.

CHAPTER 5

Modeling the Large Urban Environment

INTRODUCTION

In this chapter we will model and UV map all the parts of the large urban environment. I will try to give you various approaches to each aspect of the scene and discuss the integration of these assets into typical gaming and 3D environments. I might make reference to the various technical aspects of asset creation discussed earlier in the book, so it would serve you best to have read the first several chapters of this book, or at least to have skimmed them, and to make sure you understand the basic concepts presented in each chapter. For example, if any of the modeling concepts in the instructions are confusing or unclear to you, go back and look at the chapter earlier in the book that introduces the relevant concepts. By the end of this chapter, you will be able to take the information, suggestions, and guidelines to develop a city scene of your own that looks unique and the way you want it to, and that can operate technically in the 3D environment you are working in.

Although large and seemingly complex, the large urban environment is based on a few categories of model, each containing a few simple meshes. A few meshes in the following categories will completely populate our city:

- Base streets

- Repeating buildings

- Landmark structures

- Props and decorations

There are as many approaches to constructing a large urban environment as there are games that take place in a large urban environment. And

although each game development project is different from the last, there is a core set of methods used to construct this type of environment: modular, free-form, or a hybrid of the two. Even the most complex and advanced city-building system is based in one of these three methods, and for the environmental artist there will be much similarity among them all. Regardless of the actual specifics of the implementation and development on any given project, the assets you create will be fundamentally 2D and 3D assets that need to fit into a world that is constructed in a certain way and has certain technological guidelines and requirements. For example, a 3D mesh of a building will be the same in most any game, and the differences will fall into a list of *can- and can't-dos* that are fairly easy to address. Most of these are listed in the optimization chapter (Chapter 1), and others will be unique to the project you are working on and will be introduced to you when you start working on that development team. Knowing the basics of these methods will make learning any new aspect of game world construction much easier.

So, when you work with a proprietary system, you may learn new tools that do various tasks—such as auto-populate the world with foliage or auto-generate roads and streets. Often there will be special tools to specifically address the particular major tasks the developers are facing and which represent an important focus in the game. For a large outdoor game, for instance, there may be a system dedicated to dealing with a large and varied amount of foliage in a large outdoor world; but in a driving game foliage will most likely be treated as a prop that can be placed where needed and therefore does not require a special system.

In short, you will mostly be using basic skills to create 2D and 3D assets for use with one of the following methods to construct the world:

- Modular—Building modular pieces (Figure 5-1) that allow the construction of city blocks and the placement of buildings and objects by essentially snapping the pieces together on a grid.

- Free-form—This is usually how driving and racing games with a smaller scope and a more complex track are built. The player is confined to the vehicle and a set track; therefore objects can be placed free-form about the world to make everything look its best from the player's point of view. There is no need to snap to a grid (see Figure 5-2). Note that just because you don't need to snap to a grid doesn't mean you shouldn't take advantage of the grid. You should still design and build your assets

Figure 5-1 Modular method.

to the grid for ease of use and accuracy. There is always a use for the grid, no matter how free-form you are allowed to be.

- Hybrid—This is obviously a combination of the two. Often developers are given more than one tool to accomplish a goal. You might be able to build free-form roads and bridges that can be lined up with modular streets on a grid—for example, a freeway offramp that takes the player into a city. There are also systems that involve a large terrain–type entity that has a grid visible on it (in the game editor). Roads can be painted onto the terrain as well as placed as free-form meshes, or snapped onto a grid. See Figure 5-3.

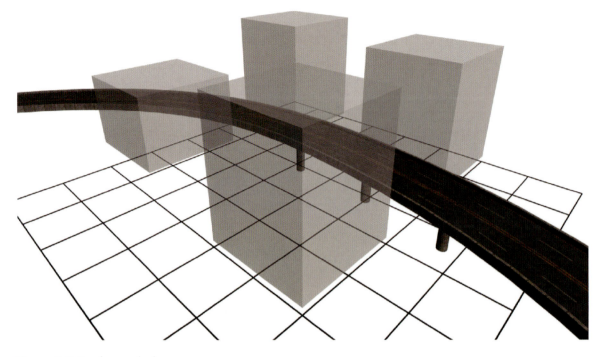

Figure 5-2 Free-form method.

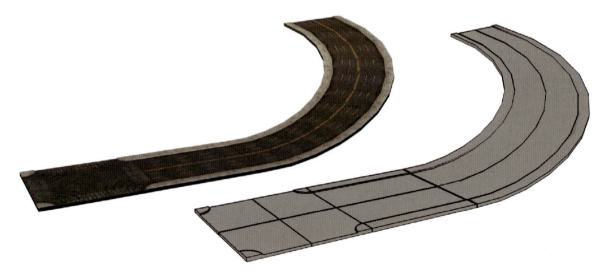

Figure 5-3 Hybrid method.

BLOCKING OUT THE LEVEL

Blocking out a game level is the process of laying out a level as quickly as possible while still being playable in the game. Objects are created and placed for functional and not visual reasons. Usually texturing, lighting, and detailed geometry are not part of level blocking, but since these aspects can be a part of, or affect, game play, they will sometimes be included in this phase.

You may be called upon to help block out the level. I actually love to be involved in this stage of development, as it gives me a very intimate knowledge of how the level will be played. If you are very familiar with where the players will be going, what challenges they may face, and what is visible from any given location in the level, the task of creating the most efficient and visually pleasing assets will be made much easier. In addition, working through this phase will help you develop much clearer communication with the designers. Blocking can take months or skipped altogether, depending on the complexity of the game, the genre, the scope, the team's experience, and other factors. Unless you are *very* experienced in game development, I would suggest blocking to some degree. Think about creating a level that looks awesome (while still considering the limits of game development and building so the work is as optimized as possible) and then having to change things every few hours as the game play becomes more refined. These changes will almost always involve more than just swapping assets if the level is too far along.

Primarily the blocked-out level allows designers to play the level and make sure their ideas work as planned without investing a significant amount of development time. But it also allows the environmental artist time to become familiar with the layout of the level as well to become intimate with what the designers are trying to accomplish. Obviously the environment is critical in creating the experience the designers are trying to give the player, so this is an area where the environmental artist can potentially have great influence. When the time comes to actually construct the level, if you've been given time to mull things over, you may have a list of things you want to try in order to accomplish the various goals of the level.

When blocking a level, simple textures and/or colors usually do the job of communicating the needed information about the level. Where the player is able to go may be one color or texture, a climbable wall another, an

event trigger another, and so on (Figure 5-4). For this example, the geometry we use to block the level can also be used as the basic geometry of the level. We can add detail as opposed to recreating the geometry.

Setting Up the Grid

The first thing we do is set up the grid to match across our tools so we can work consistently and more easily. The grid you use in your 3D app should match the grid in the 2D app and game editor. So, a 512×512 cube should snap onto a power-of-two grid in your 3D app, the texture you map to it should fit perfectly on it, and both should snap into place in the game editor (see Figure 5-5). A primary benefit of this is the ease and speed at which you can work. It also allows for accuracy and consistency. An accurately created world can use smaller assets and actually look better than a sloppy, larger one. Using the power-of-two texture still is advantageous in most game engines, as they can process these sizes faster.

To make this happen you simply need to set the grid in each application to a power of two. This is usually expressed in generic units in a 3D application and pixels in Photoshop, and then again as generic units in the game editor.

The Basic Parts

Fortunately for us, a large city is usually laid out on a grid and with standards applied to the size, shape, and color of things, among other attributes. This makes it easy to create a street model that we can lay out with ease on the grid and fill in with buildings. Using a system of various building meshes and textures that are mixed and matched with a few landmarks (large and unique buildings or structures) and details, we can make a rather large and convincing cityscape.

A city is fundamentally created with very basic shapes; in fact, most of these objects are cubes. You can see in Figure 5-6 that the intersection of this city street is nothing more than a handful of cubes with a texture laid over them. In Figure 5-7 you can see that even the simplest addition begins to create a city feel. If you look at almost any city street, you will also further notice that it is the ground floor that contains most of the detail and decoration. This only makes sense. Both in a game and in real life, it is where the people/players will be. Even if there are flying cars, there is still a notion of the ground floor. The movie *The Fifth Element* has a huge

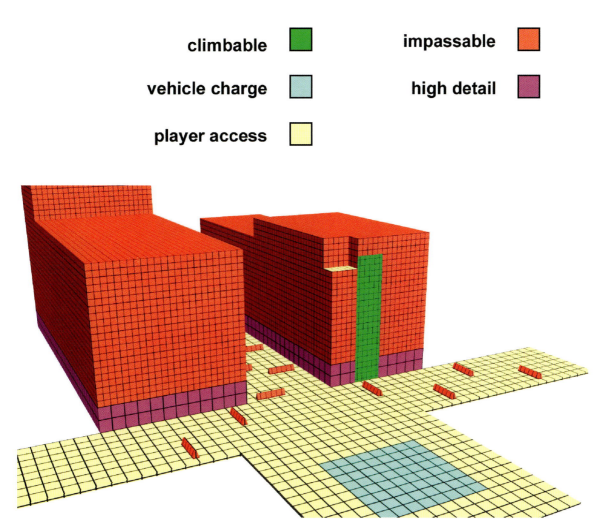

Figure 5-4 Blocking example.

cityscape with incredibly tall buildings, but the people tend to congregate at certain levels, and the traffic is routed to certain elevations and directions. This allows high-density details to be concentrated in a few areas while the vast majority of the city can be of low detail. Therefore, the detail level of the streets is based on the extent of access the player has to them. In this scenario the player can drive on the streets but not walk on them, so we will make them look good from a close distance, but we'll forgo high detail.

Note: We are building the street in sections here, but they need to be built according to what's best for the game technology you are working with.

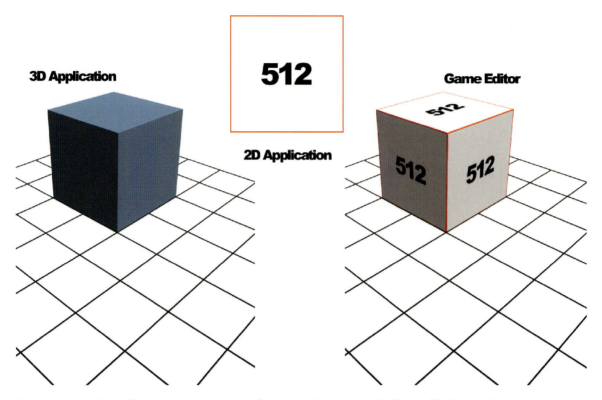

Figure 5-5 Working with the same units across applications makes it easy to build a world. The 3D object, the 2D asset, and both together in the game as they come together exactly.

Some game levels are built as one large entity, and the engine decides what to draw (or not). In that case you need to have smaller chunks so the game engine isn't always drawing one huge model.

WORLD MEASUREMENTS AND SCALE

Early on the designers of the game should know measurements of all the players' available moves. Measurements of every dynamic aspect of the game should be known. If the player can run, how fast can he run? How far can he run? If he can jump, how high and how far? Does he jump farther if running? You get the idea. You may be involved in figuring out these measurements, but you can't effectively start building the game without them. If you get too far along without this information, you will undoubtedly have a lot of reworking to do. It happens in development that these numbers may change, but a lot of thought must be put into such a decision. What if a jetpack is suddenly introduced into the game late in development? Suddenly the player can fly in a million places he couldn't

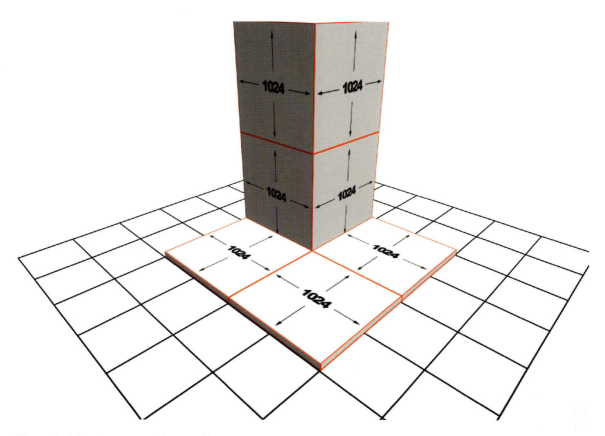

Figure 5-6 The base texture of our world.

get to before! This blows all your work out of the water, especially if you did any optimization as you worked. Suddenly the player can fly over buildings from which you already eliminated all the (previously) nonvisible faces. They can possibly fly out of the level, so what do you do then? Maybe they can fly over jumping puzzles and avoid traps and encounters that have been scripted. It may sound crazy, but this actually happened on a game once. The development essentially started over from the drawing board just to accommodate the jetpack, negating months of work.

The longer that development has been going on, the more serious any change becomes. Limiting the player can also be as potentially damaging as allowing greater freedom. What if the players' ability to jump thirty feet is suddenly considered silly so the distance is cut to 10 feet? Cutting this down to 29 feet is equally as problematic: in a game either you can jump the distance or you can't, so any measurement lower than the jump height

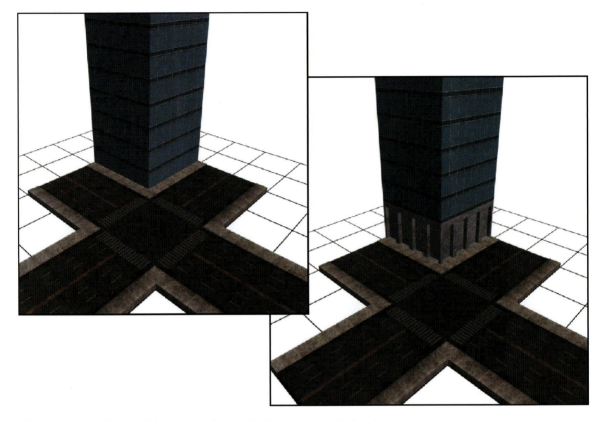

Figure 5-7 A building and then a lower floor added for interest and believability.

is unobtainable by the player. Suddenly the player can't get around the world as easily as before. There may be many places the player suddenly can't get to or can't get out of.

There are many measurements to know, but some of the more common ones are

- Character height

- Step height

- Walk speed

- Run speed

- Jump height (running or standing still)

- Grab-able ledge height

- Crouching height

- Prone (or laying down) height

- Trigger height

- Weapons ranges, blast radius, weapons distance

- Even radius measurements for audio

And, of course, we need to know about the world. Usually a game world constructed faithfully to real-world measurements doesn't look or function correctly. Ceilings look too low, doors are too narrow to pass through. And real-world distances—miles and multiple yards—usually have no room in a game world. From a game play perspective, walking the actual distance across Los Angeles is incredibly boring. This is mostly due to the fact that our view of the world is limited to a small screen and lacks our real-world binocular vision. Developers also open up the camera angle to accommodate for this, causing a fish-eye effect. Try cutting a small square hole in a box and putting it over your head. Run around a busy intersection near your house. You will see how limited a view of a game world you really have. (If you do this, have a friend nearby with a camera and *please* send me the video.)

Although the units of measurement in most games are generic units and real-world scale doesn't translate well into games, you do need to develop a set of standard measurements to build by that work in the game. These standards are based on what works. You usually start with the player avatar as a baseline for scale. If the player is primarily human sized, you will develop all your measurements based on this fact and work outward from this, considering design and artistic aspects of the game world. For example, we may start with the base scale of 16 generic units equals a foot; therefore an average human would be 96 units high. Based on real-world measurements a door would be roughly 128 units high and 48 units wide. But considering the limits of vision in the game world and how the door will look in game, chances are you will end up making the door larger, and as a result the ceilings will be pushed higher and buildings themselves made larger.

If you know how high a doorway is and how high a step has to be, you won't be figuring this out every time you build something. It is easy to develop a visual reference for these measurements, a visual conversion

between feet (or meters) and generic game units. Usually these charts contain standard measurements, such as door height, window height, height from the ground, step height, and so on (see Figure 5-8). These measurements are usually derived from the player and the players' allowed movement. For example, a first-person shooter and a driving game will allow the player different modes of movement in the game, as well as different speeds and access to different sized openings. If the player is controlling a man-sized avatar in the game world, he could enter a standard doorway, whereas a vehicle-sized avatar could not.

These measurements are all developed as a reference and need to be developed based on what works in the game. You cannot be held to real-world standards and measurements when creating a game. In fact, it is pretty rare that a real-world unit looks good and works perfectly in a game. Going back to the differences between a first-person shooter and a driving game: in a game where you are a running human, the distances are often compressed so you don't get bored running forever. In a driving game distances are often expanded, especially in the width of the street or track, as the cars are numerous and moving very fast. We must be careful to take into account the many variables in game development, which can include the goals of design and the limits of technology. There are always choices to be made: Do we create a large environment and sacrifice detail for a setting where many players can congregate and wage battle? The size is needed for the number of players to battle, and the detail must be conserved for the numerous events spawned by the players (see the introduction to Chapter 1 for a little more information). On the other hand, if we were to create the same size of environment for a game limited to a few players, we could probably add more detail—larger textures, more polygons, and so on.

After you determine what sizes work in your game for doors, ceiling heights, and the like, write them down. Then, for work ease and consistency, list some of the common objects and track their sizes and measurements on a simple, rough foot-to-unit conversion chart. You may want to establish sizes for the average human, doors, windows, streets, and sidewalks; and in our case we may want to know the height of a light pole, traffic sign, and other elements common to our environment. For this example, an average six-foot human would be 96 units, a door that looks good might be 128 units high, and so forth. The following simple table presents a baseline conversion.

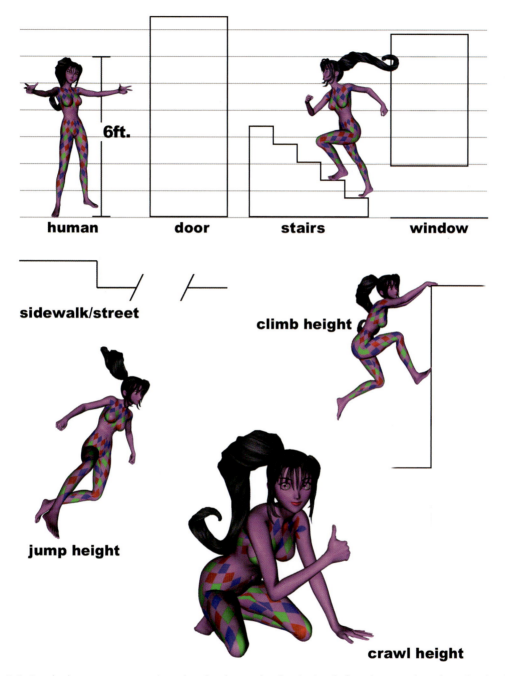

Figure 5-8 Standard measurements, such as door height, window height, height from the ground, and step height, should be determined before asset creation.

Units-to-feet baseline

16 = 1 foot
32 = 2 feet
64 = 4 feet
128 = 8 feet
256 = 16 feet
512 = 32 feet
1,024 = 64 feet
2,048 = 128 feet

MODELING THE STREETS

Do we start with a box? Do we extrude a line? It really doesn't matter. After practice you will know the best way to get to your end goal. In the case of such a simple mesh, it really doesn't matter how you start but how you end. As long as the mesh is solid and accurate, you are okay. However, one factor to consider in choosing one way to start your mesh versus another is the speed in which you will finish it. In this case I started with a spline because starting with a box would have required more steps to complete the mesh.

But, you may ask, "How large do I make this object?"

The size of the streets depends on how they will be used, and these measurements will most likely be dictated to you. In this example I decided to make these streets wide, since this is a driving game. We want them wide enough to accommodate several cars racing around (Figure 5-9). This is a great time to look at world measurements and how we determine what they are. In this case the streets are 128 feet wide, 256 feet long, and 2 feet thick. Or 2,048 units wide, 4,096 units long, and 32 units thick. This gives us room for sidewalks and six lanes of traffic. The sidewalk is 16 feet wide (256 units), and the street drops one foot from the curb (16 units). A foot-high curb in real life would be far too high, but since this is a driving game, it looks good. A curb that was lower and based on real-life measurements (3 to 6 inches) would look too low in the game. After the street was created, I added a chamfer to the edge of the sidewalk to round it off a bit.

While the depth doesn't matter for this example, in some instances depth might be a consideration. There may be a reason to make the street thin—for example, in the case of an overpass or a street that must pass

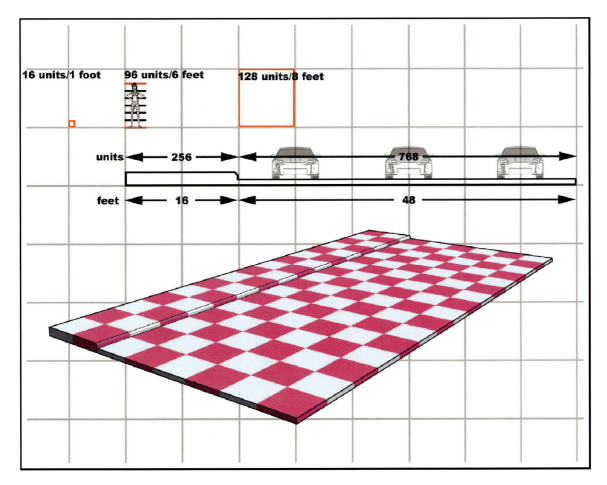

Figure 5-9 In this example I decided to make these streets wide, since this is a driving game.

over portions of the level that has underground components. Or you may need to make a thick mesh—say, in the case of a street that may have pits cut into it; or the thickness may be needed for the way the level is constructed. Alternatively, you may want a few different street meshes for variety and game play (Figure 5-10).

To create the intersection, I used a copy of the connector face and extruded the polygons using *hinge from edge* (see Figure 5-11). First you extrude this at a 90-degree angle with eight sections. You will have to go into vertex mode in the top viewport and snap the middle vertices to the grid to bring them out to where they need to be to make the line straight. To make a more rounded corner, you can add sections when extruding, but this will

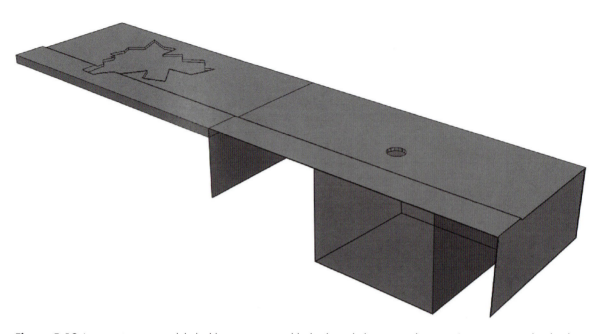

Figure 5-10 In some instances, while building a game world, depth might be a consideration. Streets may need to be thin in the case of an overpass or sections that need to pass over portions of the level that are underground, or thick if the mesh needs detail carved into it.

add faces to the mesh and increase the number of vertices you have to line up. However, that should not be a deterrent if you really can use that many polygons, as it is not much more work to drag the additional vertices to one of the three corners and weld them all together. I hinged the faces using eight segments for a nicely rounded corner. Notice that the mesh of the street is cut in half and the intersection is cut in fourths. These are complete meshes, but I cut them for efficient texturing. You will see why in the next chapter.

A curve in the street can be created from the copied connector face. Extrude it to 2,048 with 16 sections and bend it 90 degrees (Figure 5-12).

UV MAPPING THE MESHES

I am introducing UV mapping here and now. While UV mapping is often treated as a separate step, I usually UV map as I work. I do this to avail myself of opportunities to save time and effort, and two ways to do that

Figure 5-11 To create the intersection, I used a copy of the connector face and extruded the polygons using *hinge from edge*.

are by UV mapping repetitive objects and UV mapping objects before they are manipulated. Most people hate UV mapping meshes, and I am no exception. The only thing that pushes me to take my time and do the best I can is the fact that good UV mapping makes a huge difference in how good the final mesh looks in the game and how efficiently it functions. UV mapping is easy to understand (go back to Chapter 2 if you have any trouble) and fairly easy to do. It is simply the number of choices you have when working on this task and the tedium of it that makes it so hard. So, with no further delay (because writing about UV mapping is far more tedious than doing it), I present to you UV mapping.

Figure 5-12 A curve in the street can be created from the copied connector face.

Texturing and UV mapping the urban environment is pretty straightforward. Even so, before we can create and apply textures, we need first to set up the UV maps on the mesh. For this we use a special texture called a UV template or UV map (Figure 5-13). This is simply an image usually covered with colors, numbers, and a grid, to help when assigning UV maps to polygons. This type of image makes it real easy to see where a part of a mesh is mapped on the UV template. You can see where the UVs for a polygon(s) are assigned, whether they are flipped, upside down, or otherwise altered. But its greatest use is in avoiding stretching and maintaining consistency. While the textures in this environment are simple to UV map, they are either inorganic tiling textures or singular instances such as signs, and they could be mapped using the default mapping tools described in Chapter 2 (planer, box, and so on). But we will use the UV mapping tool so we can begin to understand UV mapping. Since we made the model on the grid, creating and applying textures will be much easier. Let's start with the streets.

Street UV Mapping

This mesh is literally planar mapped (Figure 5-14) so you can see that in the initial mapping, in which the texture is square, the UV map is stretched in one direction. Using your 3D application you can correct this in any number of ways. In Max I could type in a number telling it to tile twice on that axis, but we can also edit the UVs in the UV editor. On the mesh, the sides will be stretched from the planar projection but will never be seen.

0a	0b	0c	0d	0e	0f	0g	0h
1a	1b	1c	1d	1e	1f	1g	1h
2a	2b	2c	2d	2e	2f	2g	2h
3a	3b	3c	3d	3e	3f	3g	3h
4a	4b	4c	4d	4e	4f	4g	4h
5a	5b	5c	5d	5e	5f	5g	5h
6a	6b	6c	6d	6e	6f	6g	6h
7a	7b	7c	7d	7e	7f	7g	7h

Figure 5-13 UV Map guide.

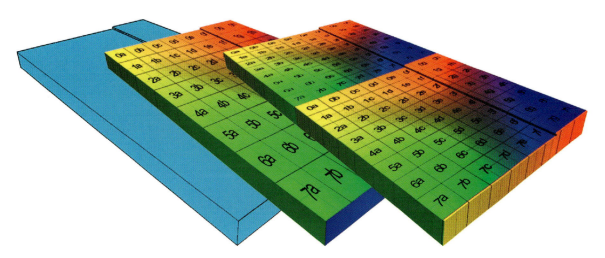

Figure 5-14 UV mapping the streets.

Repeating Buildings

We can build each building as one mesh or break it into two parts: street level and upper floors. The two-mesh approach allows for the swapping of the street level base and the upper floors. This in turn allows for more variety. If you build the building as one mesh, you need to keep the buildings and the base floors more generic, whereas with the two-mesh approach you can build a variety of bases and only a few upper floors, or vice versa. For this example we will create our buildings as one mesh. But by slicing the mesh in certain places, we can map various textures to the various parts of the buildings to get different looks. Starting with the base of the building, we can create a simple box that represents the footprint of the building. For this example I am calling a block 4,096 units. This is pretty big, since 16 units equal a foot. That makes the base of this structure 256 × 256 feet. Since the streets are built to the same grid sizing, they will line up perfectly with the bases of the buildings. This block size holds about four average-sized buildings. Each building may have multiple storefronts on the ground floor. Of course, this is completely changeable. And which method you use depends on the game and the technology you are working with.

Look at photos of several of the most common types of building in a city. At its simplest a building is a large cube. For most low polygon buildings you can simply create a cube on the grid and snap it to a power of two. See Figure 5-15 for an example of the most basic building blocks of a city: the streets and a building. Next is the textured models (Figure 5-16) and finally the first simple iteration of a building adding a different ground floor (Figure 5-17).

We will create a few meshes now that can be rotated and retextured using the textures we will create in the next chapter. As we discussed earlier, the upper floors of these buildings will be simple in geometry and texture. Initially we will develop this as a daytime level, but later we will explore the process of making this a nighttime level, and then the upper portions of the buildings become even less important, as they will be extremely dark, essentially becoming silhouettes. As part of the detailing of the level, we will also be creating numerous signs that will further obscure the buildings. The meshes are of very simple design and have a footprint of 2,048 × 2,048. The average height should be around 2,048 as well—this is roughly ten stories high.

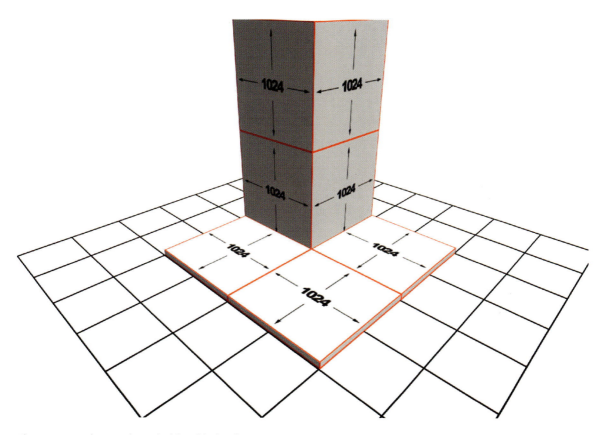

Figure 5-15 The most basic building blocks of a city.

Since the lower floors of the city is where the detail needs to be, we will build a series of lower floors that can be dressed differently. These lower floor meshes don't necessarily need to be numerous and overly unique. They will be constructed so that later we can map them with various base textures and window textures. In Figure 5-18 there are several storefronts that are more unique. Most will be simple boxes. The average height of a floor of a building from the outside is 10 to 15 feet, and the bottom floors can possibly be taller since some may contain lobbies. Figure 5-19 shows the various upper floors.

The buildings are UV-mapped using box mapping. You may have to rotate the UVs on one side of the mesh, depending on how it maps by default. Some of the buildings have more than one texture, but the UV maps are the same for each texture.

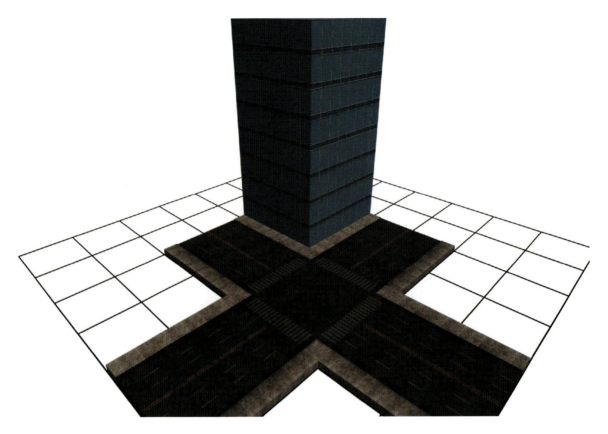

Figure 5-16 Textured models.

Landmarks

Landmarks help the player navigate the world. A landmark maybe an object of a different color, a unique object, or almost anything that is a unique and distinguishable aspect of a specific part of a level. In our case we could choose many ways to create a landmark. A simple solution would be to make one street or building stand out from the rest using varied lighting. Or we could create a special mesh that stands out, such as a tower, bridge, or special area, like a park or plaza. The approach we will take is to make all our buildings look unique, but uniform. By rotating them, scaling them, and, of course, swapping textures on them, we can get a wide variety of buildings that visually meld together—no one will stand out overly much. By every once in a while placing a structure, building, or area in our level (or more than one, depending on the size of the level) that is so different it really stands out, we add a level of realism to the level and make it easier

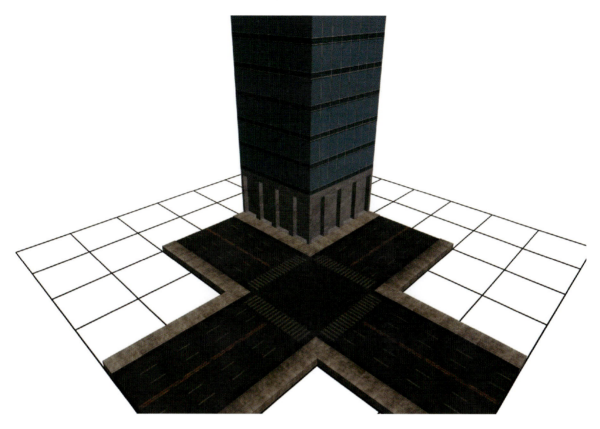

Figure 5-17 The first simple iteration of a building, adding a different ground floor.

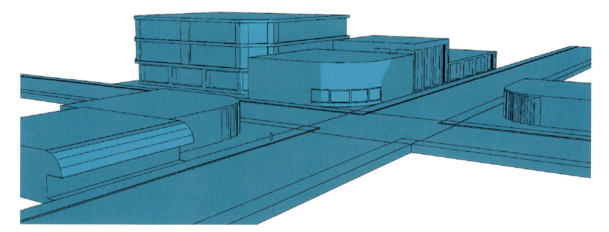

Figure 5-18 Several storefronts that are more unique.

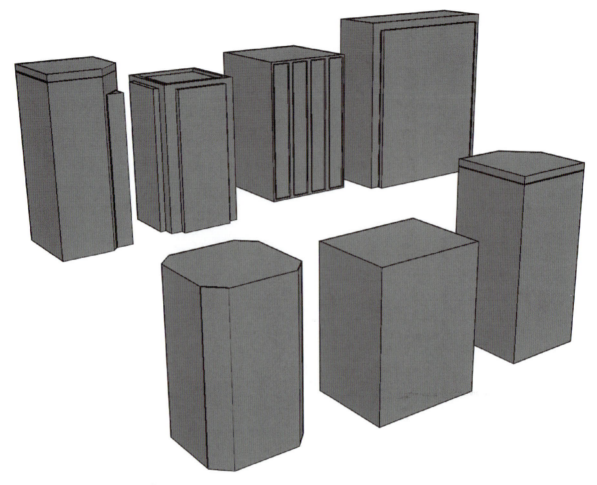

Figure 5-19 Various upper floors.

for the player to navigate. This is true to real life. Look at the skyline of any city, and you will immediately recognize major landmarks such as the Arch, the Golden Gate Bridge, the Space Needle—the rest of the buildings are visual filler.

Landmarks can also help establish place and time. If you see the Eiffel Tower in a game, you can safely assume you are in Paris. If you see the same tower under construction, you might assume that you are in the Paris of the past. If you see the tower broken but sticking above the rubble of a city, you can assume you are in a future where some cataclysmic event happened in Paris. Or maybe the tower is standing in the enormous lobby of a pristine and futuristic building.

In our level we will make a parking garage for our landmark, similar to the one in Figure 5-20. We will also detail this intersection so it is very unique. By adding many signs and lights, this will be an obvious landmark.

The parking garage geometry is basic, just as in real life. It is the composition of the simple elements that make or break a mesh. The simplest mesh can look beautiful if the scale, proportion, placement—the composition—of the mesh is well done. As a side note on this, even though we try to stay on the grid, sometimes it is necessary to eyeball something and tweak the vertices or placement of a mesh to create the proper composition of elements. Even though this is a simple mesh, after it is textured and decorated it will look pretty cool. Let's start with the base of the garage. Since the garage will take up an entire city block, I started with a base that is $4{,}096 \times 4{,}096$. Remember that 16 units equal a foot, and that makes the base of this structure 256×256 feet. The parking garage is mostly large, flat shapes for the floors and several columns throughout the structure. To add interest we can add the lobby/stair/entrance structure and the large, solid, building-like structure. Later we will add some details that will make the structure more impressive. We can build this in three parts: the main part of the structure, the lobby, and the building portion. The columns are a perfect example of an item you should UV map before you duplicate it across the building.

The Main Building

The main building is actually the simplest part of the structure. This is where the cars park, and it is nothing more than concrete slabs held up by concrete pillars. Of course, there could be more detail if you wanted to include it—lights, pipes, and other structural details. But since this is not designed to be entered, we can limit the detail to what is visible. Start with the base, which is $4{,}096 \times 4{,}096 \times 32$, and then add the columns. The columns are $64 \times 64 \times 1{,}024$ units; and you can see in Figure 5-21 that I started with one column and copied it, but I didn't lay them all out in a perfectly uniform pattern. I kept two close together and copied them twice and moved them upward and then selected the six newly created columns and copied them across the base to form four rows. I stayed on the grid but created a pattern of interest in an otherwise drab structure. You will end up deleting some of the columns later as the other parts of the building are added and the columns are obscured.

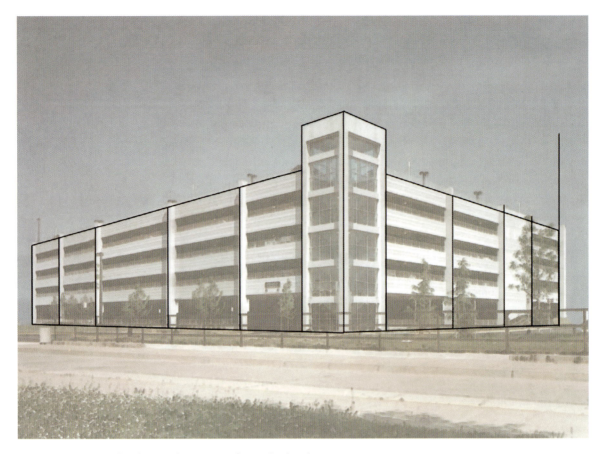

Figure 5-20 We will make a parking garage for our landmark.

Next I created the floors of the parking garage (Figure 5-22) by simply creating a box that is 3,584 × 3,840 × 128. I ended up making the box a bit smaller using vertex editing and eyeballing the size so the concrete pillars stuck out a bit from the structure. You could leave it flush if you like that look. The floors were also inset and extruded for a richer look.

The Lobby Building

The lobby building is the large glass-enclosed portion of the structure. This serves a few purposes: it marks the entrance to the building and helps make the purely functional structure a little more pleasing to the eye. For this I started with a box that is 512 × 512 × 1,792. I inset the side faces by 64 and extruded them inward by 64. Then I deleted the bottom faces shown

base and columns

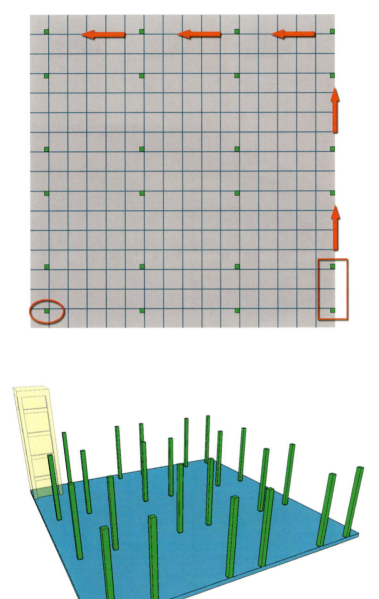

Figure 5-21 Starting with one column and copying it on the grid.

floors

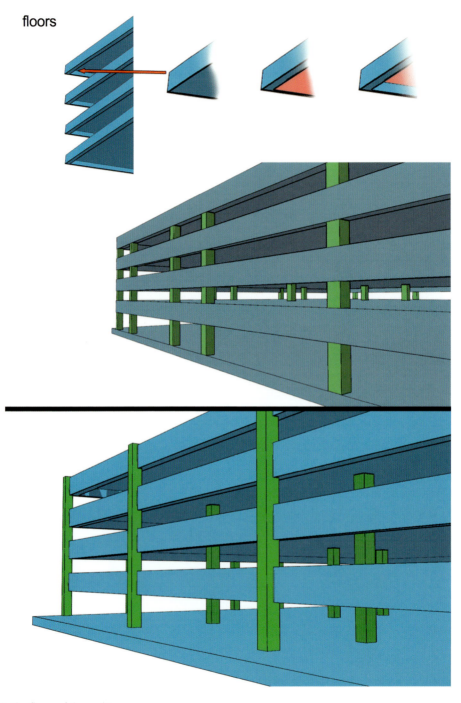

Figure 5-22 The floors of the parking garage.

in the figure, and aligned all the bottom vertices to the floor of the scene. You can use a few boxes to create the crossbars to help keep the poly count down, or you can create the crossbars so they split the mesh and add polygons. This is actually better for texturing and is the way I chose to do it. To do this, simply delete the side faces of the lobby, create a box that fits in that space (512 × 512 footprint, to fit right between the pillars of the lobby structure) and create the box with five sections (or split the mesh). Chamfer the lines and extrude the newly created faces (Figure 5-23).

The Solid Building

The solid portion of a parking garage is often where a stairwell, or even storage rooms and security offices, may be located. Aesthetically this helps balance out the structure. Copy the lobby (Figure 5-24) and nonuniformly scale or squish it down. This will thin the horizontal crossbars a bit, but that is not a problem. When we make the building wider and deeper, we need to use vertex editing and snap to the grid. Horizontally widening the building using a scale makes the vertical columns thicker, and that looks bad to me.

For a final touch I took the edge of the bottom-most floor section and pulled it down to the base of the garage. This made the first floor solid and made the entire building look more substantial. Don't forget to delete all the faces under the floor section that are now unseen.

Details

Props and decorations often take the most time in planning and creation, but these details convey the most information about an environment. They can suggest country (or planet), time, condition, technological advancement, and so forth. Fortunately, the present-day urban setting is easy to create using simple, low polygon meshes. We can quickly create a variety of meshes for the most common items seen on a city street. These items are mostly mapped using a planar map (see chapter 2 for an explanation of the mapping types).

When we create the textures, for the sake of efficiency we will be placing them on one image to form a sheet of textures, as discussed in Chapter 1. You can map the objects now or wait. In a real scenario I would wait until the texture sheet was complete before mapping the objects. Since we are

lobby

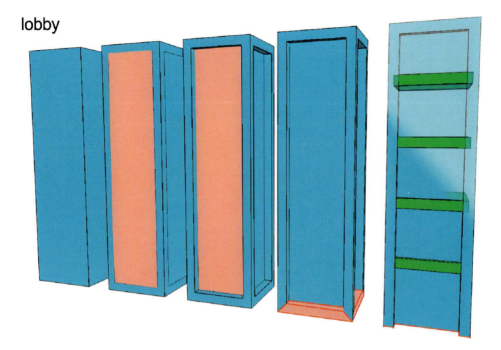

lobby alternative

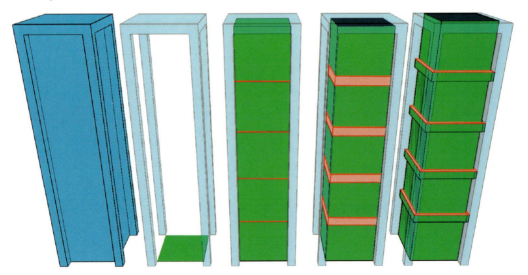

Figure 5-23 The lobby building is the large glass-enclosed portion of the structure.

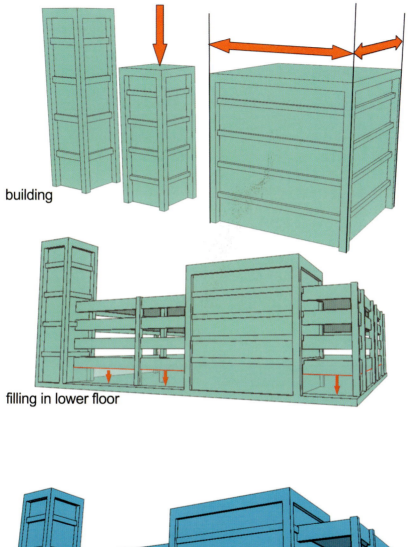

building

filling in lower floor

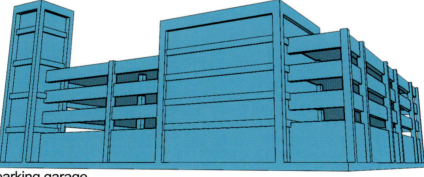

parking garage

Figure 5-24 The solid portion of a parking garage, where there may be a stairwell or even storage rooms and security offices.

creating a defined set of models and textures and know the layout of the sheet ahead of time, you have the option of mapping the items now.

Decals

For the alpha-channeled decals, the mesh is nothing more than one polygon (Figure 5-25). The challenge of these alpha details is in the texturing phase, not the modeling or UV mapping phase. The decals are the simplest of the meshes to UV map. You just have to keep the UVs from overlapping the other decals on the sheet.

Even the meshes for most of the other props are very simple and, in fact, are composed of a few cubes or simple shapes. What's most important in the modeling phase is the scale and proportions of the mesh. The building signs are an exception, as they will be built on a case-by-case basis, depending on where they are and what image they have on them. But still, they are just cubes. For props that the player interacts with, or gets anywhere near, proper scale and proportion will be what looks best in the game

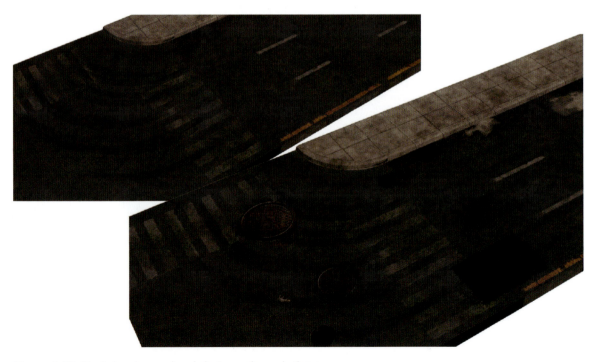

Figure 5-25 Manholes, damaged asphalt, tire marks, and oil stains.

and what works in the game in terms of game play and technological parameters.

Traffic Signs

Traffic signs are simple: a post and the sign itself (see Figure 5-26). Keep in mind that signs can also be attached to other surfaces, like walls and light posts. To create the post, make a cube that is $2 \times 4 \times 190$; for the sign, a cube $2 \times 33 \times 50$. Chamfer the corner edges of the sign slightly so it doesn't look so square.

Newspaper Machines

These can be built using a simple visual reference (Figure 5-27). In Figure 5-28 the steps are laid out for one style of newspaper machine.

Newspaper Machine 1

1 Start with a box ($22 \times 22 \times 4$).

2 Extrude the top face 3 units and scale it inward to create the base.

Figure 5-26 Traffic signs simply comprise a post and the sign itself.

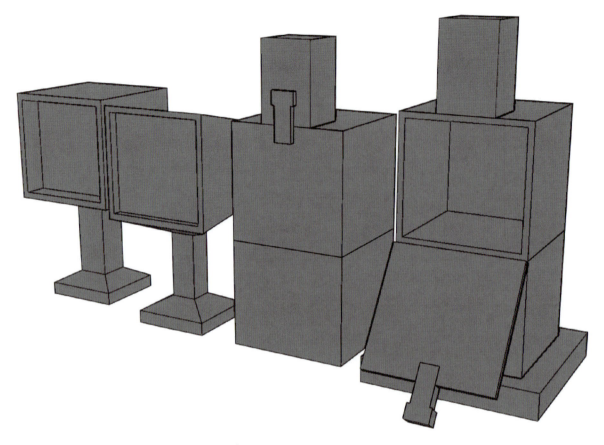

Figure 5-27 Reference for the newspaper machine.

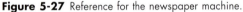

3 Extrude again (24 units) to form the pedestal of the base.

4 Extrude this face a tiny bit, and then scale it outward to the width you want the body of the machine to be. I extruded outward to create a 32 × 32 base for the body of the machine.

5 Extrude this face upward (32 in this case) for the body of the machine.

6 Select the front face of the machine and inset this face.

7 Extrude inward slightly, and you have the complete mesh.

Newspaper Machine 2

To create the common boxy newspaper machine we are used to seeing on the corner (Figure 5-29):

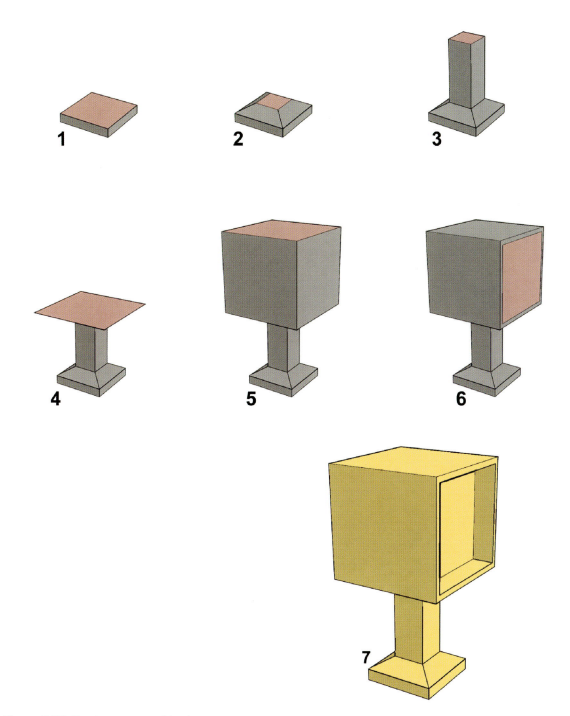

Figure 5-28 Creating paper machine 1.

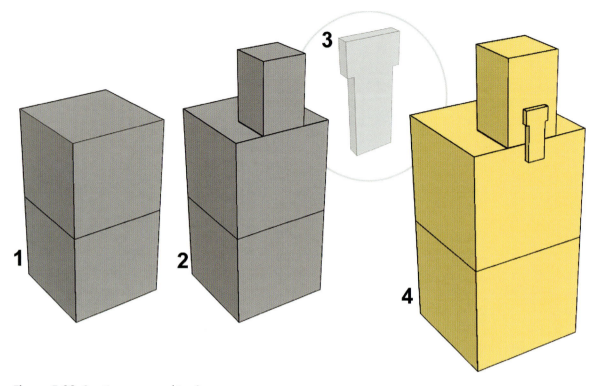

Figure 5-29 Creating paper machine 2.

1 Start with a larger box, 32 × 32 × 64, divided into two horizontally. We divide the box in half this way for texturing. I actually made my box 60 high because the proportions look better, and I didn't need it to be an exact power-of-two measurement.

2 The top of the machine is another cube (14 × 14 × 21).

3 The latch can be an extruded line or two boxes attached.

4 To create the machine with the open door, you simply create a box for the door and attach the latch to it. Inset the face where the opening will be and extrude inward (Figure 5-30).

The Bus Stop

The phone booth and the bus stop are just a little bit more involved. The bus stop is very simple (Figure 5-31) and the phone booth equally so. To start with, we will create the bus stop.

Figure 5-30 Creating paper machine 2 with open door.

1 The roof is a $128 \times 64 \times 8$ cube.

2 The legs are $3 \times 3 \times 128$ cubes.

3 The panels are cubes that fit the spaces between the posts. I inset two of these and deleted the faces and bridged the gaps to create a simple frame. On the third one I left the faces and mapped them with a movie poster.

4 Finally, there is the cold, uncomfortable metal bench that collects water and is covered in some sticky substance. This is $96 \times 18 \times 4$; the legs are $4 \times 10 \times 26$.

The Phone Booth

Next, let's create the phone booth.

1 Start with the roof: $52 \times 52 \times 12$. Use the legs from the bus stop (Figure 5-32).

2 To create the panels, use a box with six divisions, cut once horizontally and twice vertically. Inset these faces and select and delete the middle

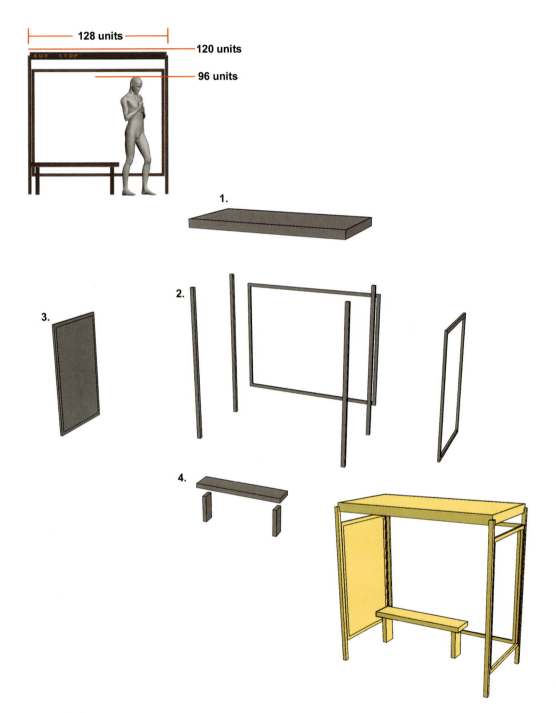

128 units

120 units

96 units

1.

2.

3.

4.

Figure 5-31 The bus stop parts.

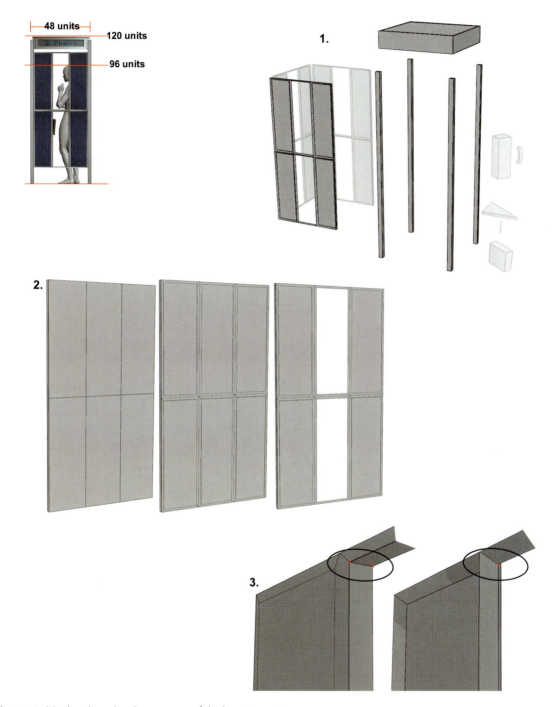

Figure 5-32 The phone booth uses some of the bus stop parts.

panels. I chose to delete the middle panels for looks, but you can leave them or delete them all.

 In addition to removing hidden faces, to optimize this mesh as much as possible, I deleted the inner faces of the frame and welded the vertices together.

 The phone itself is a box (9 × 10 × 28) and a handset. The handset is an extruded line (Figure 5-33).

 The phone book (6 × 16 × 14) is hanging from a small triangular shelf in the corner opposite the phone.

Dumpster, Trash Can, and Mailbox

The dumpster, the trash can, and the mailbox are again cubes, but with rounded tops that take a few more steps to create (Figure 5-34). I find that simply chamfering the edges a couple of times is quick and produces nice results. The mailbox has the letter shoot on it, and the trash can has an opening we need to tackle. First we will look at the dumpster (Figure 5-35).

 Start with a cube (96 × 64 × 55).

 Extrude the top by 3 units.

3 Extrude again 6 units.

4 Nonuniformly scale the topmost face inward, not from the sides. This is not a bevel, which would bring all four edges in.

5 Extrude the top 3 units.

6 Collapse the vertices as shown.

7 Add the two boxes on the edge, and you have the dumpster mesh.

Now the trash can (Figure 5-36). Not every item we model will fit neatly onto the grid. Items like the trash can will look too tall or too short if an exact power of two is used. In this case I made the can 36 × 36 at the base and 56 units high.

 Start with the cube 36 × 36 × 56.

2 Extrude the top face 14 units.

4.

5.

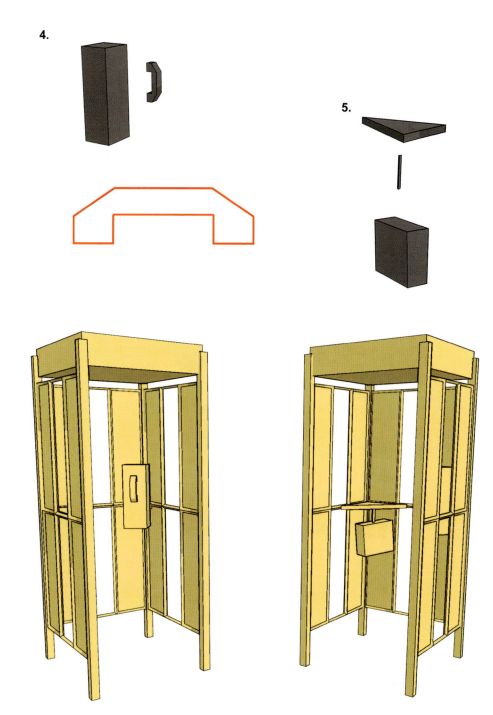

Figure 5-33 The phone details.

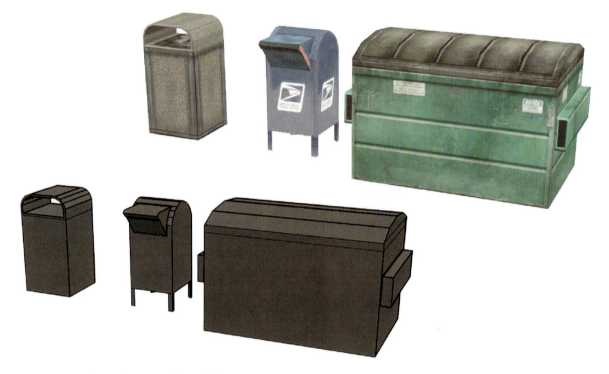

Figure 5-34 The trash can, mailbox and dumpster.

3 Chamfer the two top edges as shown.

4 Chamfer again.

5 Inset the face where the trash can's opening will be.

6 Delete this face and bridge the two openings together.

Next we'll make the mailbox (Figure 5-37).

1 Create a box that is 32 × 32 × 42 units and remove the top face.

2 Create a cylinder with a radius of 16, height of 32, with 16 sides. You can cut this in half or use the Slice option to model half a cylinder. This creates much cleaner geometry. Slice from −180 to 0. Remove the unneeded face of the cylinder.

3 Attach the cylinder to the box. Depending on how you modeled the cylinder, you may have to snap and weld any extra vertices together.

4 Lay out a line for the chute shape.

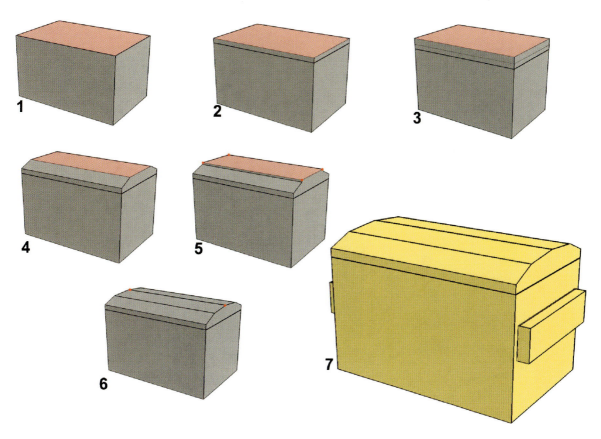

Figure 5-35 Creating the dumpster.

5 Extrude the line about 26 units, and create the legs: four $3 \times 3 \times 10$ boxes.

6 Put all the pieces together and be sure to remove the back faces from the legs and the chute.

Streetlights and Traffic Lights

To create the streetlights (Figure 5-38) we start with the base.

1 Create a box that is $56 \times 56 \times 42$, scale the top polygon inward, and chamfer the top eight edges.

2 To create the lamp at the top, create a sphere with 10 segments and delete the bottom two rows of faces and close the opening. Scale this

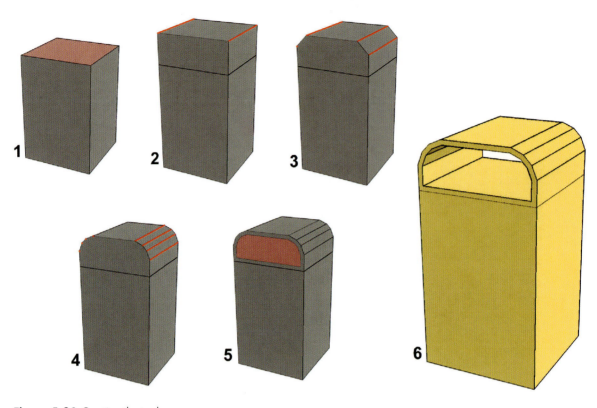

Figure 5-36 Creating the trash can.

inward and downward. Grab the back face and pull it out. If you need a smoother, higher polygon shape, you can start with a sphere with more segments or apply a mesh smoother to the shape.

3 The three poles are obviously cylinders. The main post is a cylinder that is 12 units in radius and tapers at the top. The height is a little over 512 units. I have ten sides on my cylinder, but you can have more or less, depending on your needs. For the horizontal poles supporting the light fixture, you can eyeball the length and number of divisions. You can leave the support pole off if you are going really low poly. or add more detail faces for a smoother bend.

The traffic lights start with the streetlight as a base. You add to this some of the traffic signs created earlier, the traffic lights, and the "Do Not Walk" sign (Figure 5-39).

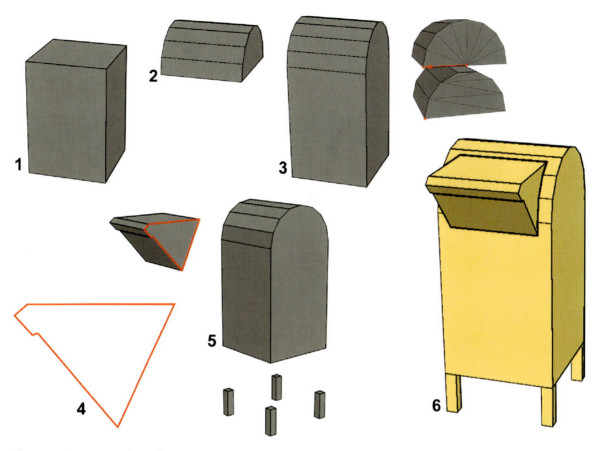

Figure 5-37 Creating the mailbox.

1 The body of the traffic light fixture is a box, 40 × 20 × 128. Chamfer all the edges slightly. Create tubes to fit. Here you have many options, depending on the polygon budget: you can leave these covers off, or add faces to create a smooth tub around the lights. You can have fully enclosed tubes or half tubes. Two small slender boxes form the braces that hold the lights together.

2 The "Do Not Walk" sign starts with a box, 30 × 45 × 45. Chamfer the four outer edges and select the front face. Inset and extrude this inward. Select the bottom vertices and pull them back to create the angle on the front of the sign.

3 The brackets are boxes rotated on their sides so they aren't so boxy.

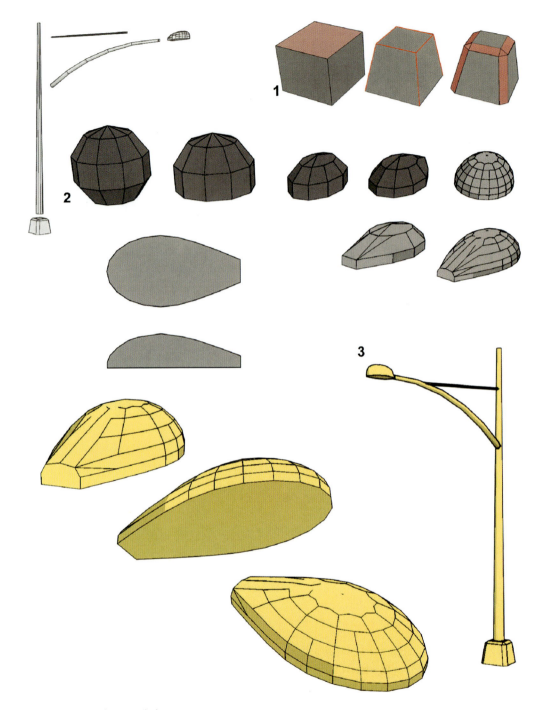

Figure 5-38 Creating the street light.

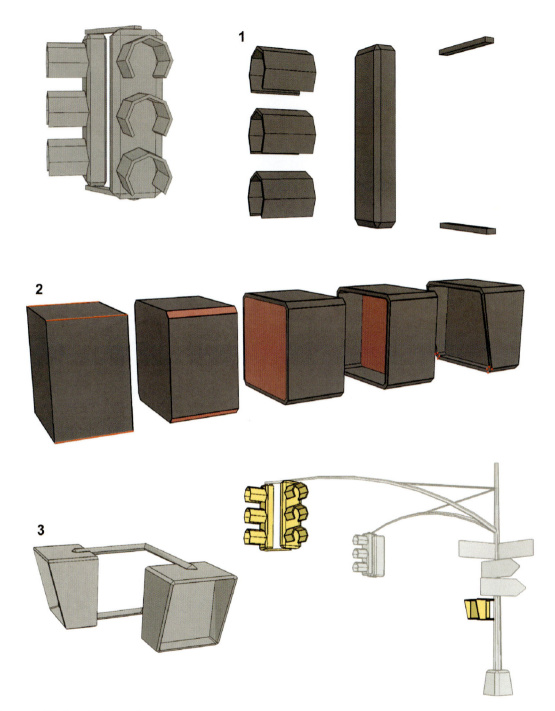

Figure 5-39 Creating the traffic lights.

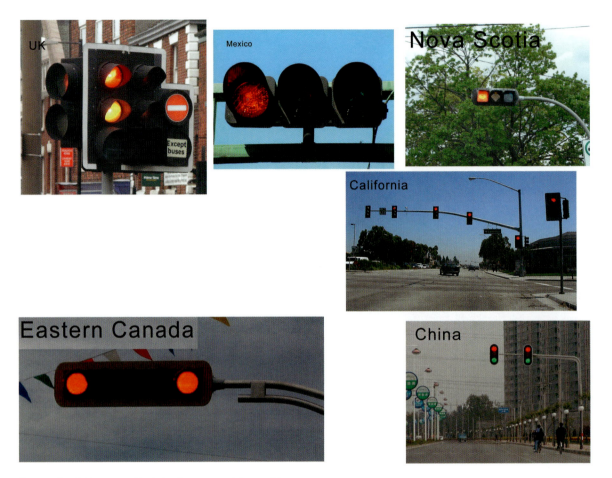

Figure 5-40 Various traffic lights from around the world.

These traffic lights are pretty generic and are based on standard American traffic lights. Looking on the Internet for a few minutes will net you a large sampling of traffic lights from various times and locations (Figure 5-40). This applies to all other props as well.

Parking Meter and Fire Hydrant

The parking meter and fire hydrant are created as follows (Figure 5-41).

1 The parking meter starts with a cylinder with 16 sides, radius 8, and a thickness of 4. Pull the bottom vertices down and move them until they are the shape of the parking meter. Select the front and rear faces and bevel them.

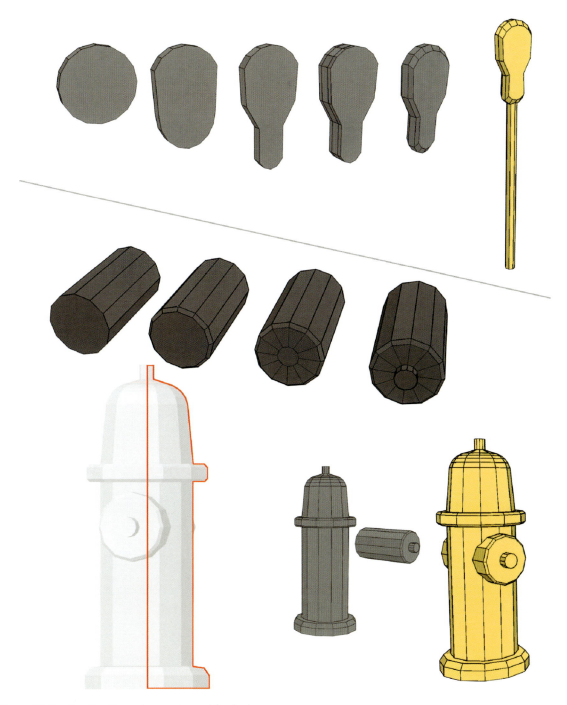

Figure 5-41 Creating the parking meter and fire hydrant.

2 The fire hydrant starts with a cylinder that is 12-sided. Bevel the outer faces and inset and extrude the faces to create the cap. The hydrant itself is a lathed line. The hydrant is roughly 46 units high.

CONCLUSION

Now that we have all of our meshes ready, we will create textures for them in the coming chapter.

Texturing the Large Urban Environment

INTRODUCTION

In this chapter we will create textures for all of the buildings, landmarks, props, and details from the previous sections. I usually start with a 1,024 × 1,024 texture, but when the time comes to place it in a game, texture resolution is usually reduced. I will not address final resolution here because it depends on many factors that I can't address without a lot more information. Keep in mind that if you are able to use a 1,024 texture as a tiling base you can add more detail and richness to the texture, but also keep in mind that even if you can use a large texture, don't choose this option just because you can. If you can get the same results with a smaller texture, you are freeing up resources and if you are able to reduce even a small portion of the textures in your game, the effects are cumulative and you will be freeing up a lot of resources in the grand scheme of things.

If possible, when creating textures for an environment, I like to separate them by the type of texturing they will receive: tiling or nontiling, alpha channeling or not, illuminated or fully bright. For this environment, I want to keep the number of render passes to a minimum, so I will choose a set of texture effects that accomplishes what I need with a limited number of effect passes. Since this is a low resource background for a driving game, there is no need to eat up resources with numerous render passes. Keep in mind that if this were a real-life development process, there could be a reason for more elaborate effects at a starting line or finish line, or that you could have the budget to add more to the entire environment, but even then multiple render passes would be a waste on an item that possibly may be obscured anyway. Most recently racing games have been post-processing entire frames with blur effects and environmental effects that tend to further obscure the background; therefore, elaborate shaders and high-detail environments might make no visual difference to the scene.

TEXTURE CREATION

All textures for this exercise are of the following types:

- Tiling base materials

- Tiling building window illumination mapped

- Nontiling details

- Nontiling illumination-mapped details

- Nontiling full-brightness details

- Nontiling details requiring alpha channeling

All of the textures and their corresponding UV maps, along with the meshes, are on the book's companion DVD so that you can further examine the meshes, textures, and the way in which they are mapped.

Tiling Base Materials

Base materials are the simplest of the textures (cement, bricks, metal, streets), consisting of all things that tile and make use of no extra maps. These textures cover large areas of the world and are called base textures because they compose the base materials of the world—they are what the world is made of (Figure 6-1). In this case, there are cement and asphalt textures that can tile repeatedly, and a couple of textures dedicated to the streets and ground surfaces. Since the first thing to do is block out the level in its most basic form, the following are the first textures you will need for the first set of geometry you will build:

- Asphalt/base streets

- Base cement/sidewalk

- Intersection

Asphalt/Base Streets

To create the asphalt, start by opening the image, *dirt_001.jpg,* on the companion DVD. This is a pretty subtle image of dirt. I spent some time cloning and cleaning this image because it has to tile over a fairly large area. Because I plan to add detail using alpha-channeled images on polygons, I can make this a pretty subtle texture. Refer to Figure 6-2 as you perform the next steps.

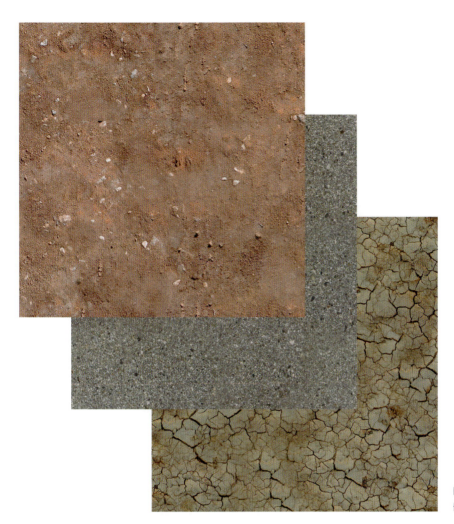

Figure 6-1 Raw images from which textures are made.

Next, I added the lines—I wanted them under all the overlays. Create a new layer and set the opacity to 25%. Create the lines by filling a selection with white and erasing parts of the lines.

Open the image *cracks_DVD.jpg*, and paste it on top of the lines. Set the blending mode to Soft Light and the opacity to 25 to 30%.

Create a new layer, set your colors to black and white (D key), and render some clouds. I also rendered various clouds a few times. Set the opacity to 25%. This helps the street look less "perfect," and a little more stained and weathered.

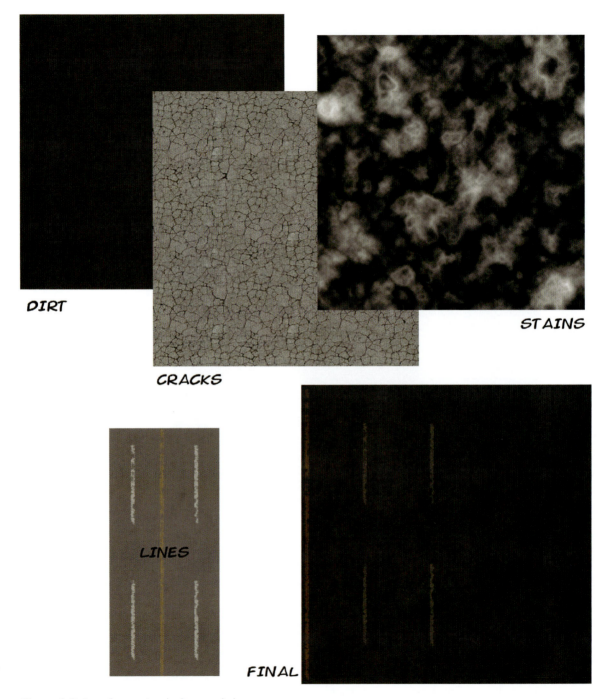

DIRT

CRACKS

STAINS

LINES

FINAL

Figure 6-2 Steps for creating the base asphalt.

Base Cement/Sidewalk

Cement

1 Start with a new 1,024 × 1,024 image.

2 Create a new layer named *base*.

3 Set the foreground color RGB at 91, 87, 85. Fill the layer.

4 Filter > Noise > Add Noise: 3%.

5 Filter > Blur > Gaussian Blur: 0.5 pixels.

6 Filter > Brush Strokes > Spatter: Spray Radius 15, Smoothness 8. Now we have a very basic and clean cement. The next step is to add subtle and varied stains.

7 Create a new layer, and name it *grime*.

8 Filter > Render > Clouds.

9 Brightness/Contrast: Brightness +10, Contrast +60.

10 Change the layer blending mode to Multiply, and take the opacity down to 15 to 20%.

11 Add the Cracks layer from the asphalt, and take that down to 13% opacity.

12 Add the image *cement_001.jpg* as a layer, set the blending mode to Overlay, and the opacity to about 70%.

Your image should look like Figure 6-3. Save this image as *base cement*, since you will reuse it. We will make the sidewalk from this image as well as building textures.

Sidewalk

1 Open a copy of the base cement we just created.

2 Turn on your grid and set it to 128 with 2 subdivisions.

3 Marquee a 256 × 1,024 section of this image and copy it. You don't have to flatten the image. Use Ctrl + C on an active layer and you can copy the image as you see it. Optionally, if you are working in a situation where the sidewalk and street textures are to be applied as separate textures, you can create two images.

Figure 6-3 Creating a base cement.

4 Paste this into the street image we created earlier, and snap it to the left of the image using the grid. Remember, because we created our street mesh to these dimensions, the sidewalk will fit perfectly on it, and we UV mapped it to tile twice lengthwise since the mesh is twice as long as the texture but the same width.

5 Copy this layer (Ctrl + J) and erase seams along the grid. I divided the sidewalk into fourths and used a rough eraser.

6 To add more detail and richness, use the *dirt_002* image and lasso a few sections. Give the lasso tool a few pixels (5 to 10) of feather, and place these on the street image. Set the blending mode to Overlay, and take the opacity down to about 75%. This image is brighter and higher contrast so that the dirt will pop more. Because dirt tends to collect off the beaten

path, place the dirt next to the curb and erase it along the curb so it looks like it stops right there (like it does in the real world). Do the same for the sidewalk if you like, but you should probably make the dirt smaller and more subtle on the sidewalk (Figure 6-4).

We need to make the intersection and the street textures tile together. Since the street is made using two halves that are rotated and placed together, this creates a situation where the texture will show a hard seam down the middle of the street—or that's how most people leave it. The street mesh is not flipped, but rotated in most cases. This is actually good because flipping the mesh would create a butterfly effect in which the mirroring of the two matching sides was obvious. By rotating the mesh and making sure that the edge pixels tile, we can create a situation where the center lines don't mirror each other. See Figure 6-5 for this part of the exercise.

1 Cut a narrow strip of pixels from the upper half edge where the streets meet.

2 Vertically flip this piece and move it into position on the bottom half. Zoom in and clean out all but a few pixels on the edge of the strip. The two halves now tile with each other.

3 If the process is still unclear, see Figure 6-6 for a more straightforward visual. You also need to repeat this process on the ends of the street texture.

Intersection

1 Open a copy of the street texture (Figure 6-7).

2 Save this file as *street_intersection*.

3 Turn off the sidewalk, dirt, and line layers. You should be left with a plain asphalt texture matching our street.

4 Turn on the grid. If you created a rounded corner, then you can simply make a circular selection from the corner with the sidewalk and invert the selection to remove portions of the sidewalk that are no longer needed. Do the same for the upper layer of concrete to create the seam; use the eraser to erase the line and let the line be a bit messed up.

Figure 6-4 Sidewalk and street created for the street mesh.

Figure 6-5 By rotating the mesh and making sure that the edge pixels tile, we can create a situation where the center lines don't mirror each other.

5 You will not use the line layers, but you do need to create the cross-walks using the same method you used to create the lines. Remember to work on the grid.

6 Finally, add some dirt, if you wish, and the tire marks. The tire marks are fuzzy curved lines with a low opacity (25 to 30%).

7 Make the two edges tile with each other in the same manner that the streets tiled. This intersection will need to meet up with the street mesh on the sidewalk edges and each other on the inner edges. Whether you use one split mesh or four meshes, they tile the same.

Building Windows Illumination Mapped

The textures that cover the upper stories of the buildings are actually simpler and easier to create than the base textures, but we will be adding

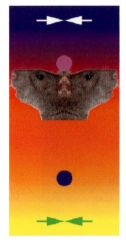

flipped

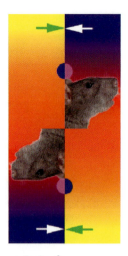

rotated

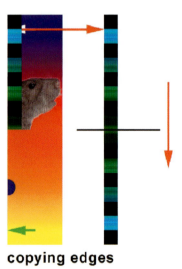

copying edges

Figure 6-6 Illustration of how to make edges tile to various edges.

tiling while rotated

Figure 6-7 Creating the corner texture.

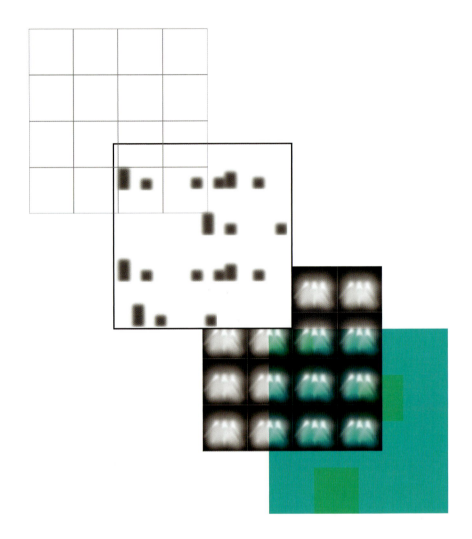

Figure 6-8 Windows.

the illumination map and that will take a little more effort. We will use the illumination map to make some windows look as if there are lights on inside the building. Generally, the windows in a modern city on the upper floors of skyscrapers are a solid pane of glass that is reflective on the outside.

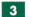 Open a new document that is 1,024 square, and name it *windows_001_DIFF*.

2 Fill the background with RGB 63, 152, 160 (Figure 6-8).

3 Create a new layer named *lights*.

4 Turn on the grid and set it to 128 with gridlines every 2 subdivisions.

5 Marquee off a 256 × 256 area to create the first set of lights. Use a soft brush of about 45 pixels and paint some random black about the edges of the area, and using white, paint some dots about the area.

6 Put a 12-to 15-pixel Gaussian blur on this, and use the brush again to put some of the hot back into the white lights.

7 Create a new layer called *stuff*, and set the opacity to 63%.

8 Make some random square and rectangular shapes in the windows. You don't even need the grid, as these shapes represent desks and file cabinets and such in front of the windows.

9 Gaussian blur this layer at about 6 to 7 pixels.

10 While the lighted portion of the texture can be tiled across the texture since it is assumed the building has the same lighting installed throughout, the "stuff" should be placed randomly but evenly distributed across the various windows. This is an opportunity to add some richness in a very subtle way.

11 Add another layer and name it *frame*. Set your foreground color to a light gray. Even though this is a solid pane window, there is a small seam that holds the panes in place. Make a selection on the grid (256 × 256), and stroke this inside at 2 pixels. Apply the layer style Bevel and Emboss, and change the size to 2.

12 You need to flatten this layer, so you might want to create a copy of it in case you want to change something about it later. After you flatten the layer (right mouse on the layer, select Create Layers, and then merge all of them).

13 Copy the *frame* across the texture using the grid to snap it in place.

Solid-Pane Illumination Map

There are two ways you can handle this light map (Figure 6-9). I actually prefer the results of the easy way, which is an on–off situation, meaning that the light map is either black or white. You can set up a light map to control all the subtleties, if you wish, as follows.

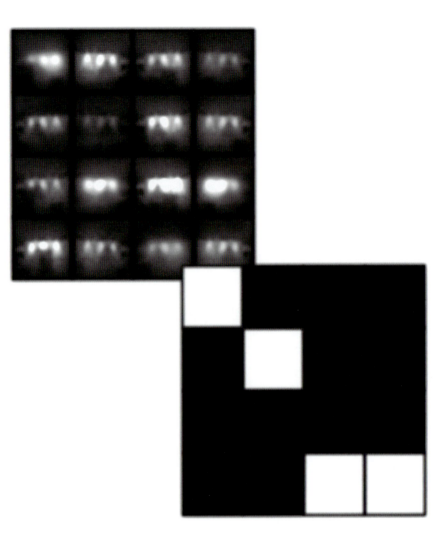

Figure 6-9 Window illumination map.

1 The illumination map starts with the color map we just created. Use a copy that is not flattened. Just duplicate the document and name it *windows_001_ILL*.

2 Use Ctrl + U to access the Hue Saturation dialog box, and take the lightness all the way down so that the frame is now black. The frame will not emit light since it is solid black.

3 The light layer is already black and white so you need to Desaturate the background layer (Ctrl + Shift + U).

This might appear to be a bit bright in the game, so we will darken the windows. You can darken the layer itself or use an adjustment layer to do this. You might want to use a separate layer of darkness so you can make selections using the grid to darken and lighten selected windows.

Other things to try follow:

- You can alter the color in various windows so that there is some subtle shade shifting among the windows.

- If possible, you can use multiple illumination maps to make various windows lit and unlit to help break up tiling if you need to.

- If you can afford the large texture, consider shrinking the size of the windows. This will allow more variety among the windows.

- Add a concrete strip vertically or horizontally (or both).

- Try variations on the strips, maybe a concrete outer strip running vertically and a darker smaller strip running horizontally (Figure 6-10).

Google "skyscrapers," and you will see that there are many variations on the shape of the buildings and the windows, but they are all simple to recreate using the base materials you just created.

Nontiling Details

- Signs

- Newspaper machines

- Bus stop

- Phone booth

- Garbage can

- Dumpster

- Mailbox

- Light

- Traffic light

- Parking

- Fire hydrant

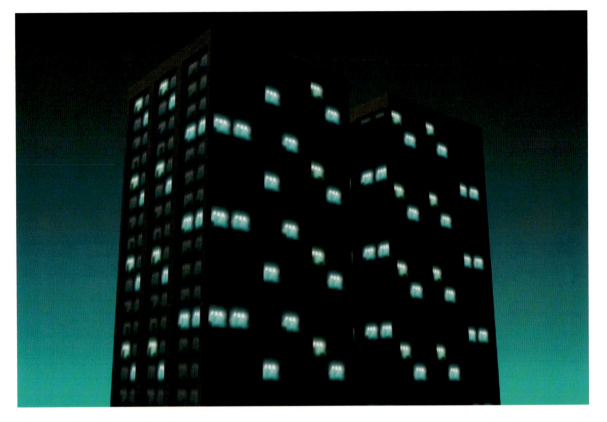

Figure 6-10 Two rendered buildings.

We can also add nontiling details for other meshes such as doors, garage doors, and other such objects.

Signs

Signs can be made easily in a few easy steps, but I have provided a sheet of many common traffic signs. Use them, alter them, they're yours. You do need to consider saturation, brightness, and conditions when putting a sign in a scene (Figure 6-11). The sign post is a strip of color in Photoshop with holes along it; the bevel and emboss filter was applied.

Newspaper Machines

I started with a photo reference and cropped it down (Figure 6-12), and then used Photoshop to strengthen the lines and create variations in the texture. By changing color, the paper in the front of the machine, and a

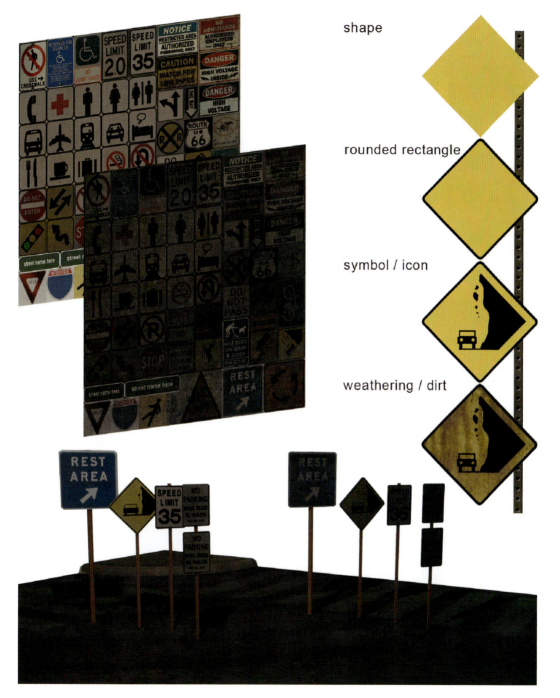

shape

rounded rectangle

symbol / icon

weathering / dirt

Figure 6-11 Signs? Easy.

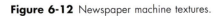

Figure 6-12 Newspaper machine textures.

few other details you can create a nice variety of textures. You can see in the figure that the panels are all mapped from the same part of the texture. The only difference is that on the sides, back, and top panels, I moved the UVs inward so that the metal frame on the lower front panel doesn't show.

Bus Stop/Phone Booth

This mesh and the phone booth are examples of where you may want to UV map one part before replicating it many times (Figure 6-13). The mesh for these objects is composed mostly of those thin square posts. The texture is very simple. There are three parts—the thin posts, the thicker bus stop roof edge, and the seat. The panels can be removed, mapped with glass, or (as I will do later) mapped with a full-brightness image from the billboards. The texture was created using bevel and emboss and touch-up with some dodging and burning.

You can see in Figure 6-13 that I used a photo reference for the front of the phone and the sign on top. The rest I created in Photoshop in the same way that I created the bus stop parts: color, bevel and emboss, maybe a small bit of noise, and finally some dodging to get that nice metal highlight along the metal parts.

Garbage Can/Dumpster/Mailbox

The can was created using a trash image from Google, a pebbled rock surface from my hard drive, and Photoshop (Figure 6-14). The dumpster was created using a photo reference. I used Photoshop to clean and crop this image, as well as create the end textures for the arm slots on the side of the dumpster. I used Photoshop to create the lid as well; that is, dark gray, some noise, and the dodge and burn tools. I worked on the grid to make the lines straight and easy to create. The mailbox was created from a photo reference and I was able to trim down the needed texture to the side, the chute, the chute opening, and the legs. The rest of the mailbox is mapped in plain blue, just like the blue newspaper machine. I simply matched the shades of blue and used the paper machine panels to cover the plain parts of the box.

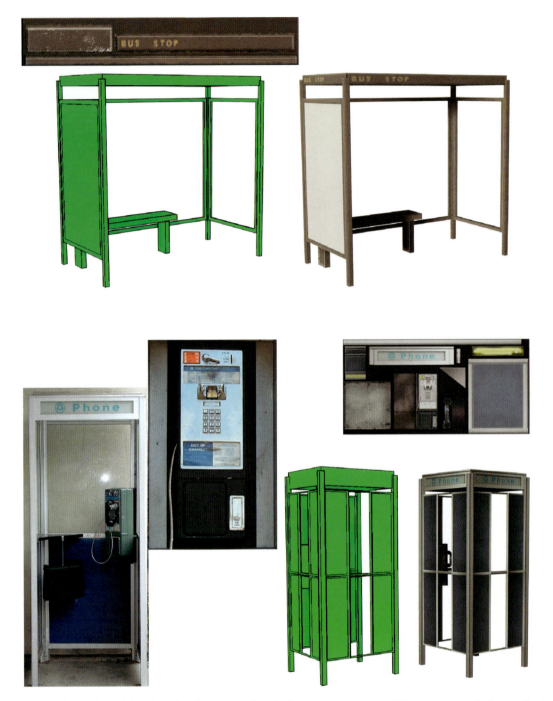

Figure 6-13 This mesh and the phone booth are examples of where you may want to UV map one part before replicating it many times.

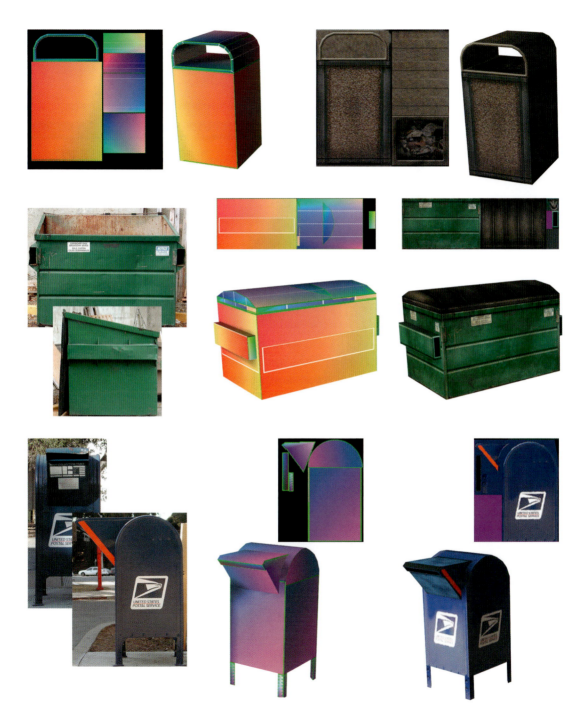

Figure 6-14 Garbage can/dumpster/mailbox.

Figure 6-15 Light.

Light

The light (Figure 6-15) has a base and a metal texture, both created in Photoshop. The actual lamp of the light can be created and placed in the nontiling full-brightness textures so that the light appears to be on.

Traffic Light

The traffic light starts with the lamp as its base (Figure 6-16). The base, post, and arms all use the previously created texture. The signs can be added as you wish. All that's left is the walk signs and the traffic lights themselves. The walk signs are created from a photo reference for the "walk/don't walk" faces, and the yellow was created in Photoshop using the UV template from the model. The street lights were created entirely in Photoshop. After creating the green base, I added the light frames by making a circular selection on the grid, stroking it, and applying the bevel and emboss filter. The lenses were painted using the brush for the color, burn for the shadow across the top of the lens, and dodge to create the small highlight.

Parking Meter/Fire Hydrant

The parking meter is actually made from about four different parking meters found on Google (Figure 6-17). I placed these over the UV template

Figure 6-16 The traffic light starts with the lamp as its base.

and painted in the silver face of the meter so that it matched the mesh. The fire hydrant was made entirely in Photoshop using bevel and emboss and overlaying a little dirt.

Nontiling Illumination-Mapped Details

For some details of the world, such as the storefronts in this case, we don't want the entire texture to be full brightness. For this we add an

Figure 6-17 The parking meter is made from about four different parking meters found on Google.

illumination map to control what part of the texture is lit or dark, just as we did for the windows. These textures are separated from the windows because these details are not tiling, and the process of creating these maps is slightly more involved. To make the base storefront texture, you can use almost any image; the ones that work best are not necessarily storefronts, but photos of a large room from eye level. Gaussian blur that and add a row of people or objects in the foreground that are dark and more in focus. Then create your window and door frames. From this separate layer of frames comes the pure black ones that you need to block light in the illumination map (Figure 6-18).

Nontiling Full-Brightness Details

Some textures can be displayed at full brightness, which makes rendering them faster and they look great. Large electric signs and billboards at night appear fully illuminated if they are backlit, or otherwise illuminated. I made over thirty billboards. You can make as few or as many as you need. The process I used was to look at recent pictures of Times Square to survey billboards in terms of color, size, composition, and so on, and started

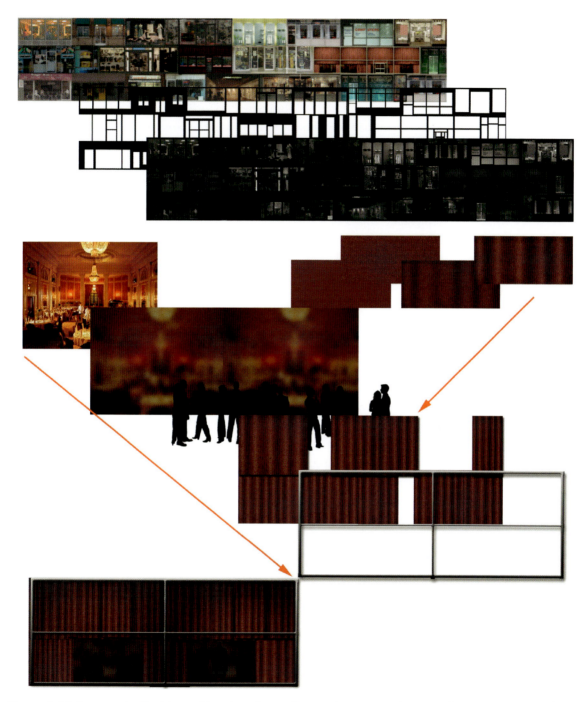

Figure 6-18 For some details of the world, such as the storefronts in this case, we don't want the entire texture to be full brightness.

making my own mock billboards based on these. The billboards don't have to be large, even though they are as such in the game. They work like real billboards do, kind of low resolution and designed to be viewed from afar (Figure 6-19).

Effective use of a fully illuminated texture is rare, but when you can, optimization may get a boost. In this case, the large signs on the buildings are, in real life, backlit and appear fully bright. All of these textures will require no special consideration at this stage. When they are implemented in the game engine they will be flagged as full bright textures. Since they will be displayed at full brightness, I made the textures a bit dark and brightened up the centers of a few so they have that uneven backlit look that many real-world signs have. The one sign I made sure that I had was for the parking garage. I made this a rather large vertical sign.

Nontiling Details Requiring Alpha Channeling

Some details require an alpha channel, such as decal-type details, plants, and glass. We will include a few of these in our scene. Since alpha channeling can be expensive, you want to use it sparingly and where it will have the most impact. An example of this would be a manhole cover or crack in the street. Since tiling textures need to be rather simple, and contain no outstanding feature in order to tile effectively, alpha details can be used to help break things up. I tend to concentrate on the corners of the city block since that's where most of the traffic occurs and where people in real life and games alike tend to pay more attention to their surroundings. The things that I decided to create were chosen because they are common at a street corner and can be reused, they are simple enough that reusing them won't look too repetitive, and some of these images hold up well under resizing. The ability to resize an image adds a lot to the world. The tire skid marks are a good example. You can stretch and squish these a long distance for a variety of tire marks. Manholes can be slightly resized and rotated as well.

I like to create all of my alpha details over the surface that they will be placed on in the game. In some cases, that's not always possible, but here all of these details will be displayed over the base street texture, so start with a copy of the base street.

Figure 6-19 Large electric signs and billboards at night appear fully illuminated if they are backlit or otherwise illuminated.

Sewer Grates, Manholes, and Access

All of these are derived from personal digital photos. I used three manhole covers and a metal plate. I copied the metal plate four times and created the four different sewer access and drain plates that you might see in a city street. The nonflattened PSD file is on the DVD so that you can see the settings I used. Basically, they are small bevel and emboss layer styles combined with blending modes to blend the metal into the streets. As I was putting the ring frames around the manhole covers, I thought an open manhole would look good as well. Later we will add more detail around these objects such as dirt and cracks Figure 6-20.

Oil Stains/Tire Marks

For the oil stains, I created several layers of various dot patterns and each layer has a different opacity setting. The larger and farther apart the oil stains, the lower the opacity setting. Add some rust brown to the stains as well. The tire marks are fuzzy black lines with a low opacity setting (Figure 6-21).

Cracks, Dirt, Holes, and Tar Patches

The cracks were created using the image *cracks_02.jpg* on the companion DVD. I used the cutout filter to get the cracks cleanly away from the noisy background. This breaks the cracks and the background down to their most basic colors so that you can select and delete the colors around the cracks. This is important because if you apply a slight downward bevel and emboss to these cracks they look great on the asphalt. Use the cracks around the objects that are on the street such as the manhole covers and access panels (Figure 6-22). Do this by placing a copy of the layer under the object and erasing all but a few of the cracks around the object.

For the dirt, I used a couple of layers and various brushes, and set the opacity low to create dirt and stains around the objects (Figure 6-23).

The tar patch and the worn-away asphalt are both simply textures (asphalt and concrete, of course); the tar has an upward bevel, and the worn-away spots a downward one. I did a slight inner glow for the worn-away asphalt so that it looks a little deeper (Figure 6-24) (and I threw a dead rat in the street and some puke).

Figure 6-20 Later we will add more detail around these objects such as dirt and cracks.

Figure 6-21 Oil stains/tire marks.

CREATING THE ALPHA CHANNEL

No layer effects can be active when creating the alpha channel. If you want to, copy the layer so that you can change things later. Create layers from the layers Palette menu and merge all the layers together. We do this because Photoshop doesn't see the pixels extending from a layer effect since they are being created in real time by the program. We need Photoshop to recognize these pixels so that it can calculate the proper alpha channel for us.

Copy the image and merge all the layers except for the background together. You need to make the objects layer white and the background black. I find that the fastest way to do this is to jack the brightness all the way up or down, depending on whether you want all black or all white (Ctrl + U) (Figure 6-25).

cracks

cutout

cracks with bevel and emboss

Figure 6-22 The cracks were created using the image *cracks_02.jpg* on the DVD.

Figure 6-23 Dirt.

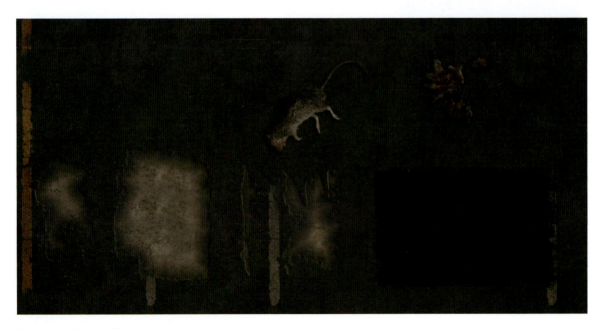

Figure 6-24 Looks like a city street to me!

Figure 6-25 The quickest and most accurate way to create an alpha channel for a Photoshop file is to merge all the layers except for the background together and make the objects white and the background black.

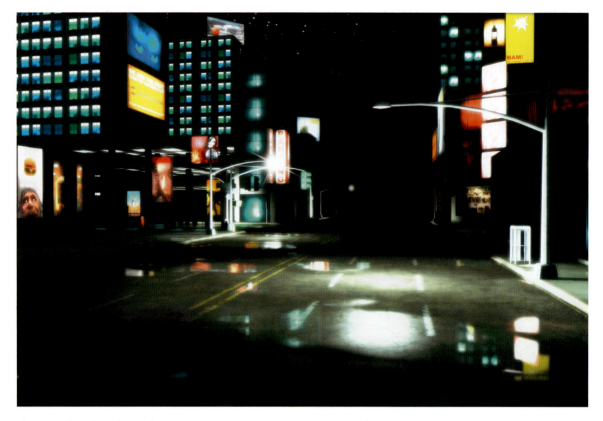

Figure 6-26 All meshes and textures in scene.

Remember, if you are going to have an alpha channel, use it. Add all the cool you can with it. Don't just add a manhole cover—put dirt and cracks around it, too.

CONCLUSION

Figure 6-26 presents all the meshes and textures in the scene.

Introduction to Natural Environments

Building a large foliated outdoor environment can be challenging, but once you break it down to its basic elements, a game environment can be fairly easy to create. The distinction here is that we are building a game environment, not a real environment. A real outdoor environment has many species of trees and plants, all with specific details. All we have to do is make this space look good and look believable. In order to do this, we need to understand what should be in a certain environment, and for the game artist the focus is mainly on color and shape. We do need to have some degree of accuracy, which we can obtain from pictures, but ultimately the environment we will create will not stand up to the scrutiny of a botanist.

The Island of Dr. Moreau, *Treasure Island*, *Jurassic Park*, *LOST*, *King Kong*, *Battle Royale*. . . . I love these adventures that take place on a remote island. In this section, we will look at terrain creation, create some trees, plants, and rocks, build a sky dome, and then model and texture a jungle base. The jungle base incorporates several environmental features that can be used to our advantage. A dense jungle demands optimization and visual trickery due to the scope of the assets being rendered, but this density can also be used to our advantage. The density of the jungle and height of the terrain allow for some occlusion tricks.

The jungle base is a large open environment but the player cannot go everywhere she or he wants to. The player is usually limited in movement by the method of movement and the environment. In some games, you can fly and the terrain is vast; in others you are limited to small places, to on-foot speeds, and to certain terrain altitudes/heights.

TECHNOLOGICAL ASSUMPTIONS

Polygons, pixels, distance fog, occlusion—these things are the same in every engine. The platform we are shooting for is a bit behind the cutting edge,

but still able to pump polygons and recent enough to handle lots of render passes and to support terrain. While that is our assumed technological baseline, this topic (the outdoors) in particular is more lengthy, but also more vague and varied than the others covered in the book. This is because there are so many more options available technologically than in any other area. There is the terrain to handle, which is a different animal than a hallway or closed room. An entire chapter is dedicated to the basic editing of terrain in games. Other aspects of the outdoors include weather and sky, water, and of course trees, plants, and other natural objects such as rocks. So a chapter is dedicated to the creation of those assets. I personally love creating outdoor environments, but I include this chapter because many consider creating assets for the outdoors a major challenge. I think the challenge lies in creating assets that look consistent, but not the same. For example, one or two trees, if arranged properly, can fill a forest and all look individual. This is far more efficient than creating a hundred trees. Creating the actual tree can be a modeling/texture challenge, but there are tools that can be of great help. This chapter will introduce you to the asset creation aspect of the outdoors as well as several tools that can assist you greatly in the creation of the outdoors.

While an interior setting can get away with a more general set of assets, the outdoors may require a more diverse set of assets from the artist. This is not to say a larger set, just a more diverse set. An indoor setting may require several panels for various parts of the world, but these are most likely similar to each other and based on common materials. In the outdoors you may be required to create rocks, trees, plants, water, and other assets that are used in different manners. From the small simple particle that is used to create an impressive rainstorm to the complex set of textures that work together in the form of a shader to make a wet palm frond look convincing, these assets all require different disciplines and knowledge to create as well as the understanding of the diverse technologies that will utilize them.

Finally there is a chapter on creating the actual assets for an outdoor setting, including the man-made assets of the world.

Note: Remember that although specific game tools are not the focus of this book, in the job hunt you will want to know at least one set of commercially useful game development tools, and—at expert level if possible. In this section, I am using screenshots from a commercial engine that handles

terrain, but will not refer to the engine or the specific menu options that are used.

Perspective

While this is a large open area, the jungle actually limits players for the most part so they will be allowed a tighter third person than a driving game or MMO. The terrain can be open, but we can also close it down using hills and fog. Distance fog in this case is expected in a hot jungle with a high degree of moisture. We can have dense vegetation which looks more realistic. There can be large rocks and trees (Figure 7-1). Flight simulators and first person shooters that take place outdoors represent the opposite end of the perspective scale so naturally they have some elements in common and some that are very different. While both may allow for the manipulation of the terrain one may require up close work with multiple layers of texture and fine-tuning of the terrain mesh for player movement as well as the fine-tuning of many more systems for foliage, decoration,

Figure 7-1 A jungle limits players for the most part so using hills, fog, dense vegetation and large rocks and trees we can limit their visibility.

impact sounds, collision detection, etc . . . The other may use a height map and a single large texture (or a MegaTexture) that was generated from algorithms or actual geological data. For our purposes we will work up close, but if this were being built for a flight simulator we would simply ask the same questions, only the answers would be different. For example, in a first person game we may have a full library of plants and trees (meshes and textures) and we may have shaders assigned to these assets for specular highlights, normal mapping, and even vertex shaders for leaf movement if a player brushes past. We may also have to create special collision hulls and assign sound events for moving through and colliding with trees and bushes. But if we were in a plane flying thousands of feet above our concerns would be very different. Would we even need models of trees if we were that high up? In coming chapters we look at an application that will generate MegaTextures and we will look at the up close and personal method of creating terrain.

Note: "MegaTexture refers to a texture allocation technique facilitating the use of an extremely large terrain texture instead of repeating multiple smaller textures. It is featured in Splash Damage's game, *Enemy Territory: Quake Wars* and was developed by id Software technical director John Carmack. MegaTexturing employs a single large texture for static terrain. The texture is stored on the hard disk and streamed as needed, allowing large amounts of detail and variation over a large area with comparatively little RAM usage. The upcoming game *Rage* powered by the id Tech 5 engine uses textures that measure up to $128,000 \times 128,000$ pixels." Source: http://en.wikipedia.org/wiki/MegaTexture

Theme

This island base, while still operational, is showing the wear and tear of being in a jungle environment. There are cracks in the concrete, rust on the metal, and mold and vegetation grow wild. In brief, it appears much like *Jurassic Park* in the later movies. Theme is important in an outdoor setting as well as an indoor setting. Think about the difference of the outdoor setting in games like *World of Warcraft* as opposed to *Far Cry*. Plants and trees are bound by the same creative forces that mechanical assets are in a game. If your world is a happy, cartoony place then your trees should be as well. A bad place can have dark spidery trees with branches like skeletal fingers.

World Size

This is a rather large world, but you can't see it all at once due to the hills and valleys of the island, the twists and turns through the jungle, and the fog. This will allow us to investigate a wide variety of outdoor building tools and techniques.

Game Fiction

The game fiction needs to answer the following questions:

Who owns or runs this island? A mad scientist, a corporation, a government?

Was this island taken over by another group? Could the aging military base support more recent additions that alert the player to a new inhabitant and where they might be from?

What happens on this island? Are there large animal pens and cages? Weird storage containers? Hatches all over the place (yes, a *LOST* reference!)? Bloody bodies gutted and tossed about randomly?

Is the island flat or mountainous?

Where is this island? Is it in a tropical or artic zone? This answers many questions about the sky and the foliage.

What was done to it in order for it to be inhabited? Was it stripped down or was it consciously left intact to disguise the presence of the inhabitants?

When was this island base built and is it abandoned? Are the structures from the recent past, distant past, or are they brand new?

Again, these questions are usually already asked and answered and you will work from sketches, concept art, and other materials, but there is always the chance you will be in the situation where you have to ask these questions.

CHAPTER 8

Terrain

In this chapter we will look at the basics of terrain creation and editing common to most terrain tools. There are three general ways to create terrain for games: manually using a 3D application, using tools in a game editor, and using a terrain generator. You usually end up relying on one way and using the others in the course of your work. Since in-game terrain tools are usually tailored to that game/game engine and combine basic terrain editing features with proprietary features, we will first look at the basics of terrain creation, followed by a brief discussion of terrain creation software. After you understand the basics of terrain editing, you should be able to quickly pick up almost any terrain in-game editor.

MANUAL TERRAIN CREATION

Creating terrain manually can be tedious; it's great if you are on a budget or simply don't need an overly large or elaborate piece of terrain. Manual creation involves a few basic operations that can be used alone or in conjunction with each other: forming the terrain mesh using a displacement map, sculpting the mesh by hand, and using application specific tools to manipulate the mesh. You can also hand paint the displacement map, but that takes a great deal of time and skill. I believe you are better off working on the mesh directly. Importing a rough displacement map is useful if you need to build terrain that fits a certain map (Figure 8-1) and work from there.

First, let's look at using a displacement map to distort a mesh. This is a pretty simple concept. Basically a grayscale map is used to determine the height of any given point on a mesh. This is best understood in illustration—Figure 8-2 shows samples of displacement maps and the effect they would have on a mesh). You can see that the finer the transition from black to white, the smoother the physical transition on the mesh. What makes

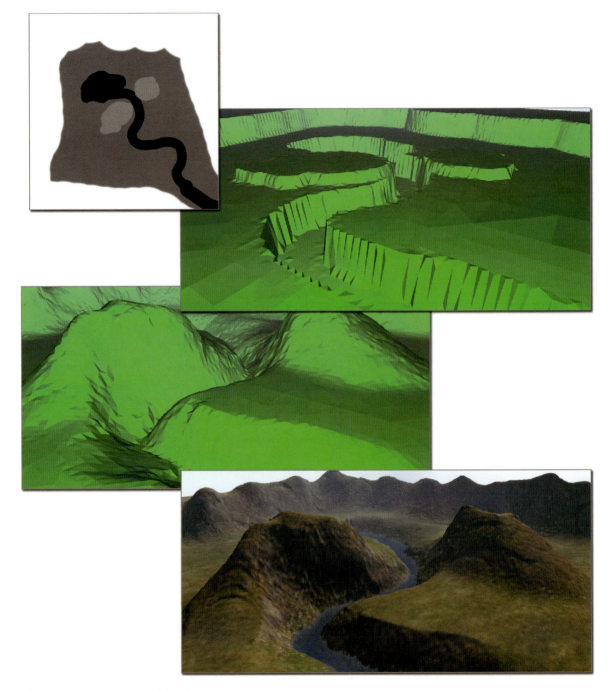

Figure 8-1 Importing a rough height map.

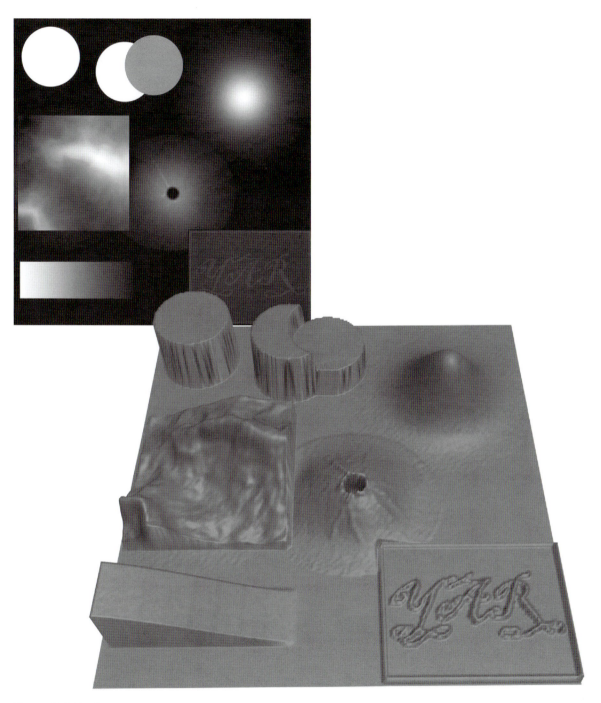

Figure 8-2 Height map.

hand painting terrain so challenging is that each shift in grayscale is a change in elevation. You can see how the slightest shade difference can cause an ugly artifact in your mesh (Figure 8-3). In this case, the artifacts were caused by extreme image compression.

When you need to hand manipulate terrain in a traditional 3D application such as Max or Maya, there are many tools to help you and each program has different tools sets. Maya has a set of mesh sculpting tools, while Max has features such as soft selection and paint deformation. So you can import a height map (Figure 8-4), manipulate it by hand (Figure 8-5), and apply various modifiers to it as well (Figure 8-6). Modifiers can include noise, ripples, waves, meting, relaxing, and much more. Modifiers tend to affect an entire mesh, but in Max you can use soft select to apply the modifier to a portion of the mesh and have the effects fade out with the soft selection (Figure 8-7).

TERRAIN EDITING BASICS

Like any mesh, terrain is composed of polygons and pixels and has resolution (Figure 8-8). The big difference in this mesh is how the game engine handles it due to its size and intended use. And because it is mesh, you can manipulate the vertices and polygons in much the same way. Note that there is a difference between the resolution of the mesh and the resolution of the height map; both affect the end result of the terrain (Figure 8-9). The mesh is composed of polygons, and the more polygons the smoother the mesh. The height map is composed of pixels, and the more pixels the finer the control it has over the mesh. Thus, if one of these is low quality, it will reflect in the other.

The basic tool for terrain editing is a brush much like the brush in Photoshop. You can determine the overall size of the brush and the hardness of the brush. The softer the brush, the more gradual the slope of the terrain. In Figure 8-10, you can see the effect of various brush settings. This is important to understand because so much of terrain manipulation and painting is based on this concept.

FREEFORM TERRAIN PAINTING

With the brush you can physically manipulate the terrain to achieve various effects. Most simply, you can raise or lower your terrain as in the above

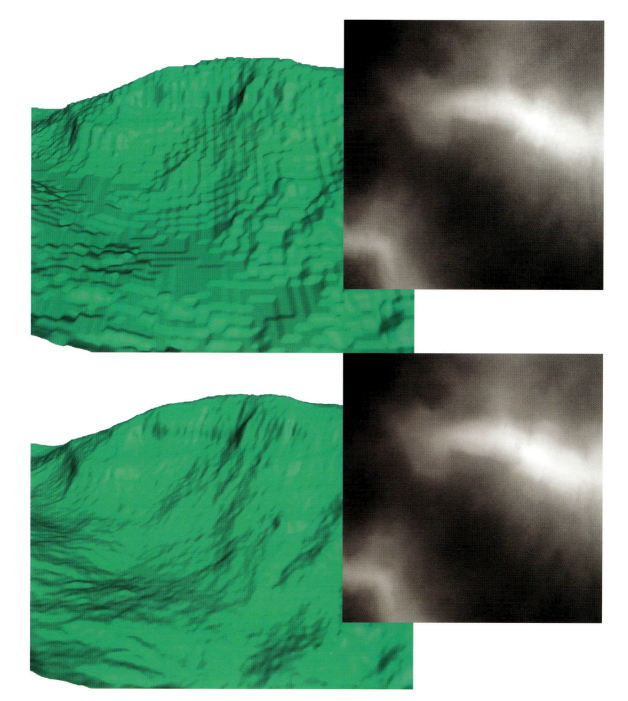

Figure 8-3 Mesh artifact.

Figure 8-4 Importing a height map.

Figure 8-5 Hand manipulation.

Figure 8-6 Modifiers applied to mesh.

Figure 8-7 Modifiers fading out using soft selection.

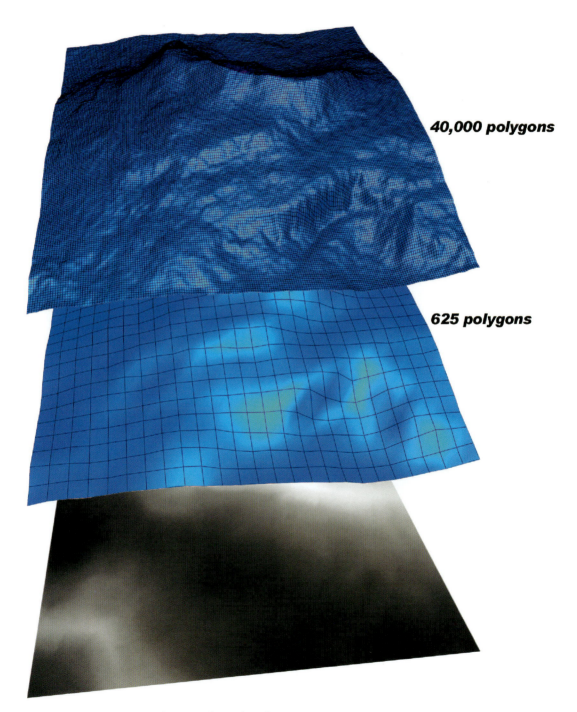

40,000 polygons

625 polygons

Figure 8-8 Same height map with terrain of varied resolution.

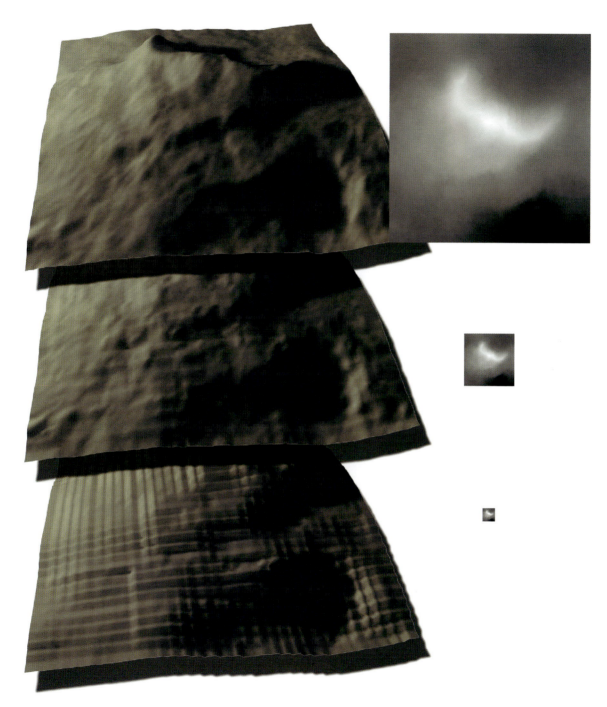

Figure 8-9 Same terrain mesh with height maps of varied resolution.

Figure 8-10 Brush and various settings.

Figure 8-11 The same brush with different strength settings.

example of the brush. But there is a lot more you can do. Keep in mind that we are not talking about textures or any other aspect other than the physical shape of the terrain mesh.

Push/Pull Lower/Raise

You can set the size and softness of the brush, as well as strength. This allows for the subtle manipulation of the surface, or a radical change in the surface (Figure 8-11).

Smoothing/Erosion

Another useful effect is smoothing or erosion. This differs from a simple lowering of the brush because it smoothes the angles between polygons, not just lowers them from the center of the brush (Figure 8-12). A good terrain editor will mimic actual erosion, which will look better than a simple smoothing of polygons. The distinction is that the smooth effect occurs mathematically, opening up the angles on the polygons affected, whereas actual erosion pulls material down and piles it up below the brush (Figure 8-13).

Noise/Turbulence

Another simple but useful tool is the ability to add random noise or turbulence to your terrain (Figure 8-14). After shaping and smoothing, your

Figure 8-12 Most terrain editors allow for a smoothing or eroding function to help you shape your terrain.

terrain may look too smooth and need some random movement along the surface. Of course, there are settings that will determine the area and strength of the effect, and often there is even a choice of which mathematical algorithm is used in calculating the turbulence.

Flatten/Set to Height

Sometimes you may want to establish a part of your terrain as a flat, inorganic space where a building may be located, for example. Terrain editors allow for the flattening of polygons, and you can usually choose to flatten the terrain to a certain height that you enter numerically, or to the height of the first polygon you select before you start flattening the terrain (Figure 8-15). For the jungle river in the illustration, I flattened the terrain along the river path so that the water table would be clearly visible to me and then eroded the banks of the riverbed.

cliff face

erosion

smoothing

Figure 8-13 Smoothing versus erosion.

Figure 8-14 Adding random movement along surface.

Figure 8-15 Flattening terrain.

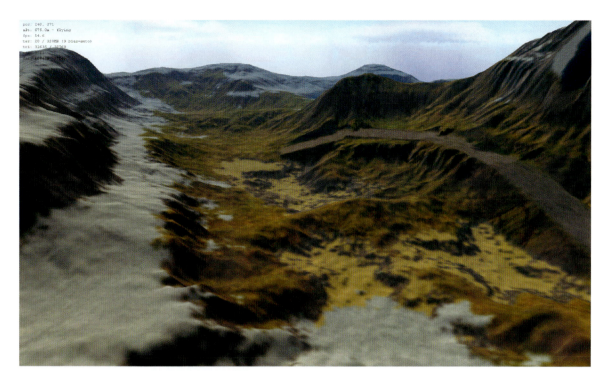

Figure 8-16 Road created in L3DT.

Other Features

Good terrain editors also allow for the creation of terrain features such as cliffs and steppes. Most are starting to support tools that aid in the creation of roads (Figure 8-16).

TERRAIN TEXTURING

At its most basic, terrain texturing is done using several tiling textures of the surfaces most common to the environment you are creating. The textures are stacked like layers in Photoshop, and either alpha channeled or combined to make a single large texture. Many large terrains in a game are using several maps just for the base level of texture: one large low-resolution color map; a smaller set of higher-detailed color maps that are chopped into tiles and loaded and displayed only when the player is on the section of the terrain that needs it; and a smaller, highly detailed map that is often a bump or normal map for the area immediately around the player where such fine detail would be appreciated (Figure 8-17).

Figure 8-17 Terrain texture MIP-map tiles.

The terrain texture can be painted by hand in the terrain editor or generated by the terrain editor. Hand painting terrain is much like working with Photoshop layers.

TREES AND FOLIAGE: DECORATION/PROP LAYERS

This section is focused on the placement of the trees, foliage, and decorations on the terrain. Creation of the assets used is discussed in the following section.

Trees and smaller vegetation, such as grass and plants, are usually handled separately for various reasons. Because trees are larger, they usually require separate collision detection, lighting solutions, display parameters, and so on. Foliage, being smaller and more nondescript, can have no lighting, no

collision detection, and can be faded out and not displayed at a relatively short distance. While some trees and larger props are hand placed, grass and smaller vegetation and props are usually generated and placed on the fly. One rock may be randomly scaled, rotated, and placed within certain set parameters to create a scattering of rocks that appears as if it is composed of hundreds of individual rocks that all look different, but seem to be part of the same scene (Figure 8-18). The technique for the placement of foliage can be taken from the ground texture itself or painted on by an artist. If the ground texture is used, the program looks at what textures are covering the surface and at what percentage and puts down an appropriate type, size, and amount of foliage (Figure 8-19). Hand painting the foliage is based on the size and softness of a brush (Figure 8-20). It is also typically possible to use multiple layers of decoration or to assign multiple decorations to a layer. There are differences in how this will behave. The first will allow for the specific placement of the decoration on that layer, and the latter will put down all the objects in that layer.

Some of the common parameters for foliage and prop layers are not only brush settings, but the assignment of meshes to the layer, the density of the decorations put down, the random rotation and scaling of the mesh, and a radius at which the decoration will shrink and/or fade out.

TERRAIN GENERATION SOFTWARE

There are many programs that can generate terrain for you, and they range in price from very costly to free and differ according to intended use. Some like Bryce and VUE are designed for high-detail renders and not real-time gaming, and use some very complex code behind that simulates various real-life behaviors. Still others are barely more than mesh manipulators that allow for layered painting on terrain. The reason that game developers are ill served by both of these tools is that the high-end tools do not produce assets easily used in games, and the latter generate vast terrains programmatically and generally lack the degree of close-up control the game developer needs. The simplified terrain editors require that every inch of the terrain be hand-crafted, or that information from other sources be imported to aid the developer and save them from creating the entire terrain by hand. So, on the one hand, there is not enough fine detail control, and on the other, we have all the control and lack tools that can speed up and enhance our work.

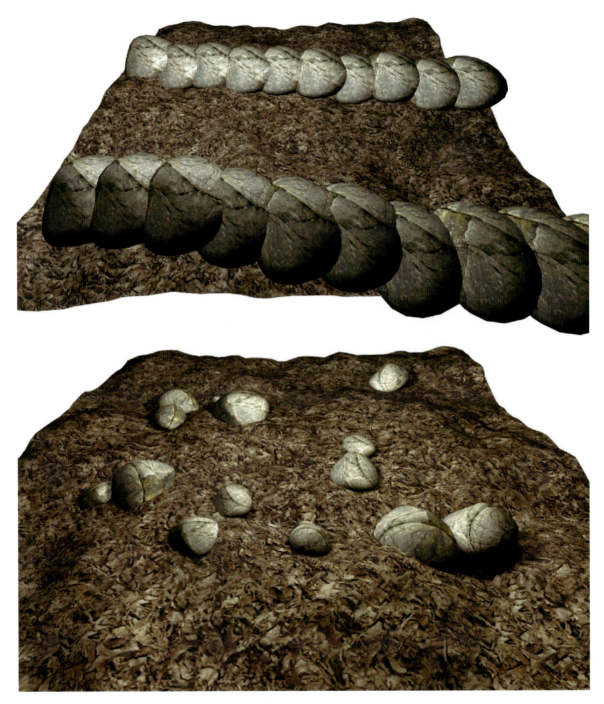

Figure 8-18 Rocks scattered uniformly and reasonably.

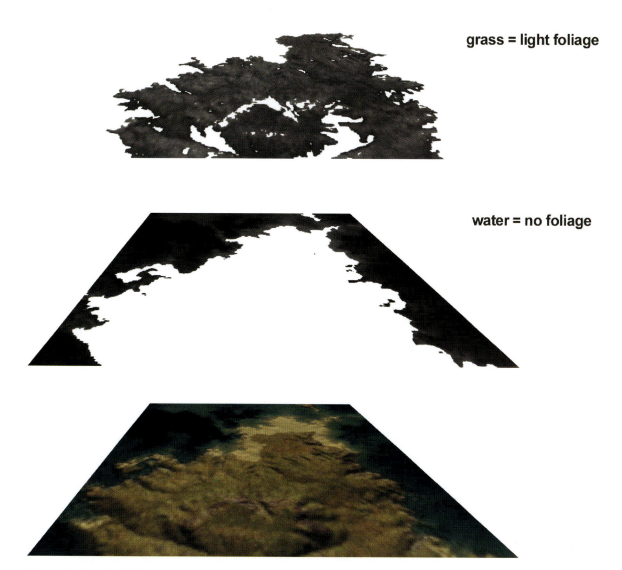

grass = light foliage

water = no foliage

Figure 8-19 Foliage placement by program. Many programs can look at the type of texture and density and place the appropriate amount of foliage.

foliage map

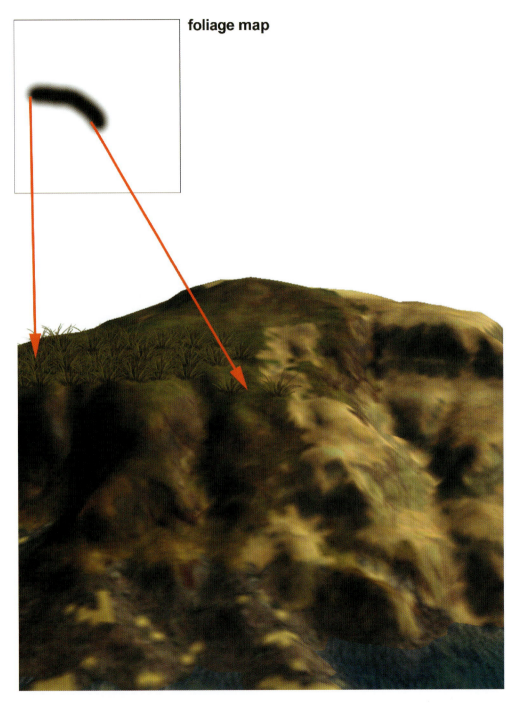

Figure 8-20 Foliage painted on.

L3DT

I have found that the L3DT serves the game developer best. This application can generate a terrain and all associated maps (height, normal, light map) and output the mesh and textures in various formats. And it allows for the up-close editing and control needed by the developer. Even the auto-generation can be controlled to a great degree by the developer, as you will see. The most impressive aspect of this terrain generator is the wizard that walks you through all the steps of terrain generation.

L3DT is a Windows application for generating artificial terrain maps and textures developed by Aaron Torpy, the proprietor of Bundysoft. There is a free standard version and a very reasonably priced professional version. The standard version can do a lot, and it is free to use commercially. L3DT was developed primarily for game developers making large worlds typical of massively multiplayer online (MMO) games, but the artist can use this as well to generate terrain for other uses.

The best thing about L3DT is that it supports several modes of operation. You can set a few general parameters and let the program do all the work, and you can also manually edit your map and use a design map. The design map is the middle ground between vast uncontrolled terrain generation and tediously pushing every vertex where you want it and painting every pixel. The design map that lets you paint the attributes of your terrain in broad strokes. You can determine the shape of the terrain, as well as specify where things like mountains, plateaus, and volcanoes go. You can add or subtract height, place cliffs, increase or decrease erosion, and more. When L3DT generates the terrain it looks at your design map and generates the fine details from there. There is even a terrain wizard that walks you through the steps of creating your terrain from the design map to the finished texture and everything in between. Quick steps to create a small simple map by just clicking a few buttons are shown in Figure 8-21.

Figure 8-22 shows a map created using the same parameters as in Figure 8-21, but the design map has been changed to include one place where the terrain is higher and more jagged. A larger, more radically altered map is shown in Figure 8-23. Using the design map, I painted in a lower valley with the temperate climate in the middle of this arctic wasteland.

L3DT also supports the common editing tools discussed previously. You can shape and sculpt your terrain, and use tools like the road builder and

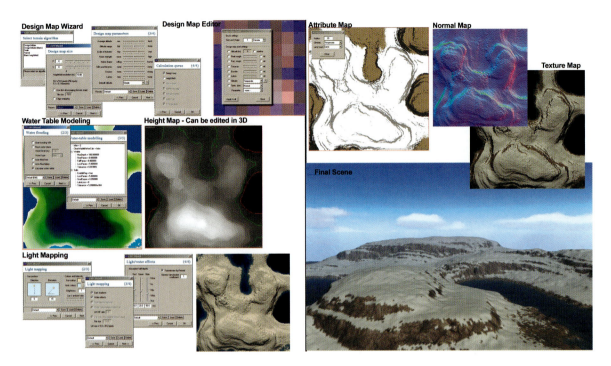

Figure 8-21 Basic L3DT steps.

erode brush. Figure 8-24 illustrates the tools in action. And when you are finished you can recalculate the associated maps, including the light, normal, and texture map. Here you can see (Figure 8-25) how altering the terrain in various fashions produces a different texture. A flat surface is grassy, a smooth hill is slightly eroded, and at a more steep angle and you get exposed rock. Note that I lowered the terrain below the water table; the area is filled with water and the textures reflect it. The shores are sandy and the terrain under the water is darkened and tinted based on the depth of the water.

The ability to control the climate is extensive. You can auto-generate the climate, alter it on the design map, and even create your own climates and save them as presets (like you can most other aspects of the terrain). The climate modeler distributes textures in a realistic fashion and this includes

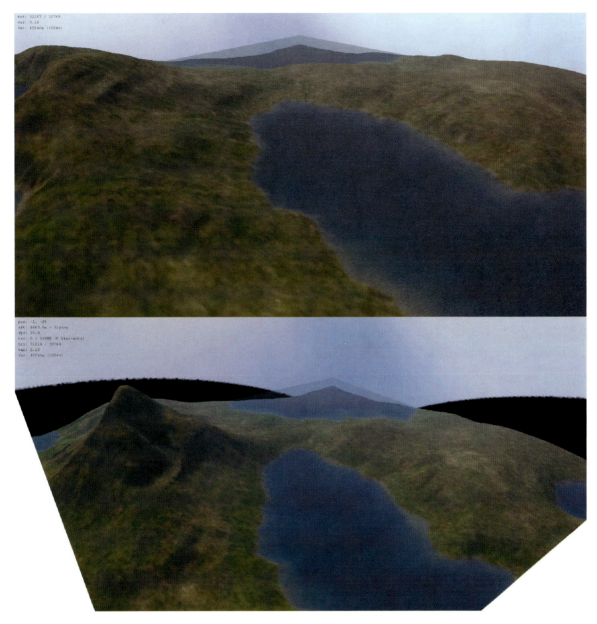

Figure 8-22 One design map parameter changed.

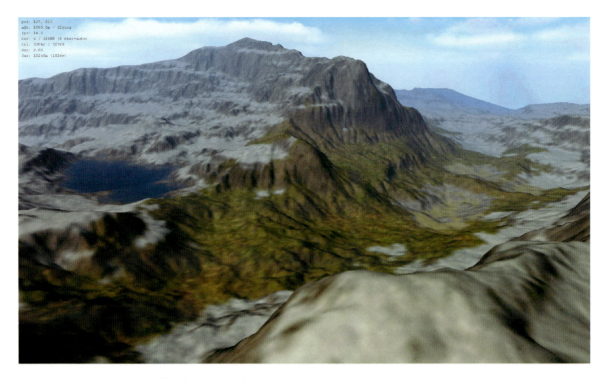

Figure 8-23 More radically altered map using the design map.

fresh and salt water effects. In Figure 8-26, you can see that the same terrain has had its climate changed and re-rendered. The water can be automatically and manually designed using the water-flooding aspects of the program or tweaking it all by hand. And this is not a simple water plane that fills the entire world at one level. It is possible to have an island on the sea with a mountain lake on a higher elevation (Figure 8-27).

L3DT was designed to generate vary large maps. The free standard version has a cap on this but the professional version allows for maps up to 131,072 × 131,072 pixels in size for the height map and 2M × 2M for the texture. You don't need gigs of RAM for these maps—L3DT includes a automatic paging system that swaps map "tiles" from RAM to the hard disk drive as required. It's called a mosaic map, and it usually caps RAM usage in the 100- to 200-Mb range (even for gigabyte- or terabyte-sized maps).

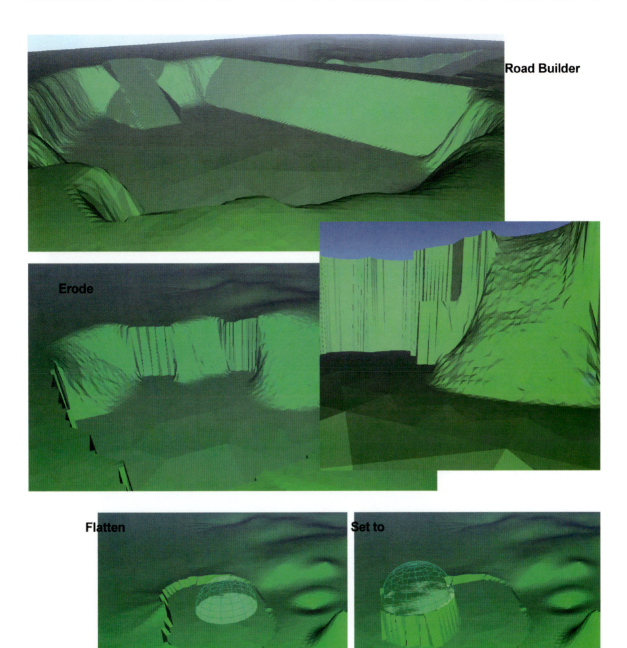

Figure 8-24 Road builder, erode, and other common functions in L3DT. Note that the erosion looks like real-world erosion—the material has slid down to fill the area below. This is not just a smoothing algorithm.

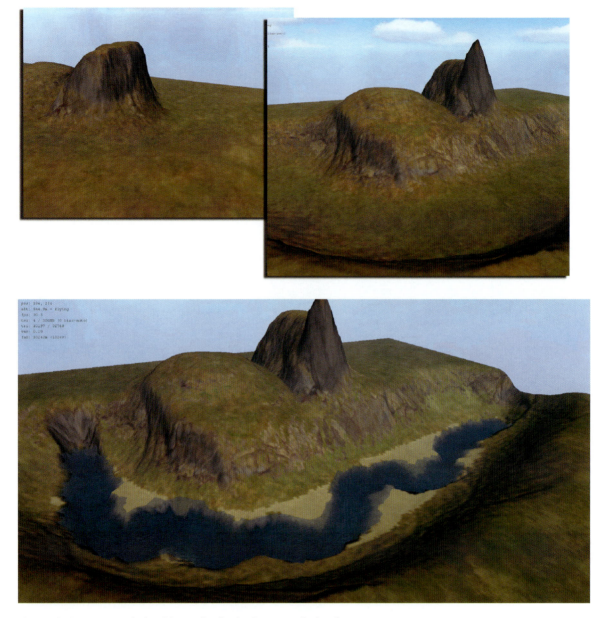

Figure 8-25 Texture calculated by angle, depth, climate, and other factors.

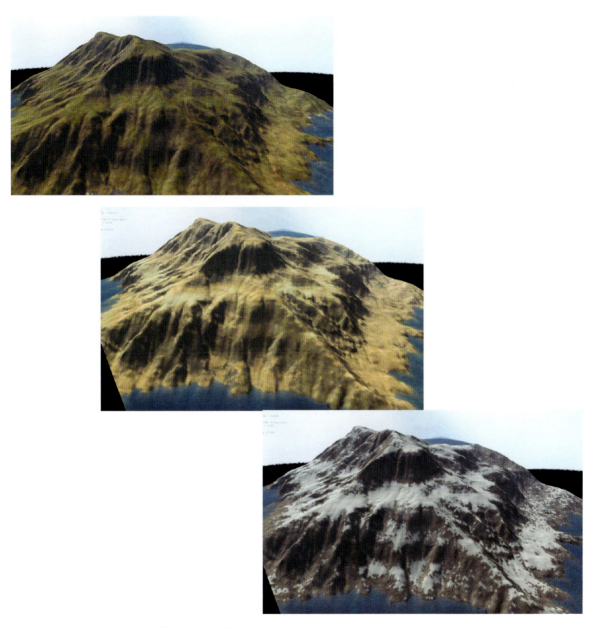

Figure 8-26 Same terrain in different parts of the world: temperate, desert, and arctic.

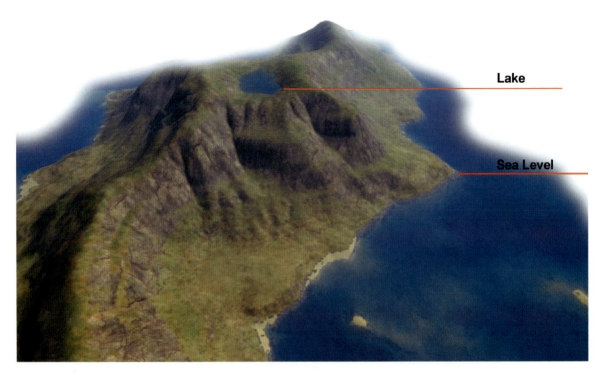

Figure 8-27 Water at multiple elevations.

These are the basics of terrain creation. For this section of the book, I used L3DT to generate a simple terrain that I will load into my 3D application. I will displace a mesh with the height map and apply the terrain map texture. Then we can start to add trees and plants to make it look like a jungle.

CHAPTER 9

Filling the World: Trees, Plants, Rocks, Water, and Sky

INTRODUCTION

While creating trees, plants, and rocks is not a huge challenge, they are organic (i.e., characterized by unique and somewhat random details/features) and can take a bit of time to create. In addition, you have to do a lot of work with the alpha channel to make the foliage look realistic. Inevitably, you end up going through a complex number of steps to separate a tree branch from its background. I think it is much faster, and you get a better result, creating these assets by hand. Even if you can't paint, there are numerous tools that allow for the painting, and assembly, of these assets. We will examine the following applications in this chapter.

- TreeMagik G3

- Plant Life

- SpeedTree

- Caustics Generator

- Deep Paint 2.0

Now that we have our terrain in place, we need to add trees, plants, and rocks. Then we need to fill it in with water and cover it with a sky. Because the environment is a jungle, we have to develop some really lush and green vegetation. When it comes time to develop the plants and trees for an environment, many like to be 100% botanically correct and others do what looks good to them. This is a game, so I tend to do what looks good, but there is nonetheless a minimum level of accuracy you want to have. For instance, jungle plants tend to be green and broad-leafed not brown and spiky. No matter how you try and color correct it, a cactus is going to look

out of place in a jungle. You don't have to have a degree in botany; just gather some good reference pictures of jungles from the Internet.

Don't be intimated by the great outdoors. I have always had fun creating assets for the outdoor setting because it can actually be simpler in some ways and net more impressive results than nonorganic subjects. Many games available now have truly impressive outdoor environments due to technological advancements. We are no longer confined to hallways. As computers become more powerful, creative possibilities will expand still further and we will continue to see more of the outdoors. Already we are seeing impressive outdoor spaces being built for games, with expansive terrain and high poly-count models. This trend will continue and will get even better.

Large, impressive, and elaborate environments can be challenging to create in many ways, but they are also easier to create compared to just a few years ago. Partly this is due to the fact that most outdoor environments consist of similar elements (grass, dirt, leaves, bark, and stone), and a good set of assets can go a long way if they are used correctly with the newer technology. A relatively small set of textures can be mapped to an equally small set of meshes, and then the models placed, rotated, scaled, and arranged to produce an enormous amount of variety. This alone gives us the ability to create a more convincing forest or jungle. But the major reason that creating outdoor environments is now easier is that the tools are more powerful, more refined, and more user-friendly.

Most game engines now handle terrain texturing by combining multiple layers of textures in a manner similar to how Photoshop handles layers. This allows the terrain textures to be composed predominantly of a single material, and therefore easier to tile. Add to this the fact that we are also able to use much larger textures and you can get some really great-looking outdoor environments. The days of tiling one texture repeatedly over a large terrain are gone, as is the need to create numerous versions of the same texture to place a specific object such as a road or dirt patch. We are no longer limited to roads running in straight lines and at right angles. Now we can create a few large textures of a specific terrain material (packed dirt, grassy dirt, dried dirt, grass, dead grass) and paint them onto the terrain. You can lay down a base layer of grass on your terrain and paint on darker grass patches, and add an organic winding dirt road—you can create any kind of terrain you can imagine. Painting and erasing layers on

terrain are easy and the results superior than any previous technique. As seen in Chapter 8, simply using large textures (mega-textures) is also an option. Simply creating one large texture that covers the world is a technique being used in some games.

ASSET LIST

We will create assets (meshes and textures in most cases) for the following:

- Terrain

- Trees

- Plants

- Rocks

- Waterfall

- Sky

TERRAIN TEXTURES

In a dense jungle, the ground tends to be covered with a dark, moist, matted blanket of rotting vegetation. For the jungle floor, you can create a texture with several images of moist ground and leaves. Even some dead grass on top and blended properly can work because of the contrast. When overlaid, it looks as if the grass occasionally grew, and then died and became matted down with the rest of the jungle floor. Even if you use L3DT to create the terrain texture, you can create your own climates and use your own textures (Figure 9-1). The textures I used are seen in Figure 9-2. You can see the complete texture at the top left and an enlarged portion of the texture at the bottom.

TREES

For the trees I start with the bark. I usually create a base texture in Photoshop and then create the mesh. Creating a texture designed to be cylindrically wrapped around the tree is a common technique, but with hardware advances (larger textures, faster GPUs, and multipass rendering), I decided to create a tree skin, a texture that doesn't tile but wraps like a skin around

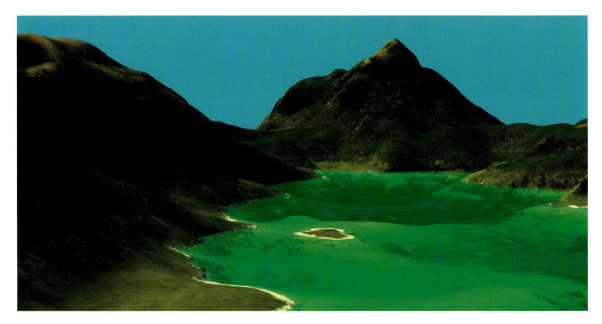

Figure 9-1 A jungle climate created in L3DT by simply using various textures.

the mesh. I used the pelt puller in Max to stretch the entire tree skin out so that I could paint the entire tree, without seams where branches meet trunk (Figure 9-3). Using this method, I can add vines that wrap around the tree and vary the bark appropriate to specific parts of the tree. This method is great when you have a few big complex trees as opposed to a huge forest of individual trees.

Tree bark is actually a bit hard to digitally photograph. It is usually in less than ideal lighting conditions, and it is wrapped around a cylindrical shape. This means that even though you can see about half of the trunk facing you, only a small portion of the bark is actually positioned facing you straight on. For a venerable old jungle tree, I used the Fiber Filter in Photoshop and stretched the image vertically, and then used the tree bark as an overlay. I also used Liquefy to add some organic details to the rendered fibers. I added a layer of vines using layer styles in Photoshop and this layer can be used to create normal maps for the bark later on. See Figure 9-4 for the progression of the tree bark. For the tree mesh you can use TreeMagik G3 to create the mesh, or do it by hand.

Deep Paint 2.0 is freeware, and can be downloaded from various file sites. It is very useful, just for the texture brushes alone, and is a great

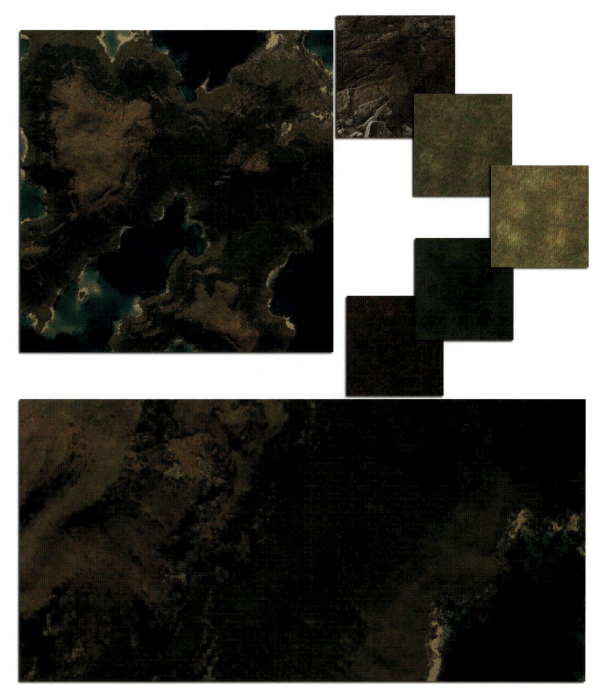

Figure 9-2 Assets for the jungle climate.

Figure 9-3 Creating a tree skin as opposed to tiling bark texture.

Figure 9-4 Progression of the tree bark.

complement to Photoshop. You can assign a color image to brush, and not only to the diffuse channel—you can also assign separate images to the bump, specular, and alpha channels. This is extremely useful for painting branches and other foliage. In addition, there is a plug-in that allows for a back-and-forth workflow between Deep Paint 2.0 and Photoshop (it works with PS CS3). This is in addition to Deep Paint's primary function, which is to mimic a realistic painting experience for artists and produce realistic visual results. Deep Paint has fully editable brush and canvas settings and paint functionality for realistic paint effects. Thickly textured oils, bold acrylics, and dramatic watercolors are part of what can be produced (Figure 9-5).

TreeMagik G3

There are a few high-end professional solutions for trees and foliage in games, and they are well worth the money if you can afford it, but if you can't, TreeMagik G3 is a great tool. It is much easier to use and is more affordable. Even if you are not a hobbyist or a very small studio, you may simply not need a large fully forested environment but only a tree or two. TreeMagik creates low-poly and high-poly 3D trees. You can design and shape tree trunks and even manipulate individual vertices. You can import branches and limbs and cover them in leaves. There is even a Leaf Painter system with a large number leaf materials to choose from. Best of all, you can create your own textures directly inside TreeMagik and apply them immediately and export them. I mentioned Deep Paint 2.0 in the previous section and that I prefer to use this tool to paint my branches. Exporting is what makes TreeMagik useful. You can export LOD models (level of detail) and billboards (see Chapter 1 for more info on LOD). Billboards comprise one or two polygons of the tree so that when viewed from far away you can display this small efficient billboard rather than the entire tree. You can preview all of your work within the application. And part of optimization is masking versus alpha channeling, and TreeMagik supports masking, alpha, and mip-mapping, as well as UV scaling. Figures 9-6, 9-7, 9-8, and 9-9 show the interface and steps in tree creation.

A Look at SpeedTree

Released in 2002, SpeedTree is a set of tools for the creation and rendering of real-time forests. The number of games using it has increased, and the

Figure 9-5 The various brushes of Deep Paint 2.0, now a free download.

Figure 9-6 Import a trunk, shape it manually or automatically, and add branches.

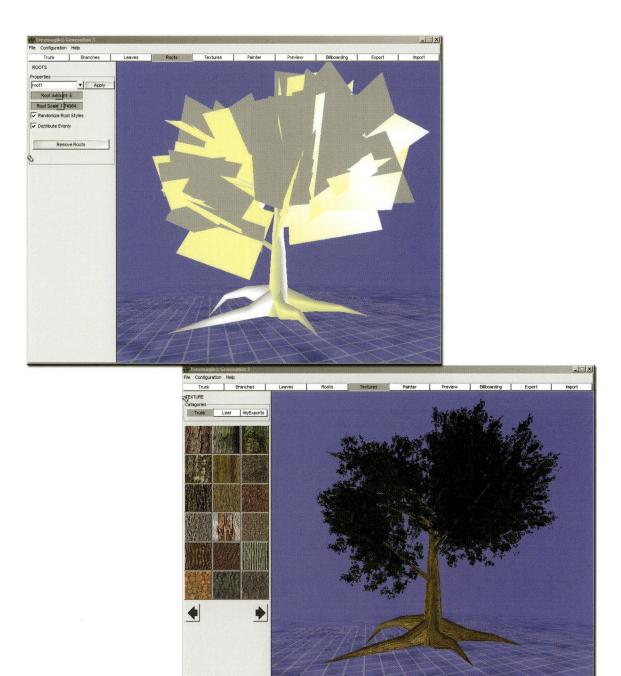

Figure 9-7 Add or import trunk and leaf textures.

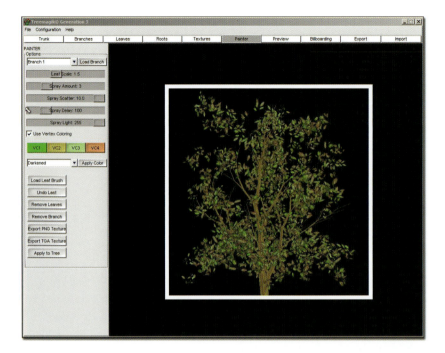

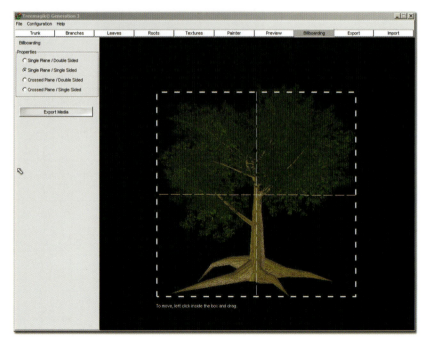

Figure 9-8 Paint your own leaf textures and export them—create billboards of your trees.

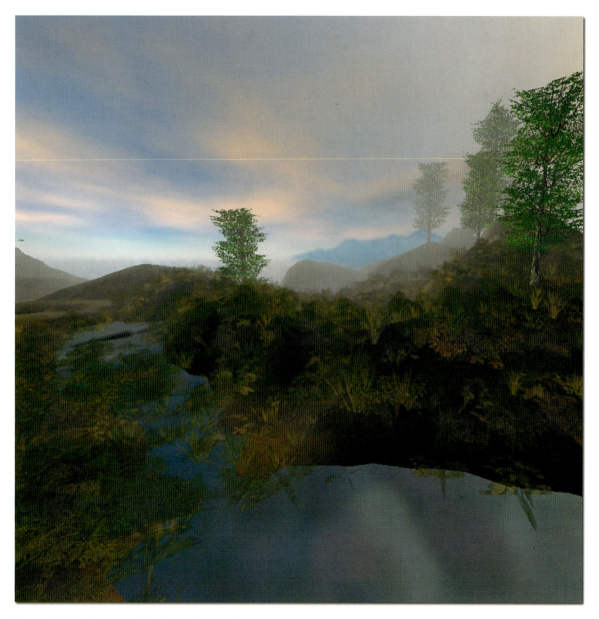

Figure 9-9 Preview everything in preview mode.

SpeedTree site maintains an updated gallery of screenshots from those games. Shots from the SpeedTree website and their demos are seen in Figures 9-10 and 9-11), Elder Scrolls IV (Figure 9-12), and Conan (Figure 9-13).

SpeedTree actually comprises several tools that work together; SpeedTree-CAD is a stand-alone Windows application that is used to create and edit trees. There is also a tree model library that contains hundreds of pre-made trees that can be used as is or as a starting point for creating custom trees. SpeedTreeRT is the reel-time software that game developers integrate into their engines to use the SpeedTree files. SpeedTreeRT can do wind effects, (LOD, and bill boarding. You can also get SpeedTreeMAX and Speed-TreeMaya, which are plug-ins for both 3D applications that can be used to import trees created in SpeedTree. SpeedTree also generates bushes, flowers, and grass, among other plants.

PLANTS

Plants are simpler models than trees, but can more complex in their creation and texturing. Unlike trees, where you can generally get away with one or a few types of tree, a wide variety of plants is necessary to look convincing. Flowers, weeds, grass, mushrooms, and so on can be covering the ground at the same time in any given setting. Of course, a jungle has a lot of plants, so we really need the variety here.

Plant Life

This is where Plant Life comes in handy. Plant Life can generate a very large variety of plant meshes quickly. This application also has a large library of textures to apply to the plants, but I find that their resolution is too low and they usually don't work in terms of color and contrast. But they are numerous and make the job of plant creation a lot easier. I like to create my own larger textures for these meshes after exporting them. There are many ways to do this, including using photo sources or other applications to paint the foliage, or simply working with Plant Life textures.

Plant Life is perfect for low-polygon environments. With this application, you can create foliage from very-low-poly to high-poly scale. There is a large library of textures to make the plants you create truly unique. Considering the types of plants and the parameters associated with each,

Figure 9-10 Screenshots from the SpeedTree site and demos.

Figure 9-11 Screenshot of a highly detailed tree from SpeedTree.

Figure 9-12 Screenshots from Elder Scrolls IV: Oblivion.

Figure 9-13 Screenshots from Conan.

you can create an almost unlimited variety of foliage (Figure 9-14). There are ten modules that come with Plant Life: flowers, twigs, ferns, mushrooms, bushes, tropical, lily pads, weeds, grasses, and rocks. And these modules are adequate for most requirements (Figure 9-15). For a little extra variety, you can get other modules that create sage, sunflowers, clovers, and so on. One thing I find useful is that you can export the meshes and textures from the program. When you export the texture choices you made for your plant (flower, leaves, stems, etc.), all are combined into a single texture. The export options are pretty comprehensive: DirectX, OBJ, Half-Life, Milkshape, VRML 1.0/2.0, and many more.

Rocks

There are many types of rocks, formed by erosion, cracking, and other processes. In the jungle, you would expect see rocks (if you saw any at all) deeply buried in the dirt and covered with moss and foliage. These rocks would tend to be rounded with no hard edges. To model this rock, I used a geo-sphere, as these tend to deform into rocks better than other primitives. Starting with a very-low-polygon count sphere, you can deform it as seen in Figure 9-16, and then apply a basic rock texture to it. The deformations I used were to first square it up a bit using the free-form deformation in Max and then pulling in the middle handles. Next, I applied a little noise and further deformed it to get a more organic look. Finally, you can add a mesh-smoothing modifier to the mesh if you want the rock smoother and you can afford the polygons. I also used the shrink-wrap UV setting as opposed to the spherical, as it produces fewer stretches and seams.

The rock texture was simply a colorized image of rock (Figure 9-17). I lowered the contrast and saturation, and I made it into tile. In fact, I made it seamless. Technically, it doesn't tile because I left the bottom of the texture darker to simulate shadow and moisture, as if the boulders were sitting in the ground for a long time. If this texture were tiled across a large surface, you would see the repeating pattern. This texture was made specifically to be wrapped around the boulders. I also added some moss by simply copying the layer and colorizing it greenish and then erasing portions of the layer.

Skyboxes

A good sky can add a lot to the feeling of depth and atmosphere in a virtual world. Typically, in a game, the sky is handled in the following ways:

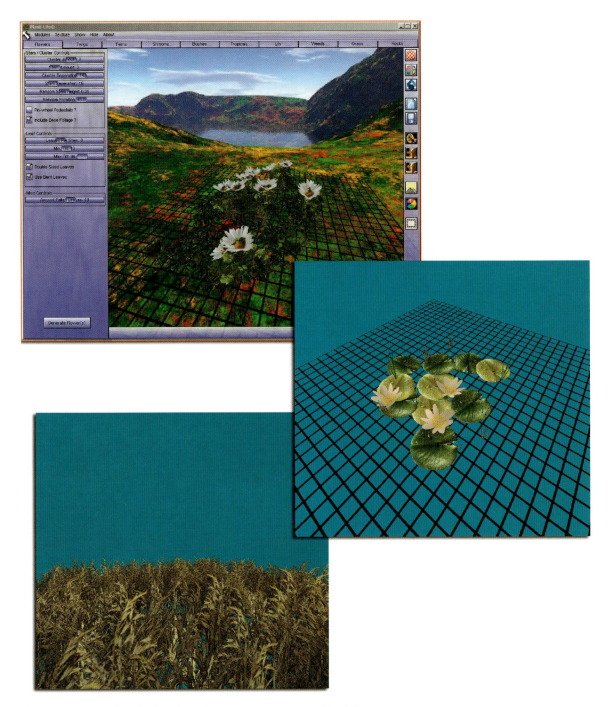

Figure 9-14 Samples of a few plants that you can create using Plant Life.

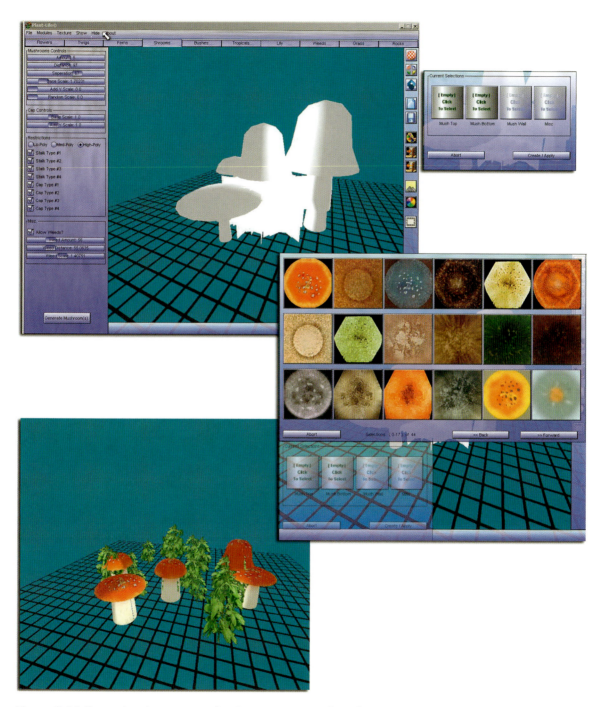

Figure 9-15 The quick and easy process for plant creation using Plant Life.

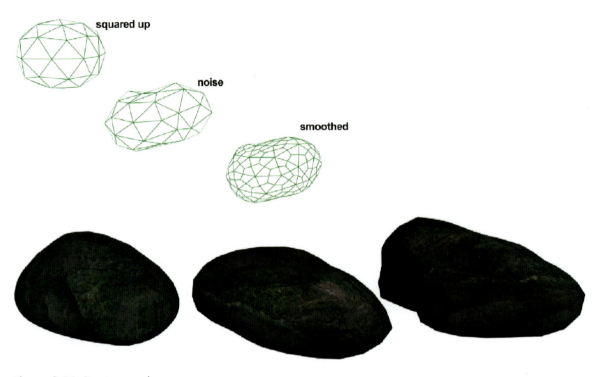

Figure 9-16 Creating a rock.

- Single image
- Sky dome
- Sky box

The single-image technique is used in only a few, generally older, games that have a limited view of the world. Most older 3D games and many driving games kept players on a certain path. You were in some form of a 3D world, but your view was restricted to a 2D plane; you could only look left and right but not up and down (you could often walk up and down stairs, just not tilt the camera to look up at the sky). These games used an equally limited technique for the sky—a single image that only moved left to right and up and down as the player moved about the world.

The sky-dome technique is simply a fixed model that is part of the game map and is large enough to encase the entire world. This approach is referred to as a sky dome because typically when using this approach, a dome shape looks best, but you can also use a simple cube (assuming an

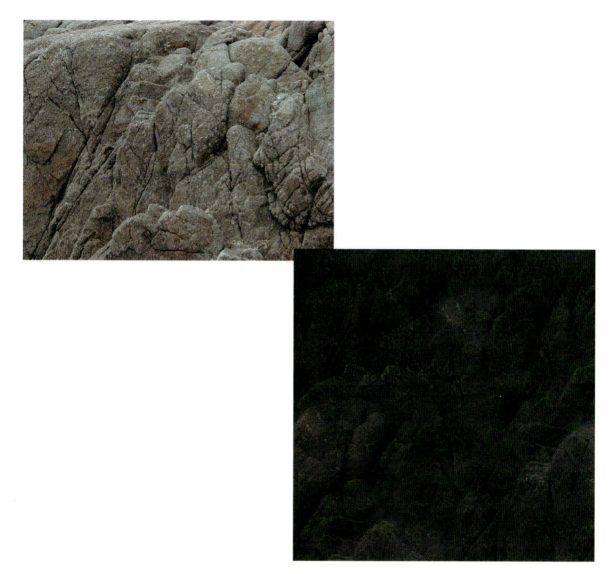

Figure 9-17 The rock texture.

acceptable look) and save a lot of polygons. Mapping a texture to a dome is easier, whereas a cube requires more tweaking to get things to look right. See Figure 9-18 for an illustration of the sky dome and Figure 9-19 for an example of a sky box with a seam showing.

Personally, I don't like the fixed dome for several reasons. First, it's harder to work inside the map with the sky dome in the way (if your editor doesn't

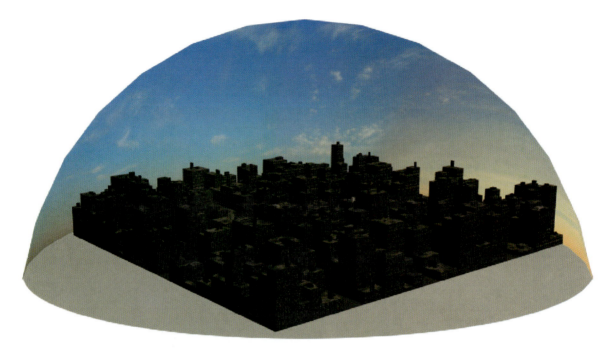

Figure 9-18 The sky dome is simply a fixed model that is part of the game map and large enough to encase the entire world. This approach is called "sky dome" because typically a dome shape looks best with this approach, but you can also use a simple cube (if it works) and save a lot of polygons.

take this into account). Second, if I hide the sky dome, the level doesn't look like it will in the game and it's harder to accurately judge the work that I am producing. In the game, the dome is also a physical limit, and the player has to be kept away from it. This isn't at all conducive to the larger worlds we can create, or are required to create, today, especially worlds on the scale of a present-day/near-future MMO game.

The sky-box technique is actually a separate area in a map (like a little room) with only the sky elements in it. There is a camera centered in the area that doesn't move, but swivels in the same direction as the player's camera. What this camera sees in the sky box is composited with what the player sees and the result is impressive. I like this method because it is easier to work with, you get better results, and the player can walk forever and never reach it. Moreover, the player can never view it from an angle where it doesn't look its best. Since the sky moves with the player, you can control precisely how it looks to her or him. It is easier to get a sky

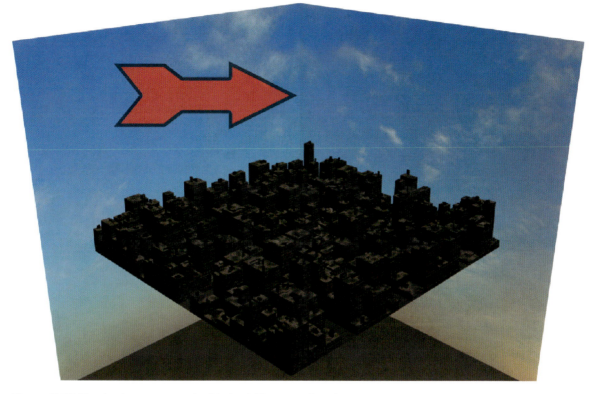

Figure 9-19 The sky dome using a cube (sky box). The seam often shows.

box looking perfect from one angle than every conceivable angle. See Figure 9-20 for an illustration of how the skybox works.

CLOUDS

It has always bothered me that I couldn't render clouds or a lens flare on a transparent layer. In Photoshop when you create clouds or a lens flare, you must have a background color. In other words, clouds must be rendered with two colors and can't fade into transparency like a gradient can (Figure 9-21).

For most Photoshop users, the Blending Mode function is the answer for a realistic cloud or lens flare overlay. You can render clouds on a layer above your image and play with Blending Mode until the clouds look the way you want them to (Figure 9-22).

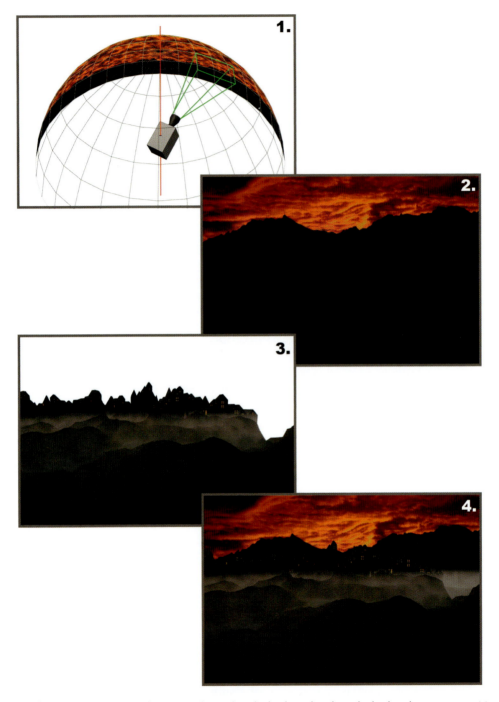

Figure 9-20 The camera is in its own location and swivels to look where the player looks, but does not move. Number 2: The view of what the skybox camera sees. Number 3: The player's view with no sky. Number 4: The sky and player's view composited together.

Figure 9-21 Gradient fade.

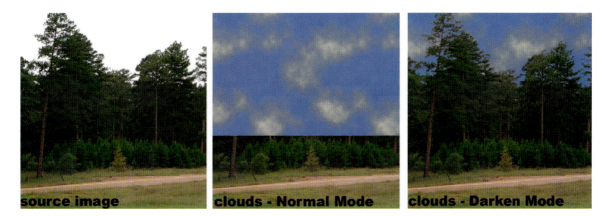

source image clouds - Normal Mode clouds - Darken Mode

Figure 9-22 Blending clouds into a still image.

In game development and interactivity, the images created often need to be used in applications that don't have the sophistication and power of Photoshop. We don't have access to blending modes, and the image must come into the application with transparency already in place. As a result, I have developed a quick way of creating a lens flare or clouds on a transparent layer. I will step you through the process using clouds, but this can be applied to lens flares as well.

1 Open Photoshop and create a canvas of any size. Keep in mind that because of the way that the Clouds Filter works, the larger the canvas the finer the clouds will be. I used a 512 × 512 image size. For standard clouds, select white as the foreground color and black as the background (Figure 9-23).

You might think that a sky blue would be the better choice for a background color, but that will leave a bluish cast in the image. You can see in Figure 9-24 that on the left I used an image created using this tutorial using blue as the background color and on the right I used black. The blue tint is not desirable, as it limits the flexibility of the image and makes accurate color work harder.

Figure 9-23 Foreground and background color in black and white.

2 Create a new layer by clicking on the Create a New Layer icon and name this new layer *Clouds* (Figure 9-25). Filter > Render > Clouds on this new layer.

Note: You can hold down the Alt key while running this filter to make your clouds pop more. The default clouds are on the left and the clouds with more contrast are on the right. These images were originally 512 × 512. For this exercise I used the softer clouds on the left (Figure 9-26).

3 To create the alpha, or transparency, image for the clouds, simply duplicate the *Clouds* layer by dragging it onto the Create New Layer icon and rename it *Alpha*. Using a separate image to dictate transparency is how many applications function (Figure 9-27).

Apply Auto Levels to the image: Image > Adjustments > Auto Levels. This alters the pixels in the image so that they better function as an alpha map for games. You can also skip this step. The results are still good, just different (Figure 9-28).

You can see how an alpha map works in Figure 9-29. The source image is to the left and the alpha mask in the middle. The resulting image has a

Figure 9-24 Don't use blue as your background color for clouds.

delicate transparency that makes the clouds look real and soft. The second example uses a figure with a more distinct outline. This makes it easier to see how the alpha mask works.

4 To actually remove the pixels from the layer in Photoshop—creating a layer with transparency and not just a separate alpha image—follow these steps. Select the entire *Alpha* layer and copy it; Ctrl + A selects all and Ctrl + C copies it. Go to your Channels tab and create a new alpha channel (Figure 9-30).

Paste the copied *Alpha* layer (Ctrl + V) into the new alpha channel (Figure 9-31).

From the menu, Select > Load Selection and check the Invert box. Make sure that you have the Alpha Channel selected (Figure 9-32).

Go back to your original *Clouds* layer and press Delete. You can play with brightness a little if you like, but it shouldn't need much. Here I changed my background color to a sky blue so that you can see the clouds (Figure 9-33).

Figure 9-25 Create a new layer.

Figure 9-26 Clouds with contrast.

To thin out your clouds, press Delete a time or two more before deselecting (Figure 9-34).

Figure 9-35 shows the cloud image in a 3D application using the alpha mask that we created. Note that the clouds tile automatically using this method. Also note that I used two layers of clouds (using the same image), making one layer display the clouds larger and move slower to add more depth.

Single Clouds

If you want a single cloud rather than a tiling sky full of clouds, use the Lasso Tool with a very large feather. I used a 512 × 512 image and a 45-pixel feather. Simply draw an organic curvy shape and render clouds. You can use a large, very soft, eraser to gently sculpt the clouds a bit if you need to (Figure 9-36). Figure 9-37 shows a giant single cloud I created for this 3D scene.

Figure 9-27 Creating the cloud alpha.

Figure 9-28 Adjusting levels.

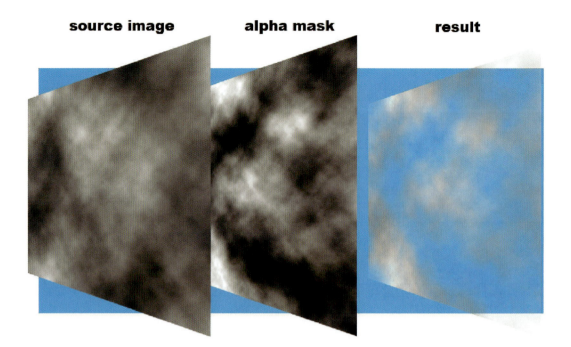

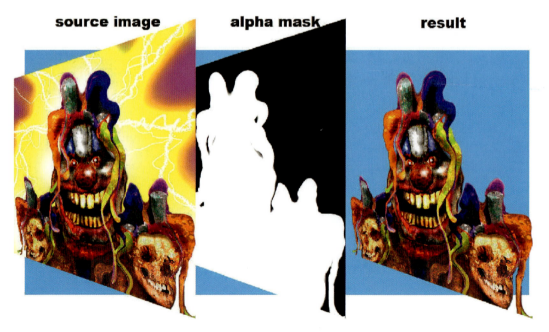

Figure 9-29 How alpha mask works.

Figure 9-30 Removing pixels.

Figure 9-31 Creating an alpha channel.

Figure 9-32 Selecting the transparency.

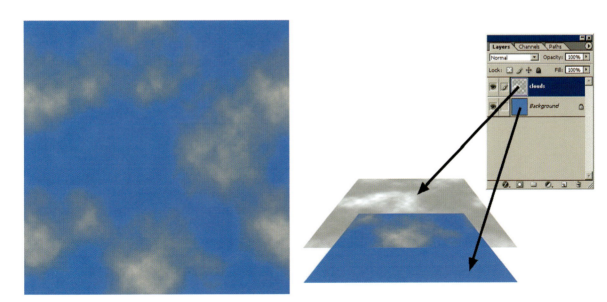

Figure 9-33 Deleting the pixels.

Figure 9-34 Thinner clouds.

WATER

In games, water can be made using a simple flat water plane or shaders that deform the geometry, followed by adding any number of effects with maps such as normal maps, specular maps, and alpha maps, among others. Particle systems even play a part in some water effects for things such as mist. Usually a good-looking water source in a game uses several of these combined. A water plane is a large, flat polygon with a water texture. Sometimes an alpha channel is on this texture. If it is supported, the texture can be multilayered and animated (Figure 9-38). The plane can consist of a large number of polygons and be animated so the waves have physical depth like the real ocean. Add to this the use of shaders to control the reflection, light effects, and normal mapping for smaller waves, and the water starts to look really good. Top it all off with a mist of spray using particle effects and you get some really convincing water (Figure 9-39).

Caustics Generator

One effect that water causes is called "caustics." An extremely simple explanation for caustics is the pattern you see when the sun shines through water into a shallow pool or clear ocean (Figure 9-40). If you find yourself without access to a high-end 3D program, you can download this free caustics generator at http://www.lysator.liu.se/~kand/caustics/.

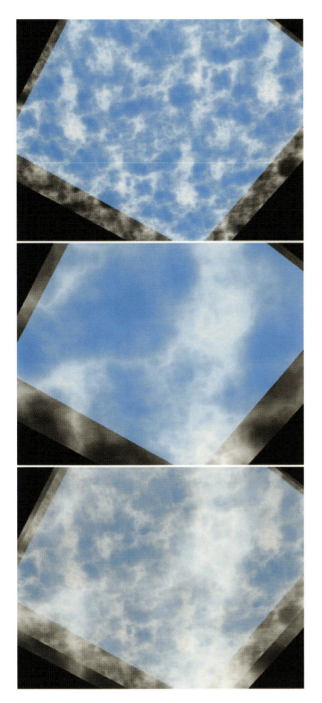

Figure 9-35 Same cloud, multiple layers.

Figure 9-36 Creating a single cloud.

The subject of caustics is quite complex and involves the process of light converging with light. Caustics are caused by light that is reflected or refracted several times before actually hitting a surface, such as through waves. The more light that is refracted to the same area on a surface, the brighter the area will be lit; hence, the bright pattern we see. To calculate the effect of light refracting through water requires complex math, but thankfully, because of the Caustics Generator (Figure 9-41), all we have to do is push buttons and look at pictures. The Caustics Generator produces rendered frames that are tileable. You can also generate multiframed animations. There is no alpha channel support, but that is a simple thing to create. The Caustics Generator is available in two versions—freeware for everyone and a commercial version aimed at professional users.

Waterfall

A waterfall can be made using some unlit scrolling textures. The assets for the waterfall were created by Rick Ruiz. The texture assets are shown in Figure 9-42, and the mesh assets in Figure 9-43. You can see that these are

Figure 9-37 Single cloud in scene.

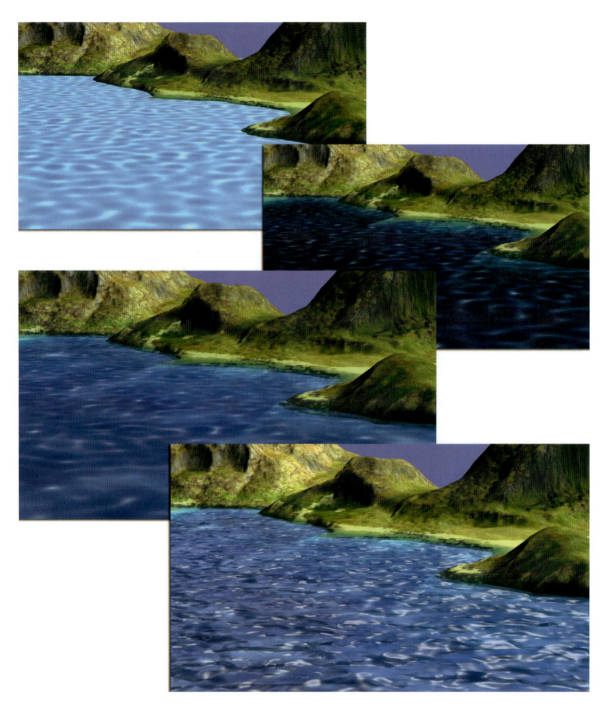

Figure 9-38 Water can be a simple plane or use many complex shaders: top, flat plane; second, opaque; third, two layers animated; and bottom, bump mapping and specular highlights added.

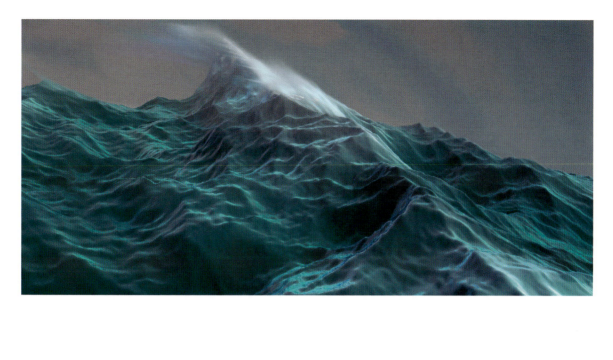

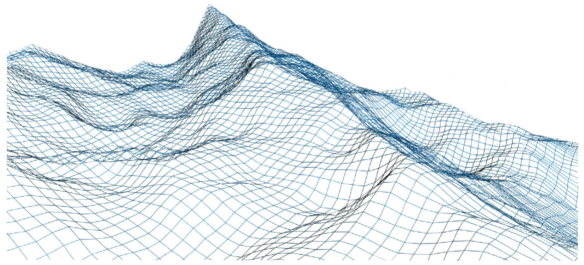

Figure 9-39 Water in games is already achieving results close to this due to pixel and vertex shaders.

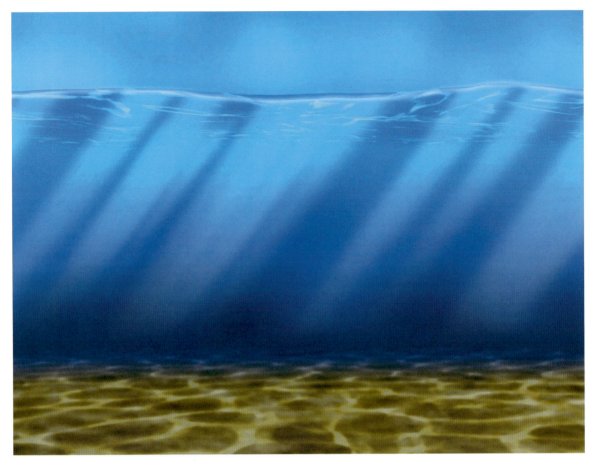

Figure 9-40 Caustics comprise the pattern you see when the sun shines through water into a shallow pool or clear ocean.

Figure 9-41 Interface of the Caustics Generator.

Figure 9-42 Waterfall assets.

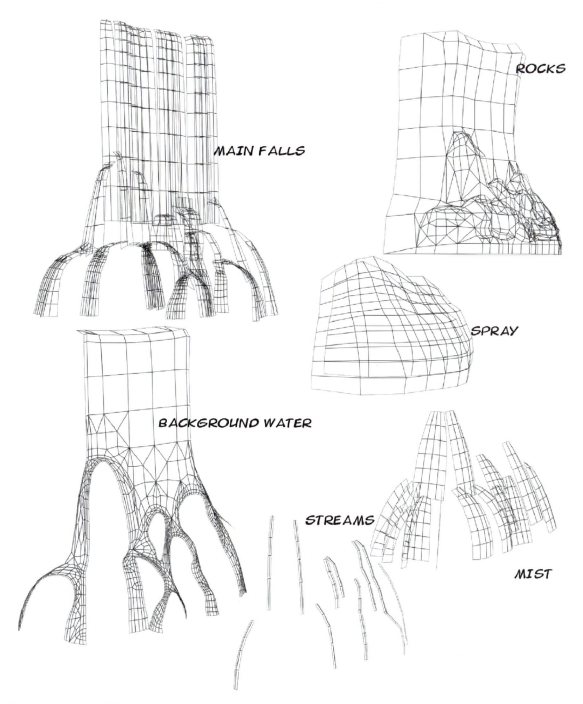

Figure 9-43 Waterfall meshes.

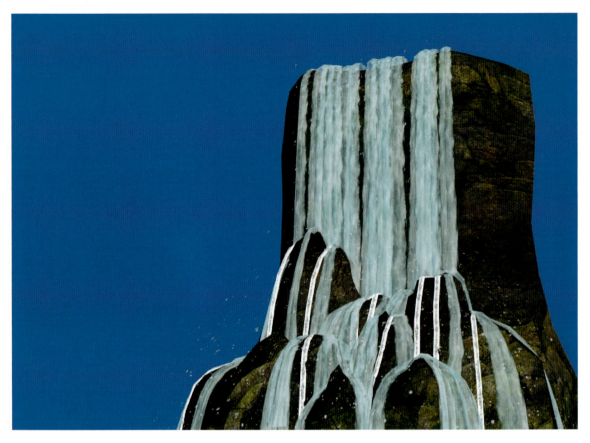

Figure 9-44 Finished waterfall.

Figure 9-45 Finished waterfall incorporated into concept art.

fairly simple assets, but when they are all moving in unison down the cliff face, the effect is impressive. The key to the effect is to get the scrolling speed just right. If the speed is too fast or slow, it looks odd. Figures 9-44 and 9-45 show, respectively, the complete waterfall and the waterfall incorporated into a piece of concept art.

Modeling and Texturing the Jungle Base

INTRODUCTION

The jungle has grown over this once-impressive base deep in the jungle. What was this place? Adding detail can tell us a great deal. The first question to answer would be the text on the signs. Will they read, "Beware of the bloodthirsty genetically engineered schnauzers," or will they say something more cryptic and confusing like, "Threat Level Alpha: Caution." And if this place is so decrepit and nonfunctional, what happened and where is the once-contained threat now? Let's start creating the models for the jungle base so that we can answer these questions. Many of the models will be generated for us, and this goes for the textures as well, so that we can focus on making this space be what we want it to be. Simple details like which way bars on a window are bent (in or out) will tell the player if something broke in or out. Larger details may be color choices (slick and corporate or drab and military), and the quality of the material that any given object is made of can indicate something about the resources invested in the enterprise that existed here.

We will be creating the following models and textures:

Mechanical Models

- Electrically charged, double-access gate

- Old building with doors, barred windows, and old vent pipes

- Guard tower

- Heavy-duty gate to keep whatever is in the jungle out

- Concrete bunker–type wall to hold the massive gate

- Industrial light towers

- Assorted ominous signs

Organic Models

- Rocks

- Plants

- Trees

- Foliage backdrop, ground, sky box

Mechanical Textures

- General textures: rusted metal, concrete, wood

- Lenses for industrial light towers

- Assorted ominous signs

- Specific texture for massive doors

Organic Textures

- Rock

- Plants

- Trees

- Foliage backdrop

- Sky-box textures

MECHANICAL MODELS

First, we will tackle the models of the manufactured objects in the scene. These objects are pretty easy because they are made by people, and thus incorporate right angles and diverse repetitive patterns and measurements. In the case of the gate, as in most other items, you need to create only one fence post, regardless of the number of posts comprising the fence.

Electrically Charged, Double-Access Gate

The electrically charged, double-access gate (Figure 10-1) is the first object we will create. This gate was designed to carry a lethal amount of electricity, but also has a double-gate feature so the gated area is never exposed to the wide-open jungle; one gate at a time can be opened while the other remains closed. This gate looks impressive, but is composed of only a few

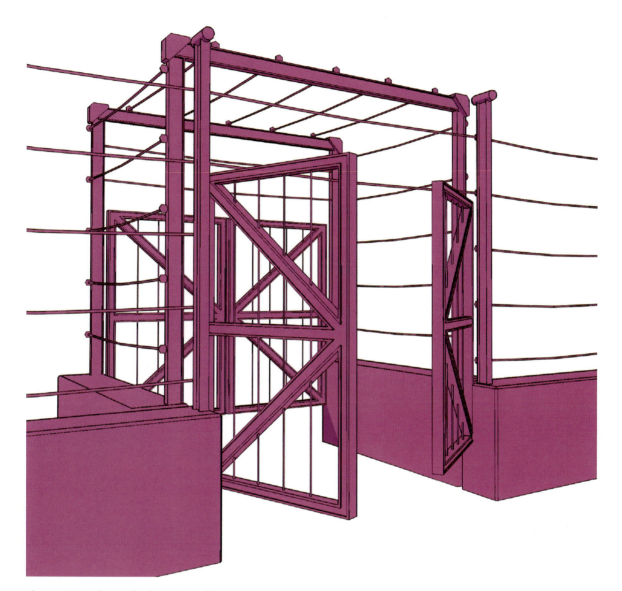

Figure 10-1 Electrically charged, double-access gate.

parts. As seen in Figure 10-2, there are only five simple parts to the gate itself: the base is a box with chamfered edges, the post is an extruded I-beam shape, the cables are cylinders with five sides and one division (so the cable can bow slightly down in the middle), the insulators holding the cables across the vertical bars are cylinders as well, and finally, the object on top of the electric fence is a capsule. The capsule is a light that will

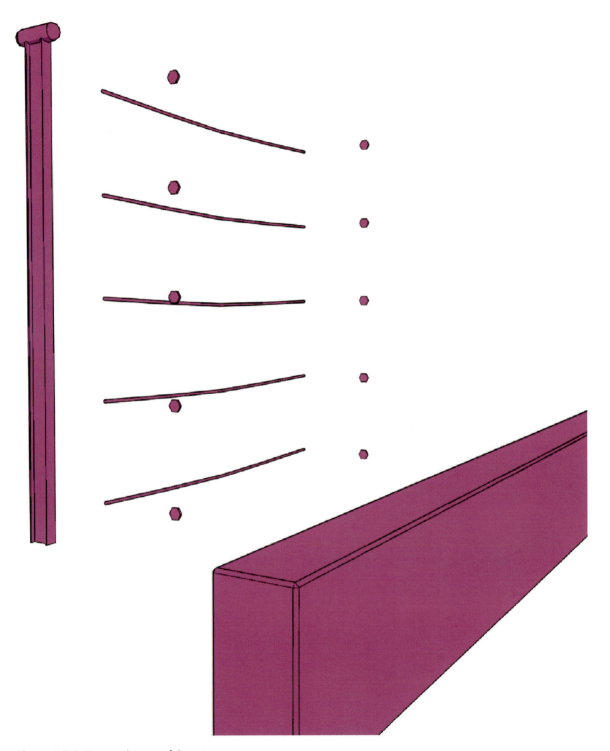

Figure 10-2 Five simple parts of the gate.

flash when the gate is armed. You can also make it a simple cap object or remove it all together.

If you start by creating the parts and assembling them as seen in Figure 10-3, you will be most of the way there. Every other part of the fence is built up from these parts. For the actual gate cage, you will need to create the angle caps as seen in Figure 10-4, and you need to build the gate itself

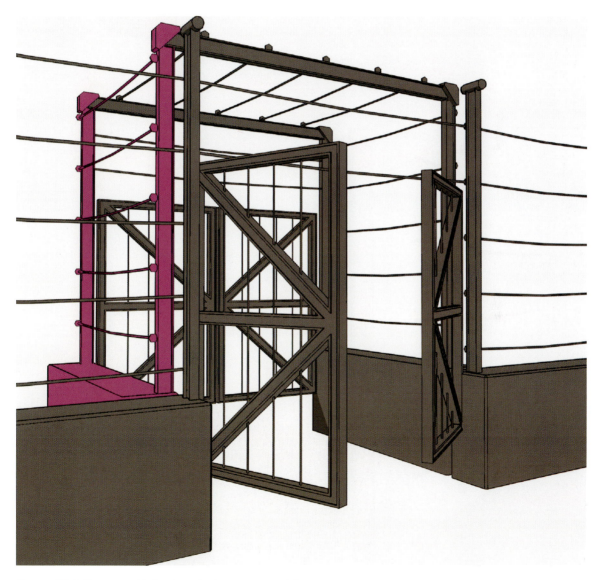

Figure 10-3 Parts assembled to form the base structure of the gate.

Figure 10-4 End caps.

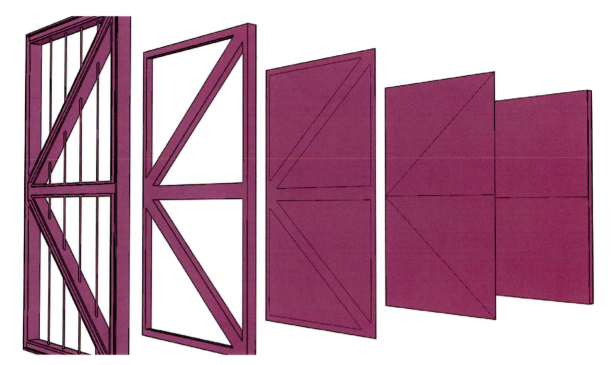

Figure 10-5 Gates.

(Figure 10-5). The gate is a box with one horizontal division. Inset the individual faces and the crossbars will be automatically created. Extrude these inward and delete the faces. If you can afford the polygons, you can inset and extrude the frame faces for an I-beam structure. The vertical bars are simply cylinders (these are electrically charged as well, so be careful).

Interesting additions to the gate would be signs (we will add these later), a latching mechanism, debris such as palm fronds hanging on the fence to indicate neglect, and a few broken cables. Delete a few of the cables and add some with more polygons so that you can bend them (Figure 10-6). This is not only visually interesting, but can also communicate many things to the player—the place is not kept up, the place is no longer safe because of the breach in the gate, the gate is not functioning, and perhaps the gate is the way in. You can even take a gate off and lay it on the ground, or bend it in half and place it farther away if you really want to convey a serious brute-force threat.

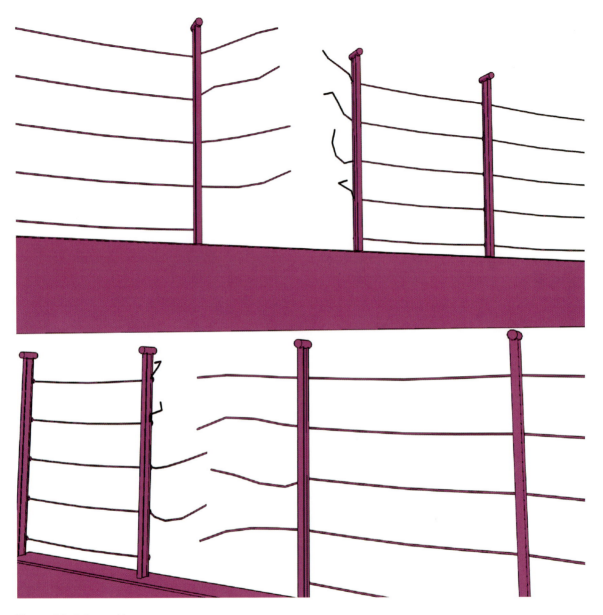

Figure 10-6 Bent cables.

Figure 10-7 Parts of the guard tower.

Guard Tower

The guard tower stands next to the gate. This is a functional and unimpressive wooden structure that is composed of several boxes. The only challenging boxes to deal with are the roof and the body of the tower. The roof is a box sliced from corner to corner and the center vertex is pulled up (Figure 10-7) to form the peak. You may have to turn some edges to get the faces at the correct angle. You could also use a pyramid primitive to do this, but you would still have to extrude the bottom face to create the trim. The body of the guard tower was created in the same manner as the gate in the last section. Start with a box with the number of divisions you need, and inset and extrude them to form the window panes (Figure 10-8). Leave the polygons if you are going to create a glass material for the windows or delete them.

Industrial Light Towers

The light towers are built from the base up. The base is a box with the top face scaled inward to form a beveled surface (Figure 10-9). The extended

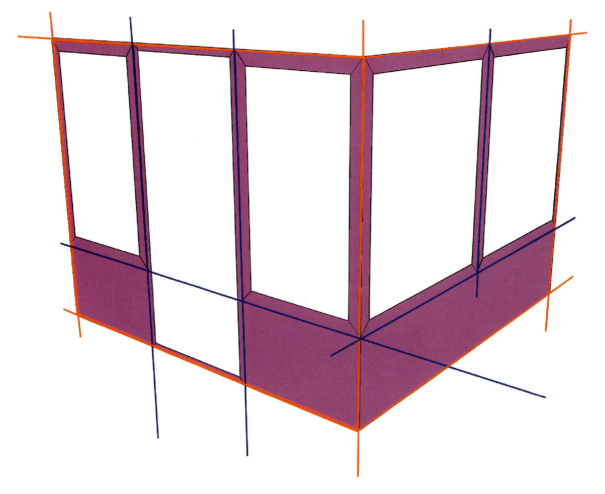

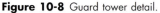
Figure 10-8 Guard tower detail.

support feet are actually the same box scaled down and edited at the vertex level. The back faces were removed. If you had a need to keep your geometry sealed, you could build the support feet by insetting the original face and extruding the feet from it. This is true in most cases when modeling. It creates more faces, but in some instances more faces are more efficient if it means keeping the geometry sealed. The inner faces of the main tower will be mapped with an alpha channel later to create the crossbars (Figure 10-10).

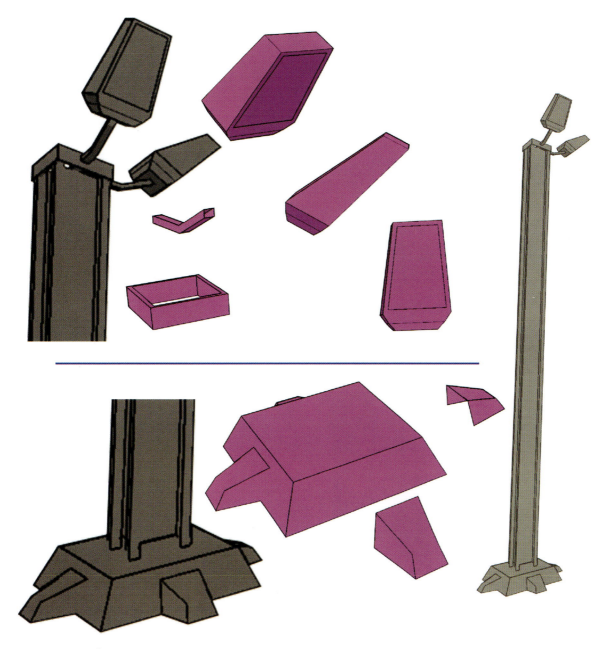

Figure 10-9 Light tower construction.

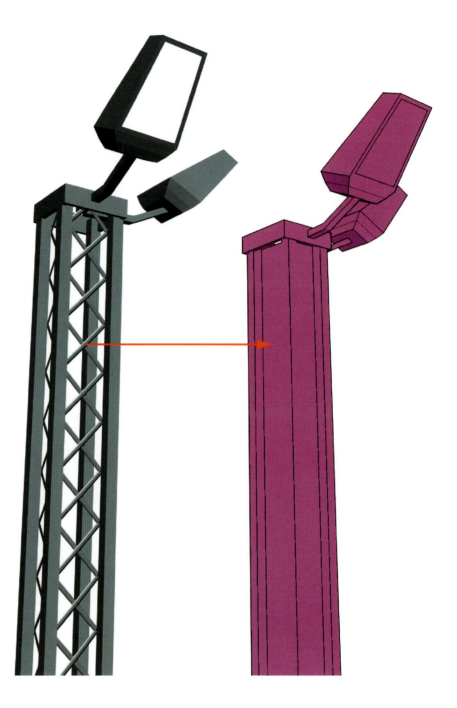

Figure 10-10 These faces will have alpha on them.

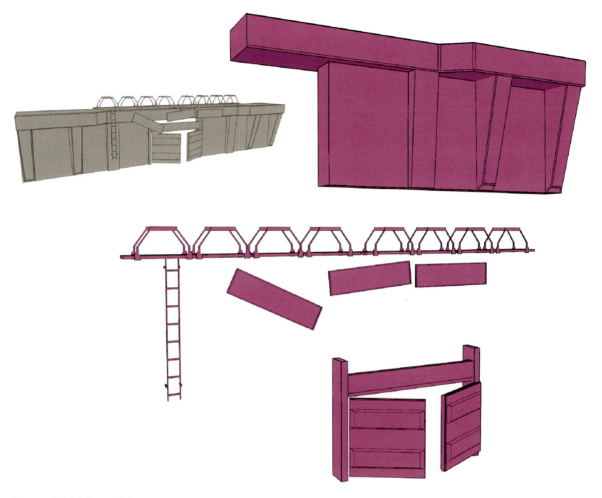

Figure 10-11 Parts of the main gate.

Heavy-Duty Jungle Gate and Concrete Wall

There are three main parts to the heavy concrete wall that keep the island's threats at bay: the wall itself, the door, and the details on the wall such as the signs and the catwalk (Figure 10-11). The wall (Figure 10-12) is an extruded line with slightly beveled edges for the top and a box for the wall below this. A few angular arches dress things up. The door (Figure 10-13) is slightly more complex. Start with a box. The front is inset and extruded and then sliced across the front polygon to form the two faces we will bevel. The backside is simply inset and extruded and three smaller boxes were added as braces. The door frame is a thicker version of the I-beam from

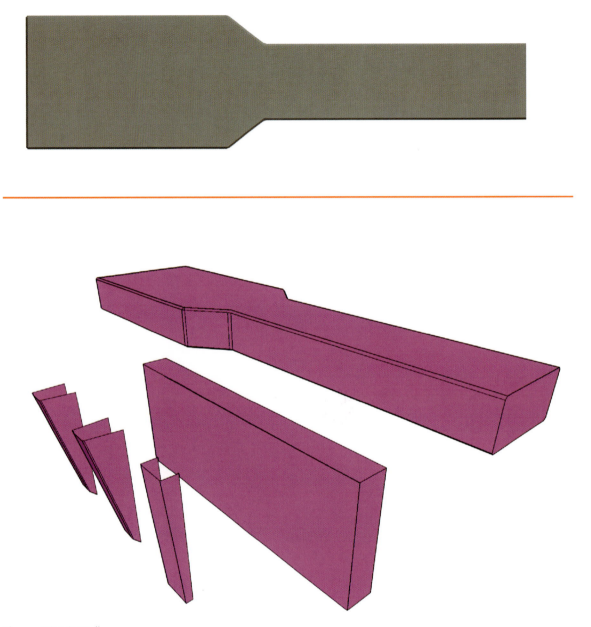

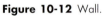

Figure 10-12 Wall.

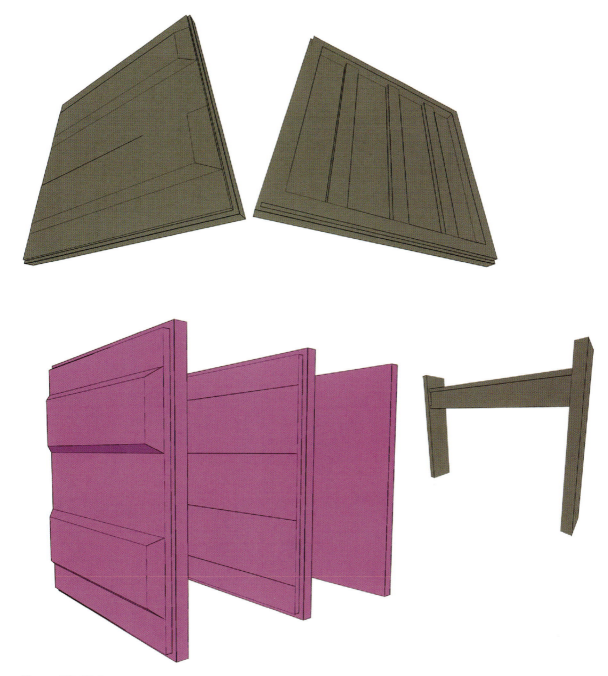

Figure 10-13 Door.

the fence. Finally, the details include the catwalk, ladder, and signs (Figure 10-14). The ladder and signs are simple enough, and the catwalk railings are one extruded shape copied several times along the box that forms the platform.

Old Building

Finally, we get to the building. The building has several parts, including the building itself, doorway, bars, and vent shaft and fuse box on the side of the building (Figure 10-15). The template of the front of the building is displayed in Figure 10-16. The steps to create the front of the building are shown in Figure 10-17. You only need to detail the front, so I removed the rear of the building to make the illustration clearer. You start with the eight faces and pull the center vertex up to form the peak of the roof. Inset the three sections and extrude them back. Inset and extrude these again to form the windows. For the door you are going to want to pull the back face deeper into the building and make the opening both wider and taller. Finally, we have the trim as seen in Figure 10-18. You can see the front and top profile of the trim as well as how it fits on the building. The bars on the windows are small cylinders with bent edges. In Figure 10-19, you can see the side and front of the bars. Note that the bars can be bent in the same fashion as the fence cables. These bars can be made from lower-polygon models if the ends are left straight. You can also experiment with various bar types for a different look. As displayed in Figure 10-20, security bar types range from the purely functional to the fancy and historic.

The doorway (Figure 10-21) has three parts: door, heavy security door, and door frame. The heavy security door is just a copy of the gate from the last exercise, so that's done. The door frame is created in the same manner as the front of the building (Figure 10-22). Start with a plane with eight polygons across, drag the middle vertices out to make the opening large enough for the doors, and be sure and keep an even amount of room around the frame to create the side and top panels. Delete the face where the doors will go and inset and extrude the remaining faces. The doors themselves start with a box divided into half and the top face divided again in half (Figure 10-23). The proportions of a door are not actually very linear, so look at the door template and note that the windows are not perfectly square and that they are not centered vertically on the door as if they were perfectly inset and extruded. Adjust the vertices to match the template or

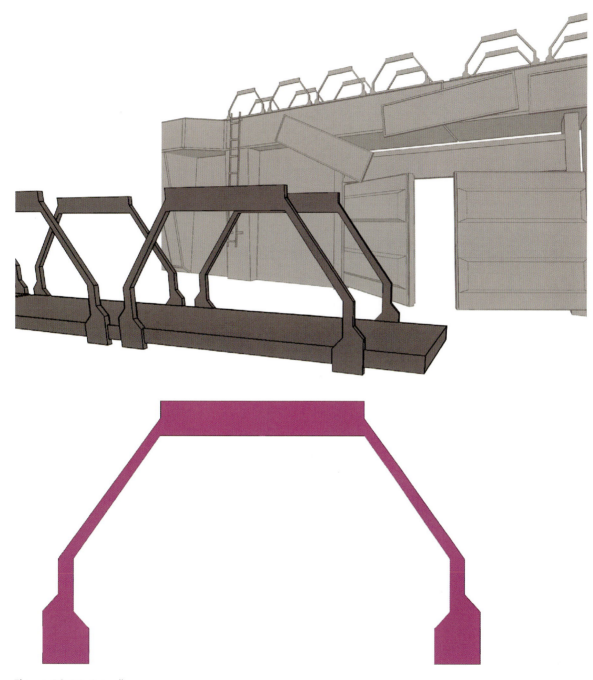

Figure 10-14 Catwalk.

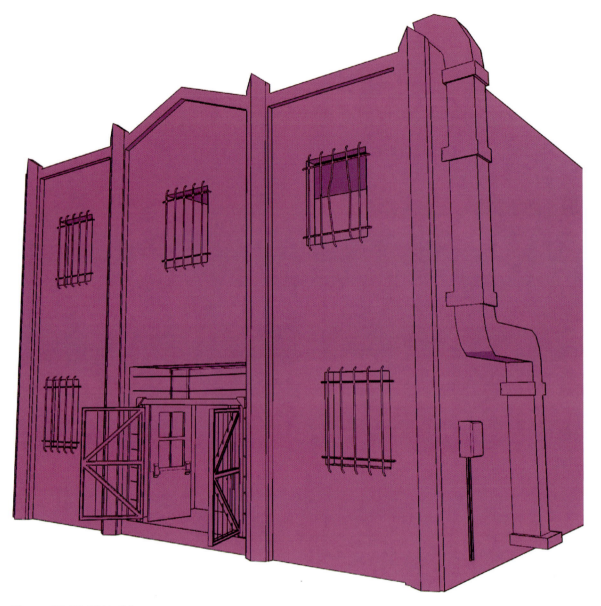

Figure 10-15 Old building.

Figure 10-16 Front of building template.

to the proportions of the door you are making. The door also has hardware both inside and out (Figure 10-24). Inside there is the push bar and outside the handle. I deleted the window panes for the illustration, but you should keep them in. Later we will texture them so they look like broken dirty glass.

Finally, let's focus on the vent pipes and fuse box. The vent pipe starts life as a box. Create the base by insetting the face, and then extrude this to form the first vertical vent shaft (Figure 10-25). Use Hinge from Edge on the top faces to get the turns in the pipe (a 90-degree angle with as many

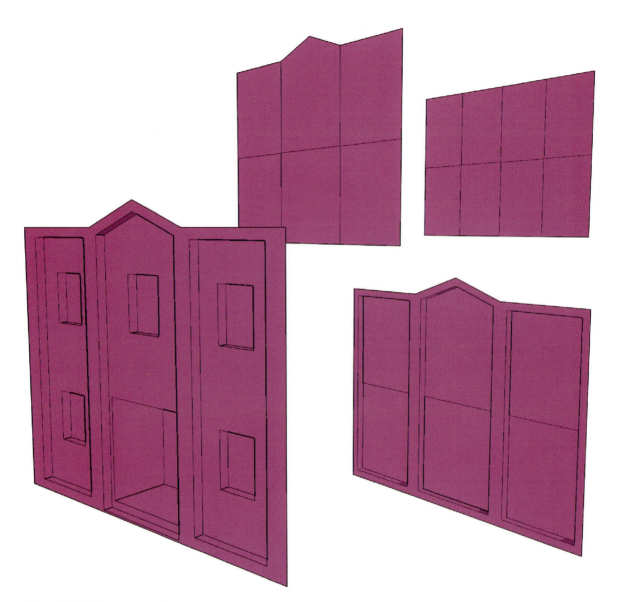

Figure 10-17 Front construction.

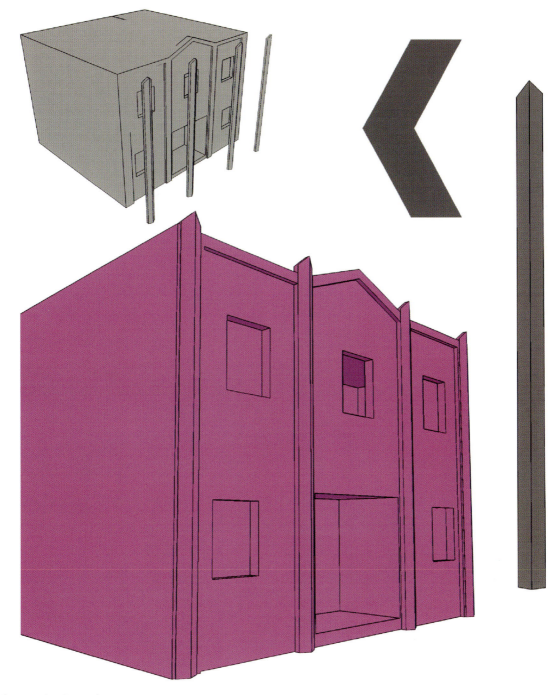

Figure 10-18 Detail trim.

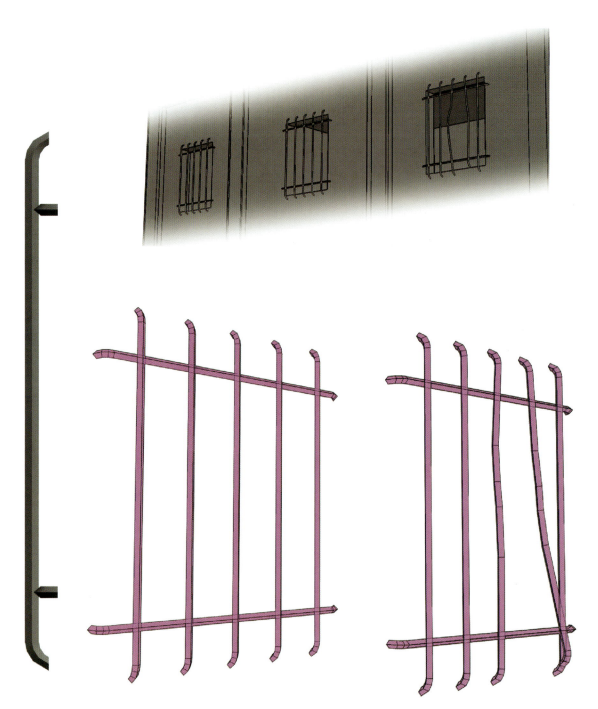

Figure 10-19 Bars.

Figure 10-20 Bar types.

sections as you want). The brackets holding the vent to the building are boxes. The fuse box comprises a beveled box and two cylinders (Figure 10-26).

ORGANIC MODELS

Rocks

You can create a convincing rock quickly by deforming a geosphere. The consistent face pattern of the geosphere makes it deform evenly so you can create a rock mesh that doesn't have that weird sphere peak at the top (Figure 10-27). Roundish rocks are the only object that I ever came across that the shrink-wrap UV modifier works on.

Plants

Plant Life is great for quickly laying out the meshes for all types of plants. I used it to create the ferns, lily pads, smaller tropical trees, flowers, and weeds (Figure 10-28). If you intend to export models and textures from Plant Life and import them into another program, the single-sided polygon option is usually preferable. Be aware of the fact that generating a plant

Figure 10-21 Front door with security bars.

with double-sided leaves means that there are two polygons facing out from each other.

Trees

The trunk of the palm tree is a slightly tapered and bent cylinder. The leaves are six faced polygons that are bent as well. You can of course add or subtract the number of polygons according to your needs. You can also add or remove fronds from the tree. The fronds are laid out in the manner illustrated in Figure 10-29. They are generally rotated around the tree three and four at a time. The top fronds tend to stick up straighter and are shorter

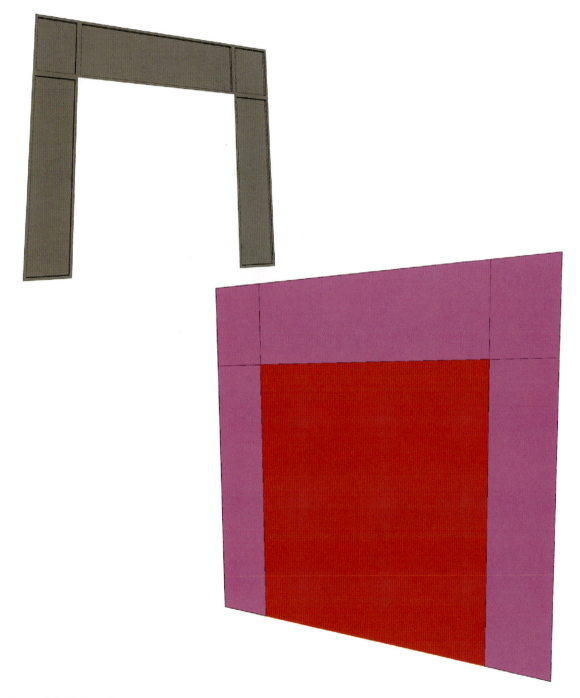

Figure 10-22 Door frame.

Figure 10-23 Door.

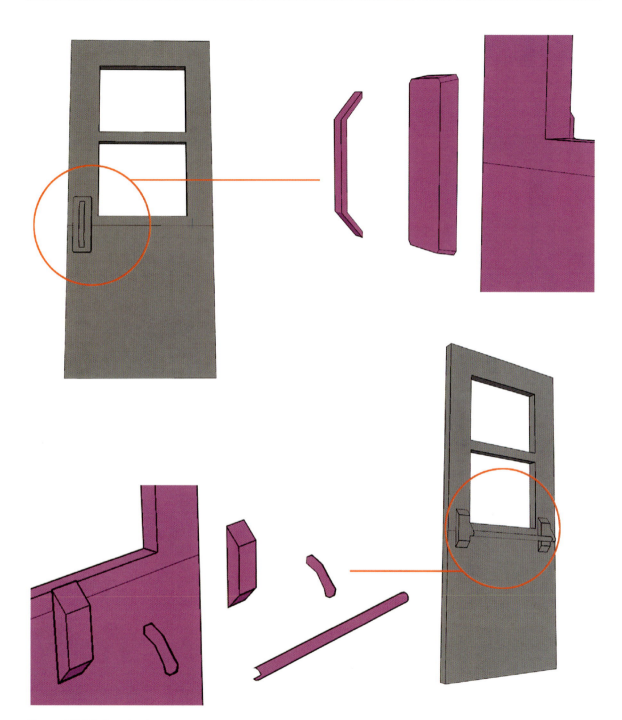

Figure 10-24 Door hardware.

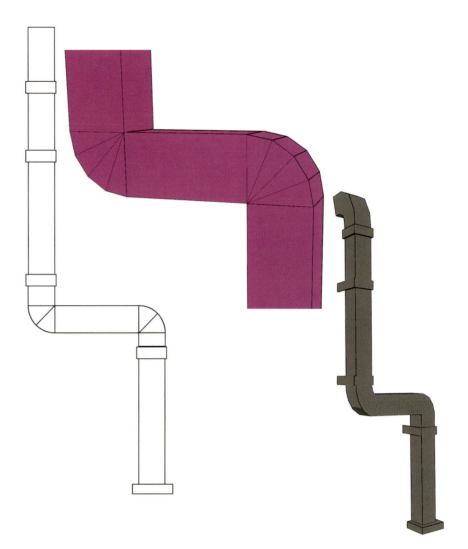

Figure 10-25 Vents.

than the lower fronds, which tend to be larger and to droop as they grow older.

Foliage Backdrop, Ground, Sky Box

The foliage backdrop and sky box are very basic shapes and can be created easily. Depending on how you ultimately handling the sky the shape could be a cube or sphere. We can create these assets as they are needed when we start creating textures for clouds, and so on. The foliage backdrop is nothing more than a single rectangular polygon mapped with a texture we

will create later. This plane can be placed in the distance (on hills and places away from player access) to add a large degree of depth and realism to a scene. The ground was exported from L3DT. The height and texture maps were exported and used to create this scene. The earlier chapter on terrain addresses the use of a displacement map to create this mesh (Figure 10-30).

MECHANICAL TEXTURES

To start our set of textures for this scene we want to develop a set of tiling textures of the most basic materials. Metal, rusty metal, concrete, and wooden plank tiling should be all we need until it is time to create specific-use textures.

General Rusty Metal

This is simply a photo source that was cleaned up with some cloning and erasing and then it was tiled (Figure 10-31).

General Tiling of Galvanized Metal

This is simply a galvanized metal pattern that is made in Photoshop (Figure 10-32). We can use this as is and tile it on many of the simpler objects such as the light towers and the gate ladder. Since this metal is located outdoors, I would put a slight overlay of rust using the tiling rust texture.

1 Create a new 512 × 512 image and name it *galvanized_metal*.

2 Create a new layer and name it *base*.

3 Fill this layer with a medium gray.

4 Add Noise: 5%.

5 Gaussian Blur: 2 pixels.

6 Filter > Pixelate > Crystallize: Cell Size 33.

7 Add Noise: 1%.

8 Duplicate and offset the layer to erase and/or clone stamp the hard edges out of the texture.

Figure 10-26 Electrical box.

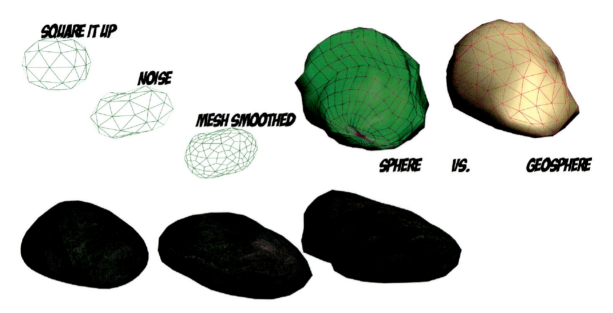

Figure 10-27 Modeling a rock.

Tiling Moldy Concrete

All the images you need to create the concrete texture are on the DVD. The PSD file is there too if you don't want to set it up yourself. The cement is created using several images in layers as seen in Figure 10-33. Most of the overlays can be used again as you stain and weather the rest of the world.

Tiling Wood Planks

Open the image on the DVD titled *wood_moldy.psd,* and examine the various layers. The source files are also included for you to use and examine (Figure 10-34). The source is nothing more than an image of some wooden planks that were cleaned up (remove hot spots and make the image tiling), and the overlays from the concrete were used. Keeping some planks without seams is recommended for long objects that you want to texture such as the legs of the guard tower.

Figure 10-28 Creating plants.

Figure 10-29 Creating some trees.

Figure 10-30 Gate scene.

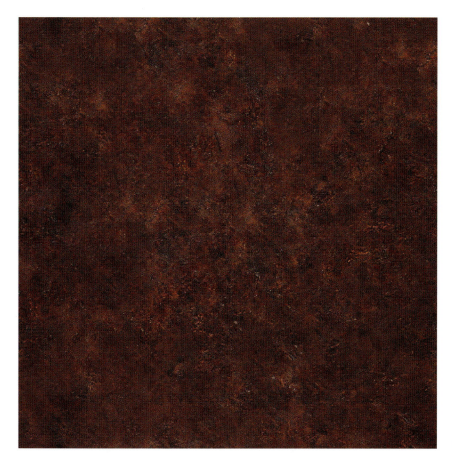

Figure 10-31 Rust.

Specific Detail Textures

Remember that the mold overlays can be used from the concrete. This is not only easier, but makes the weathering in the world more realistically consistent.

Massive Doors

To create the texture for these massive metal doors that have been rusting and getting moldy in the humid jungle for a very long time, we can use many overlays. Some of these overlays we have stored, while we will create others for the specific material that we are making now. Let's start with the UV template from the DVD, *main_gate_UV.jpg* (Figure 10-35). Start

Figure 10-32 Galvanized metal.

by opening and copying our rusty base into this image and blend it with the galvanized metal tiling to form the base material of the gate. Create separate layers for the door, door edge, and the panels on the door (Figure 10-36). I apply a slight outer glow of darkness to set the panels off from each other. The panels are also used later to quickly select and mask off portions of the gate.

Open and use the following images from the DVD:

scratched_paint: vivid light 17%

pitted_paint: overlay 17%

cement_smooth_blotchy: multiply 71%

Figure 10-33 Moldy concrete.

mold drip.psd OVERLAY 64%

green_streaks_002.psd SOFT LIGHT 62%

mold overlay.jpg MULTIPLY 65%

green_streaks_001.psd OVERLAY 32%

cracks2.jpg OVERLAY 30%

cracks.jpg PIN LIGHT 20%

seams Fill 0% with Layer Effects

cracks subtle.jpg HARD LIGHT 65%

blotchy.jpg LINEAR BURN 28%

cement_blotchy.jpg NORMAL

Figure 10-34 Wood planks.

rusty_chipped_paint: soft light 73%

scratches: screen 7%

Now for a layer of peeling paint. This is a common trick that nets impressive results. An online posting by Stefan Morrell offers some variation on this process (http://forums.cgsociety.org/showthread.php?t+373024). Create a new layer on the top of the file named *paint* and select the paint bucket. Check the All Layers box, select a nice desaturated color, fill an area, and watch what happens. To get different results, try playing with the tolerance of the tool and masking off the panels so the paint only fills the panels, as if they were painted a different color. You can also use a pattern fill, which is how the caution stripes were done. That image is on the DVD as well, and you can use it to create a pattern in Photoshop. I

Figure 10-35 UV template.

create the *paint* layer last, so it needs to be on top so that you can see what you are doing, but you need to move it under all the overlays for it to look right. For the text, I simply rasterized a text layer so I could erase some chips from it. The rivets are an overlay. Finally, add the mold overlays from the concrete wall on top of all of this. Sometimes a 1-pixel, very slight bevel will give the paint some perceived thickness as well as an equally subtle dark outer glow (Figure 10-37). Note that the fuse box and vent pipe textures can be created in the same manner as the metal for the massive doors.

Doors

Open the UV template for the doors from the DVD and open a copy of the massive doors texture. Use the same techniques to create the door

Figure 10-36 Beginning texture for the door.

texture that you used to create the massive doors texture. You can use most of the already-created layers in the massive door texture (Figure 10-38). One thing that I added was a brassy-colored texture for the fixtures on the door, including the push bar, handles, and other hardware.

Assorted Signs

The signs are similar in their weathering due to the fact that they are in the same environment as everything else. You can make these look like thin rusty metal or as if they were created from wood. I used a wood plank base and built up the mold and cracked paint layers. Add some text layers and create an evil logo if you need to (Figure 10-39). I thought the three

Figure 10-37 Final door.

signs over the gate should scream out dire warnings, whereas the signs on the gate and building could more informational.

Crossbeams for Light Towers

The crossbeams for the light towers are our rusty/galvanized metal tiling with an alpha channel to mask off the crossbeams. The beams themselves have a layer effect on them applied in Photoshop to make the crossbeams look thicker and more substantial. This effect would not be needed if you were using normal mapping or some other method of creating geometric depth in the object (Figure 10-40).

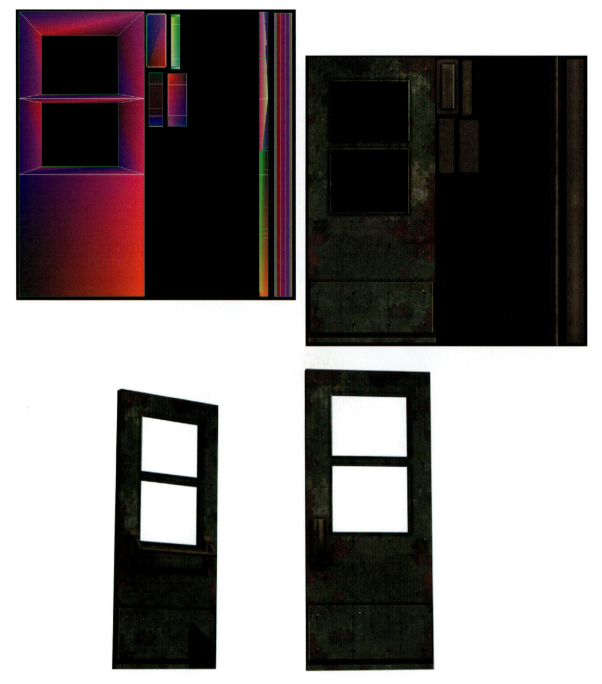

Figure 10-38 The double-doors in the building are based on the material used on the massive doors.

Figure 10-39 Signs.

Figure 10-40 Crossbeams for light towers.

Windows

Examine the reference photo for the warehouse windows (Figure 10-41). You can see how they are built from this photo, which shows a fairly simple construction, but we can do a lot to add detail and interest to even such a simple item with variations to the panes and frames. We can also use the alpha channel to make the windows look broken and dirty.

Window Frame

The window frame consists of a metal frame and panes of glass. We start with the metal frame and work down to the panes. This way we can control the amount of weathering on the windows to our liking.

Figure 10-41 Warehouse window reference photo.

1 Open a new 1,024 × 1,024 file and name it *windows_base*.

2 Set your grid to 256 with 1 subdivision.

3 Create a new layer set and name it *frame*.

4 Create a new layer in the set and name it *outer_frame*.

5 Set your foreground color to a very dark brown. I used RGB: 69, 59, 54.

6 Select the entire empty layer using Ctrl + A and right mouse click and select Stroke. Set the width to 18 pixels and the location to Inside.

7 I like to create the outer frame separate from the inner frame that holds the panes of glass, as it adds more depth to the texture. Create a new

layer and name it *inner_frame*. Make sure this layer is under the *outer_frame* layer.

8 Use the same color to draw lines along the grid. Use a hard 13-pixel brush.

9 Add the Layer Style Drop Shadow to the *outer_frame* layer and change the following settings:

Blend Mode: Normal

Distance: 8 pixels

Size: 16 pixels

10 Add noise. Filter > Noise > Add Noise:

Amount: 0.75.

11 Copy and paste the layer style from the outer frame to the inner frame layer and change the size to 6.

12 Apply the noise filter again. Ctrl + F will reapply the last filter you ran using the same settings. Your frame should resemble the one shown in Figure 10-42.

Glass

We will make the glass and then delete the portions of the glass where the frame covers it. This gives us additional flexibility when using layer styles because many of them operate on the edge of an image.

1 Create a new layer set and name it *glass*. You can turn the Frame layer set off for this part of the exercise. It will be easier to see the canvas and speed up the computer's response time.

2 Select a muddy yellowish amber (I used RGB 127,106,48), and fill this layer using the paint bucket. Or Ctrl + A to select all, right mouse click, Fill > foreground color.

3 Add noise. Filter > Noise > Add Noise: 7%.

4 Filter > Artistic > Dry Brush: Brush Size 10, Brush Detail 4, Texture 1.

5 Filter > Distort > Glass: Distortion 8, Smoothness 3, Texture Frosted, Scaling 166%.

Figure 10-42 Base window frame.

Figure 10-43 Glass panes without the frame.

6 Hit the D key so your foreground and background colors are black and white. Filter > Render > Clouds – Fade this filter to 25% (Ctrl + Shift + F).

7 Filter > Blur > Gaussian Blur: 1.5 pixels.

8 Filter > Artistic > Fresco: Set all settings to respective maximums.

9 Fade the filter to 15% and set Blending Mode to Multiply.

10 Cutting out the panes. Turn the *inner_frame* layer on and select an empty pane. Right mouse click and select Similar. Right-mouse click again and select Invert. Go to the *glass* layer and press the Delete key to remove the portion of the glass behind the frame.

11 Do the same for the *outer_frame* layer. Turn both frame layers off and your image should resemble the one in Figure 10-43.

Variations

Creating multiple variations of the panes is easy and makes this texture very flexible (Figure 10-44). Remember to create copies of the pane layer as you alter them. Some of the layer effects that I applied to the panes which you might want to try follow:

Subtle dirt: Inner Glow, Black; play with the size, opacity, noise, and blending modes.

Figure 10-44 Window pane variations from left to right are subtle dirt, subtle dust, and subtle highlights/inner light source. They have also been colorized and the saturation and brightness adjusted.

Subtle dust: Change the Inner Glow color to a very light gray; Blending Mode: Color Dodge, Opacity 65%, Noise 16%, Size 40 pixels.

Subtle highlight: Bevel and Emboss; try changing the settings to a large, low depth, and highlight and soften. This can give nice even highlights to the panes. Just be careful to avoid a bulged-out look to the panes.

Inside light source: For a large tiling texture you want to keep things even, but in the case where this window might be used in a single instance with no tiling, you can add a subtle gradient using a layer style and experiment with the blending modes and gradient types to obtain the look of a stationary light source in the room beyond the window.

Weathering and Dirt

Various types of weathering and dirt can be applied to a surface depending on the location and the material the surface is made of. In this case, the windows have been exposed to jungle conditions for many years. It would be assumed that dirt or weathering will be prevalent: the metal frames are rusted and the glass streaked with rain and dirt and covered in mold. Let's rust the frame.

1 Duplicate the layer set *frame* and name it *frame_overlay*.

2 Make sure that the new *frame_overlay* set is on top of the *frame* set in the layer stack.

Figure 10-45 Variations of the rusted pane, easily created because of the power of layers and blending modes.

3 Open the new layers set and turn off the layer effects. Link the two layers, and merge them (Ctrl + E). You now have a solid copy of the entire frame.

4 Lock the Transparency on this layer.

5 Filter > Noise > Add Noise: 10%.

6 Filter > Artistic > Dry Brush: Brush Size 2, Brush Detail 8, Texture 1.

7 Colorize. Ctrl + U, Hue 14, Saturation 30.

8 Change Blending Mode to Darken and experiment with the opacity. Around 30% to 45% is light rust and 50% to 75% is heavy.

9 Changing Blending Mode to Lighten will give you a brighter, drier-looking rust. Figure 10-45 shows a few variations of the rusted pane.

The panes can also be weathered using the mold overlays from the previous textures. You can also add some dirt as follows:

1 Start by duplicating the *glass* layer set and naming it *outside_glass*.

2 Desaturate the *glass* layer (Ctrl + Shift + U).

3 Fade this by about 50% (Ctrl + Shift + F). Now the panes look faded as if they have been outside a long time.

4 To generate a general dirt layer, create a new layer on top of the stack and name it *smog*.

5 Filter > Render > Clouds.

6 Change Blending Mode to Multiply and set Opacity to 50%.

7 Filter > Noise > Add Noise – 50%.

8 Filter > Blur > Motion Blur: 90 degrees and about 30 pixels of blur.

Rain Streaks

1 To create rain streaks, turn off the *smog* layer (you can turn it on later if you like), and create a new layer named *rain_streaks*.

2 Select a medium gray as your foreground color (RGB: 157, 157, 157).

3 Zoom way out so that your image is pretty small and the canvas fills most of the work space (Figure 10-46). This makes it easier to create various streak lengths.

4 Select a brush of medium size and softness. Go to the Brushes Palette and under Shape Dynamic change the control to Fade. Set the pixel fade to 128. This is the window to the right of the fade selection.

5 Now drag a few lines down your window. Hold Shift to keep the lines straight. Vary the length by starting to draw higher above the canvas and vary the width using the left and right square bracket keys ([,]). Be subtle.

6 Filter > Blur > Motion Blur: 90 degrees and about 30 pixels of blur.

7 Set Blending Mode of this layer to Overlay and set Opacity between 50% and 75%. I ended up at 63% in Figure 10-47. You can, of course, experiment with the color of the streaks, the blending modes, and opacity. You can even add some noise and run the Motion Blur filter again with a lower pixel blur for streaks with a little more body.

Note: If you want the lights on the towers to have a special glass texture, you can use the window texture along with the UV template of the light to create a dirty, never-used, glass texture.

Window Alpha

You should know by now that an alpha channel is a grayscale image used to dictate opacity in an image. We can make an alpha image for these windows and use it in several ways for various effects.

Figure 10-46 Small image and large canvas. This makes it easier to vary the length of brush strokes on the canvas without having to change brushes, because you can start drawing anywhere you want outside the canvas.

1 Duplicate your window image. We will be merging layers and it is safer to work from a copy.

2 Duplicate the *frame* layer set and name it *alpha*. Make sure that this new layer is on top of the layer stack.

3 Open the new set and turn off the layer effects. Link the two layers, and merge them together (Ctrl + E). You now have a solid copy of the entire frame.

4 Use the D key to reset your colors.

Figure 10-47 Rain streaks on the window.

Figure 10-48 In most applications, the white in an alpha channel is solid, so the frame is white and kept as a separate layer. Make sure that it always stays solid white if you adjust the panes.

5 Select an empty pane, right mouse click, and select Similar, and then Invert the selection and switch to the rectangular marquee. Right mouse click and fill the selection with white. We want this frame solid white because in the alpha channel white is solid and no light will pass through the frame or reflect off of it.

6 Hide the new frame *alpha* layer set.

7 The windows should already be the way you want them in terms of texture. If not, go back and change them before making the alpha so that they match. When you are ready, Merge Visible. The white frame should be a separate layer on top of your merged panes.

8 Desaturate the panes (Ctrl + Shift + U).

9 Using Levels, drag the middle arrow a little to the right to darken this image.

10 Using Brightness/Contrast, take the brightness down 20 and the contrast up 20.

11 Your image should look like Figure 10-48. If you keep the frame separate from the panes, you can adjust and alter the panes while keeping the frame solid white. With the panes this dark, they are almost completely

transparent, so you will want to experiment with light/dark and contrast settings.

This alpha image can go into an alpha channel in Photoshop, or into an image format that supports alpha, or it can be used as a separate image. Some game engines use a separate grayscale image as the alpha, while others will recognize the alpha channel of an image. Some do both, so you can use one grayscale image to define the opacity and illumination of the window and another to define the bump. In the case of a bump map for a window, you would want the panes smooth, unless there were mud splatters that would stand off the glass, and the frame would protrude. In Figure 10-49, you can see the window texture with various effects on it that use the alpha channel. Note that in the image with opacity, there are broken panes. This was easily done by making the broken and missing portions solid black with hard edges.

The size of the texture and the number of panes will fluctuate depending on your parameters. One approach is to make more panes in the same texture space; another is to make one pane if the panes are all the same. This would allow a smaller image size, but more detail per pane. You can even have a polygon for every pane in the window and make an image with pane variations, including normal and several broken in different ways. Then the environmental artists can cover most of the panes with the normal pane and randomly place the broken ones.

Note: Some game engines and 3D applications use black as solid and white as transparent, while some may use the opposite. If this is the case, you can simply invert your image using the Invert command (Ctrl + I).

ORGANIC TEXTURES

Organic textures derive from a photo source. Some can be generated using applications such as Bryce and L3DT, among others.

Rocks

I started with the photo source from the DVD and added the mold overlay from the concrete (Figure 10-50).

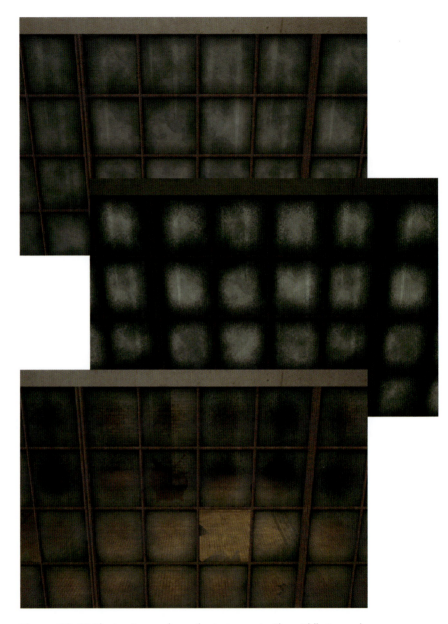

Figure 10-49 The top image shows the texture as is. The middle image has an illumination shader on it. It is difficult to see in this image, but if you were on a dark street these windows would be bright as if there were a light inside. The bottom image has an alpha channel used for opacity. White is solid, so black is clear. The broken panes are just solid black shapes on the alpha channel.

Figure 10-50 Rock texture.

Plants

For the plants I used the images generated by Plant Life: flowers, ferns, weeds, tropical lilies, and so on, and worked on them a bit (Figure 10-51). They come out very saturated and of high contrast. They are also designed to be used with masking rather than alpha, so their edges are jagged. I take the generated images into Photoshop and smooth the edges and adjust the brightness, color, and contrast. I even replace the image sometimes with a higher resolution or more appropriate image. In Photoshop, I usually Gaussian blur the image just a little and then use Enhance Edges to help smooth out and strengthen the image. You often have to swap the image quadrants about; the UVs are flipped when I get the Plant Life mesh into Max, and I find it easier to change the texture than the mesh.

Trees

I end up using photo sources for trees, and sometimes I render tree branches in an application like Bryce (Figure 10-52). The textures for the palms are based on photo sources for the bark, and the fronds are rendered in Bryce. The smaller broad-leafed plants were created in Photoshop. I used a base

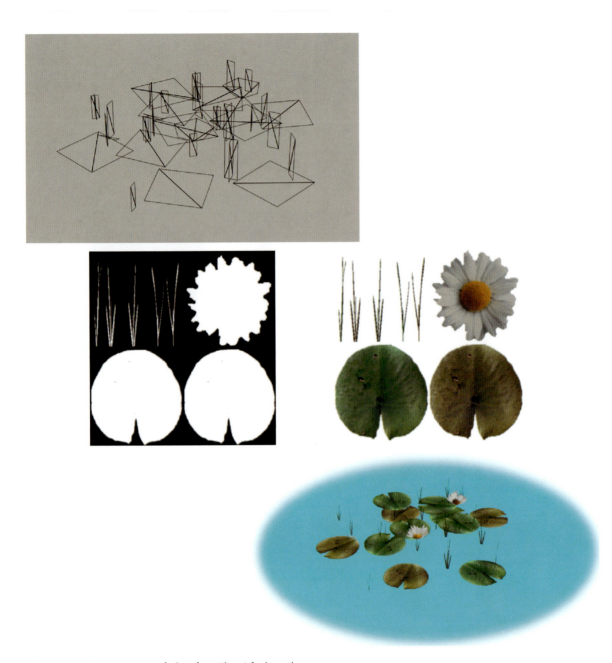

Figure 10-51 Progression of plant from Plant Life through stages.

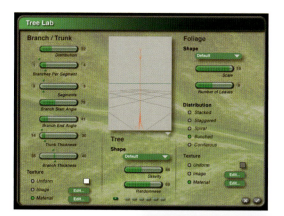

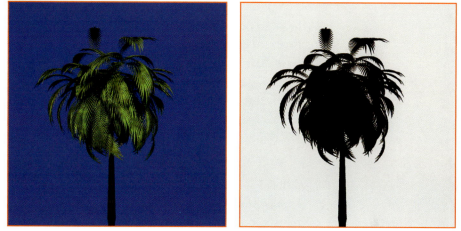

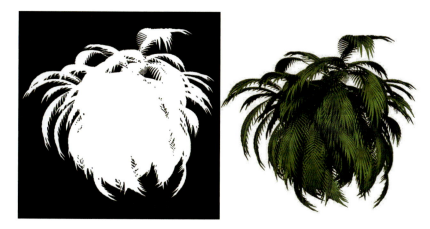

Figure 10-52 Trees from Bryce.

leaf that I found on the Internet, cut and shaped it, and finally adjusted the color (Figure 10-53). I used Liquefy to push the triangular slits in the leaf edge into the leaf.

Foliage Backdrop

Use renders of all your tree and plant assets, from various angles if possible, and layer them in Photoshop until you have the backdrop you like. Make it tile and create an alpha channel (Figure 10-54). You can even use other sources of foliage if they blend in with the foliage of your world.

Sky Box Textures

In addition to clouds (see Chapter 9), I create my sky assets largely in Bryce. This is a very reasonably priced application from DAZ 3D (www.daz3d.com), priced at about US$60. The ease of creating photorealistic—and seamlessly tiling—sky images makes the price well worth it for that feature alone (Figure 10-55). There are, of course, many other features for terrain, water, vegetation, skies, and other elements in the natural environment.

Even though the easiest way to get a sky out of Bryce is to output the traditional six images for a sky box, I have a method for creating a sky dome. I really prefer the dome over the box and here is what I do. After rendering the six images for sky out of Bryce at a high resolution, I map them to a cube in Max and then spherify or mesh smooth the cube. Spherify will take a cube with fewer faces and make it a perfect sphere, whereas a mesh smooth function often takes more faces to create a round object (Figure 10-56). I find this is a very easy way to make such an object, and I also have an easier time working with six separate square images than a single large distorted thing. The beauty of this process is that it relies on the multisub object function (in Max), so the images are still six flat ones and therefore still easily editable as separate flat images. The fact that they are six flat images mapped to a sphere makes the top of the dome mapped with a full image you can work with and not some tightly gathered image that was squished to a spheroid object.

THINGS TO TRY

Multitexturing is the process of laying more than one texture on a surface. This can involve using various sets of UV coordinates for each set of

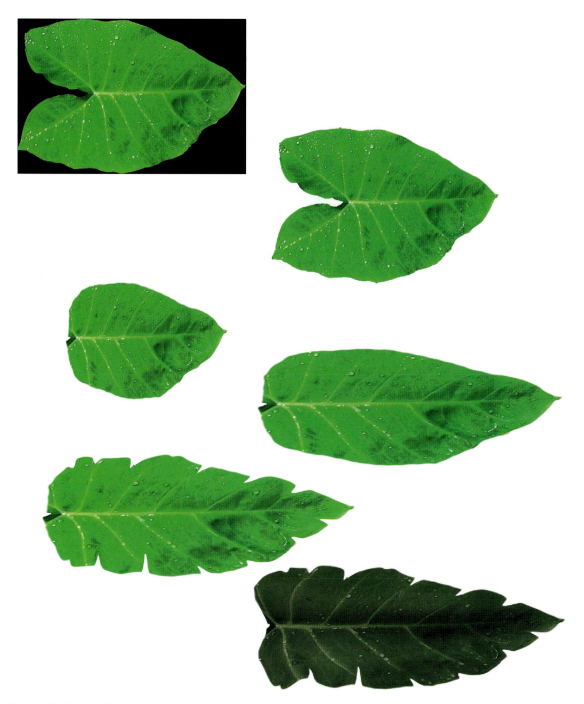

Figure 10-53 Broadleaf plants.

Figure 10-54 Progression of the foliage backdrop creation.

Figure 10-55 This is an extreme fish-eyed view of a sky box with a Bryce texture. You can see five of the six faces in this shot.

textures. This is traditionally how light maps function and other maps such as bump and specular, and so on. Due to its flexibility, the method can be very effective in game development in terms of efficiency and visual quality. You can set up a faux multitexturing scenario in Max or any other application that supports multiple UV sets. In Max, you would use the Composite material function. *Game Art: Creation, Direction, and Careers* by Riccard Linde contains a great section on multitexturing and it is broken down for setup in Maya. The four basic stages of multitexturing as laid out by Riccard Linde follow:

- Base map—color

- Multiply blend one—detail with specular map

- Multiply blend two—dirt map

- Alpha texture—decal map with transparency

You can use the textures that you have already created to do this, as long as you saved them in layers. The moldy concrete we created can be used to create all these maps: color, detail, dirt, and decal. The alpha decal is the only map that requires proper pixel ratio and resolution for the world;

Figure 10-56 Bryce box images can still be used on a sky dome.

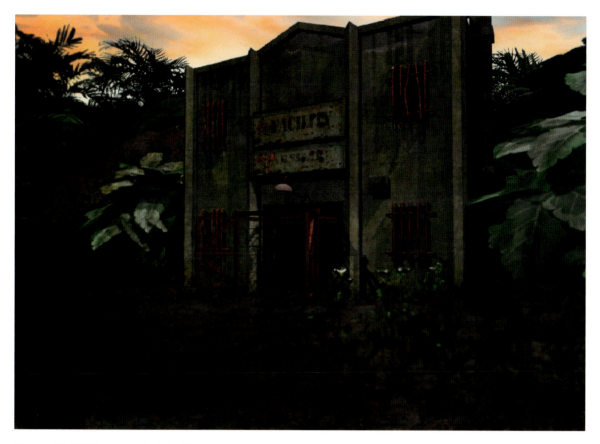

Figure 10-57 Multitextured old building.

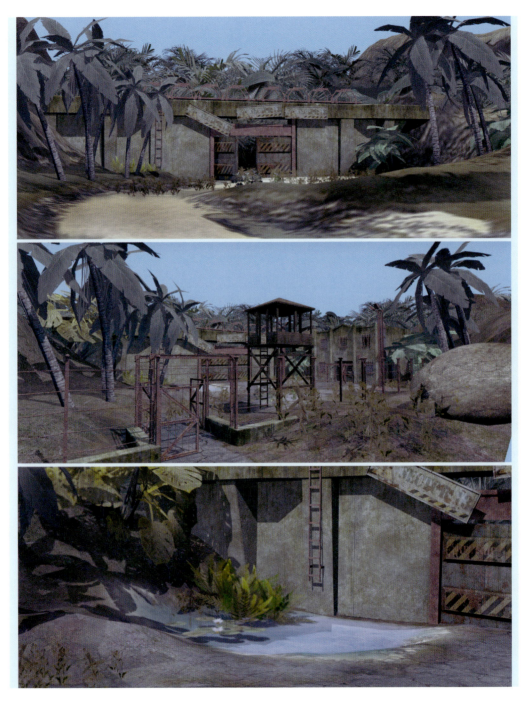

Figure 10-58 Jungle base scene.

the others can be of virtually any size. Figure 10-57 shows the multi-textured front of our old building.

I used the Composite material function in Max, which composites up to ten materials together and uses additive, subtractive, or multiply blending. Keep in mind that the first material slot is the one on the bottom of the other materials below it in the numbered slots. These are composited as ordered from top to bottom. The tiny buttons next to each of the materials (A, S, M) are the additive, subtractive, and multiply toggles.

CONCLUSION

In Figure 10-58, you can see some renders of the jungle base scene. In Chapter 11, we will discuss more advanced shaders and we will work in the sci-fi setting.

Focus on the Futuristic Interior—Normal Maps and Multipass Shaders

INTRODUCTION

Assume that the colonists on planet LV-426 have been out of touch and you need to check on them. Incredibly, they are mesmerized by a reality show: five colonists and five aliens try to live in the same space station while losing weight, participating in meaningless competitions, and voting each other off the planet.

This chapter focuses on normal mapping—specifically creating maps in Photoshop with a look at creating them using a 3D program—and creating the supporting maps for a typical environment. In the 3D program, we will create them using a more simplified method that is perfect for the environmental artist. By creating several smaller parts of geometry, you can place them where you want them to create a larger object and shoot the normal map from that. There is no need to create the same vent over and over, and no need to try and create one large complex piece of geometry that encompasses only a few details.

First, we will look at what a normal is and how lighting in games generally works. In short, a normal map creates an illusion of depth by recalculating the highlights and shadows on a low-polygon surface using the information from a high-polygon model and does it all in real time. Earlier in the book I briefly discussed bump and normal map shaders; in short, they add 3D depth to an otherwise flat surface. While bump maps are grayscale and display the most limited 3D effect, the normal map adds more depth using a color map with lighting information stored in it.

A painting can be created that looks like a real scene, but it will only look good from a single-fixed angle. When you change your viewing angle, you suddenly see that it is a flat 2D image. Imagine creating a painting that

repainted itself so fast every time you moved it that it seemed as if you were viewing a real three-dimensional scene. That is essentially what a normal map is doing as it calculates light and shadow in real time on an otherwise flat surface. We still need to maintain the silhouette of the model as best we can, meaning that the overall shape of the model will still look the same even if the flat surface is highly detailed. The good news is that using a present-day, vanilla-normal map allows us to focus more polygons on the silhouette of the model. Presently a normal map cannot change the silhouette of the model, but there is an even better type of mapping called parallax mapping that can actually take into account the fact that items protruding from the surface of an object should occlude objects behind it.

In this section, a few simple models and texture sets are used to demonstrate the normal map. All of the following assets can be found on the companion DVD:

- Wall panels

- Floor panels

- Column

- Light/ceiling panel

- Door

- Monitor

- Pipes and hoses

VERTEX VERSUS PER-PIXEL LIGHTING

The science of light is complex to say the least. Due to hardware limitations, programmers have had to grossly oversimplify light calculations in order to calculate light in real time. Programming decent lighting in-game has become possible only very recently due to hardware technology advances. There are several ways lighting can be handled in games but if it is calculated in real time it is probably; vertex lighting or per-pixel lighting. Vertex lighting (generally called Gouraud shading) uses a broad brush to determine the lighting of a surface, whereas per pixel lighting uses a very

fine brush to do so. Vertex lighting takes the brightness value of each vertex of a polygon and creates a gradient across the polygon face (Figure 11-1). This is not nearly as accurate a lighting model as per-pixel lighting where the lighting is calculated for every pixel.

So what is a normal and how does it figure into all of this? The normal is simply the way the face of a polygon is facing. Unlike the real world, where a sheet of paper or the sides of a cardboard box have a back and front (and technically sides), a polygon is generally only visible when you are facing it. In a 3D world, from the inside of a cube you will be able to see out of it because you are on the backside of all the polygons and the normals are all facing away from you. In some 3D games, you can get your character in a position where you can see inside and through objects. In fact, in some games

Figure 11-1 Vertex lighting.

players can get themselves inside objects where they can see and shoot other players, but those players can't see them or shoot back. Some programs will show you an outline when you are behind the polygon to help you keep track of your objects or give you other tools to work with in 3D, but games generally look at the normal "as is" unless specifically instructed not to. Normals are usually represented as an arrow pointing away from the visible face in a straight perpendicular line. This simple concept is important to understand because how a normal map functions is based on this bit of information (Figure 11-2).

In vertex lighting, for every normal on the mesh the angle of the normal and the angle of the lights in the scene are calculated (often with their distances included as well) to determine the brightness of the vertex and the gradient between these points (Figure 11-3) as follows:

Brightness = N (the normal) dot L (the light vector, or the line from the light to the surface)

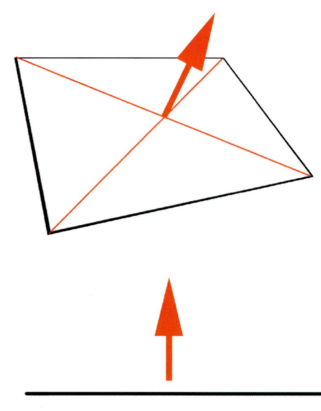

Figure 11-2 The normal.

BRIGHTNESS = **N** (THE NORMAL) **DOT** L (THE LIGHT VECTOR)

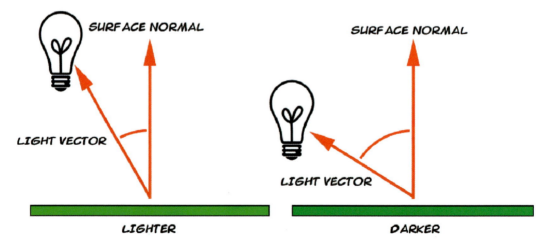

Figure 11-3 The normal and N dot L calculations.

WHAT IS A NORMAL MAP?

A normal map is an RGB texture and the various color channels of the texture (red, green, and blue) stored the X, Y, and Z values of the normal vectors from a high-resolution model. Figure 11-4 shows what a normal map generally looks like.

Creating Normal Maps in Photoshop

Normal maps are easily generated by creating a grayscale map in Photoshop and using the NVIDIA plug-in to convert it to a normal map. There are several techniques for building these maps: painting them, creating them from photos, and using parts of existing normal maps.

Painting Normal Maps

An easy way to create a normal map is to begin with grayscale height maps and use a filter (freely available from NVIDIA) to convert them into normal maps. In Figure 11-5, you can see the height map, the NVIDIA interface with 3D preview, and the resulting normal map. You can see that by using various shades of gray and creating soft or hard edges you can create almost any object you need in a normal map.

Source-Based Normal Maps

A source-based normal map is created from an image, usually a photo. While this is not always desirable, you can get some good results from a photo. In most cases, when creating environments for a game, the textures you create will be used for rounded, injection-molded plastic spaceship interiors, as well as stones, concrete, tree bark, wood, and hard-edged objects—and a lot of other surfaces that are almost impossible to model and shoot normals for. You will often find yourself in a situation where you have to use a photograph or a finished texture to create a normal map. The simple steps to accomplish this follow:

1 Start with a copy of your image and desaturate it. I often convert the image to 16 bits, since any banding in the image will show in the normal map. It will look like a topographical map (Figure 11-6).

2 Run the Photocopy Filter. You will have to adjust the settings based on the source image, but the goal is to get the lower parts of the image to

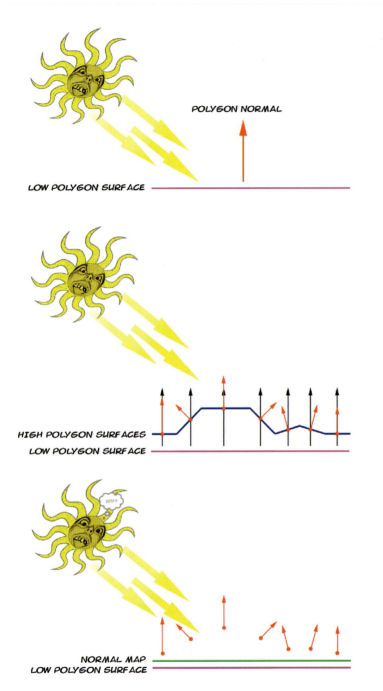

Figure 11-4 Normal map.

GRAYSCALE MAP RESULTING NORMAL MAP

POLYGON NORMAL MAPPED POLYGON

Figure 11-5 Normal map creation using varying grayscale values and softer or harder edges.

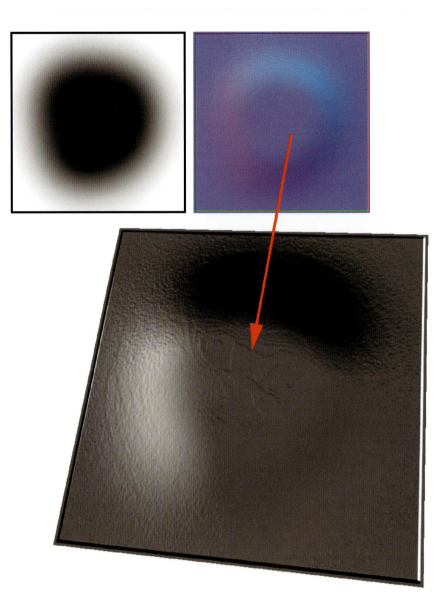

Figure 11-6 Banding in the normal map.

be black and the higher ones to be white with little distortion. Figure 11-7 shows this and subsequent steps.

3 Now you can darken the areas that are supposed to be deeper than the overall surface. In this example, I darkened the area where the bricks are exposed since the plaster is on top of the layer of bricks and should be set back in relation to it.

4 I cleaned out a lot of the noise from the overall image since normal maps are very sensitive, and typically an excess of detail on a normal map translates into a noisy and/or puffy result.

5 Finally, I took a very small brush and darkened the major cracks in the wall and put a 2 pixel Gaussian Blur to the entire image. This entire process only takes minutes and adds a great sense of depth to the image.

6 You can build up more depth in your normal map by taking it into Photoshop and creating a layer via copying and setting the blending mode to Overlay. This alone will enhance the detail of the normal map.

7 To add more depth, blur this layer a few pixels. You can repeat this process several times—duplicate the layer and blur it (making sure the blending mode is still set on Overlay) and check the results every so often until you like what you see. This extra step is great for more organic textures, as it builds depth in a way that makes the details more rounded. If you are working in Photoshop, painting in hard details is recommended.

8 The last thing to do is to Renormalize the map by running it through the NVIDIA filter and checking the Normalize Only option. This step corrects any vector information encoded into the normal map that might have been corrupted during these steps (Figure 11-8).

Use Parts of Existing Normal Maps

This can be done in 2D as well as 3D. In 2D you are simply cutting and pasting parts of existing normal maps and putting them together; in 3D you are putting various parts or geometry together to create the normal map. The 2D parts can only be moved about to be effective as parts of a normal map, but the 3D parts can be moved, scaled, rotated, and reused in many more ways.

CREATING NORMAL MAPS USING A 3D PROGRAM

The process for creating normal maps using a 3D application starts with the two models: a high-polygon (the sky's the limit on detail) and a low-polygon model (needs to run in the game engine you are creating it for). It doesn't matter which one you create first, but there are some pros and cons to both approaches. After the two models are created, the process

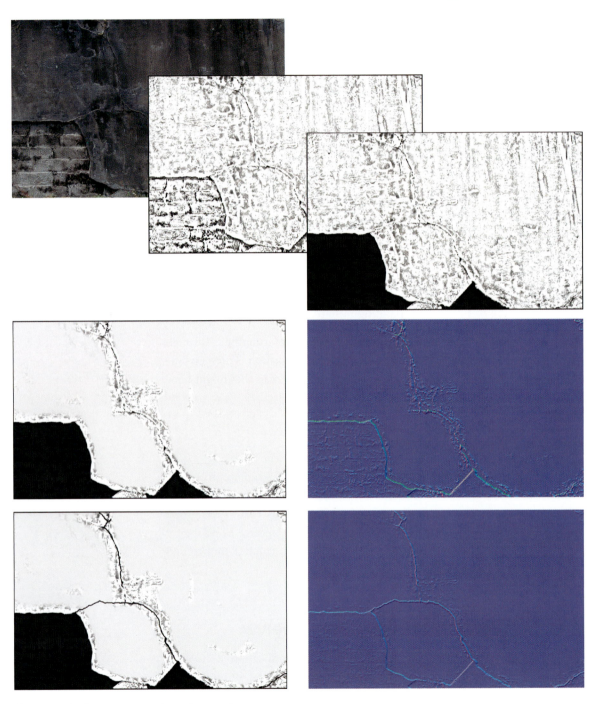

Figure 11-7 Creating a normal map from a photo.

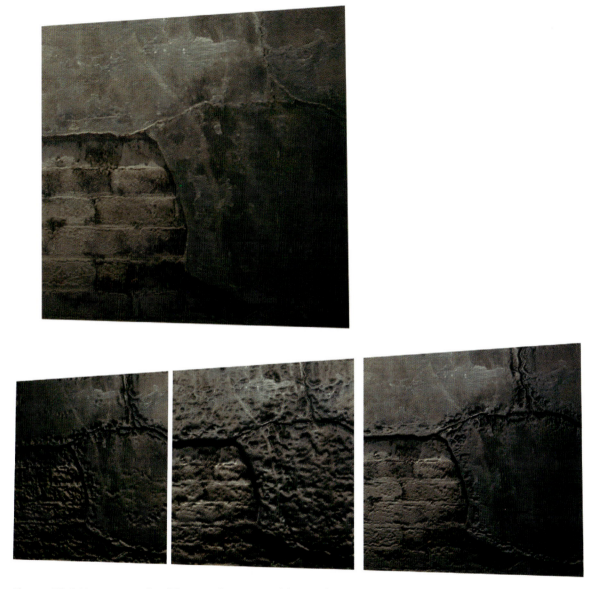

Figure 11-8 Various strengths of the normal map created from a photo.

generally involves arranging the two models so that they are on top of each other and generate the normal map correctly. This step can be the most time consuming and frustrating. When the application that generates the normal map is run, it is doing the following:

- Mapping an empty texture to the low-polygon model.

- Calculating, for each pixel of the empty texture on the low-polygon model, the corresponding normal from the high-polygon model.

- Recording that information in the texture map as an RGB value.

This method is what is required for very highly detailed characters and some organic props, but the time and effort spent on this method for environmental art (walls, floors, control panels, etc.) is overkill and often produces inferior results. If you can't achieve your result quickly in 2D, then here is a method for the quick creation of normal maps in 3D. Essentially, you model all of your high-poly details as separate parts so that you can arrange them and shoot the normal map once (Figure 11-9). In fact, a simple prop with a few sides can more easily be modeled and normal maps shot by building all the separate faces of the model flat (similar to laying out UVs, but in 3D), and shooting the normal maps and assembling them in Photoshop. I have seen inordinate amounts of time go into normal map creation for things as simple as vents on a wall (I am talking days) when it should have taken under an hour the first time and only moments thereafter since the asset can be reused.

ASSETS FOR THE FUTURISTIC INTERIOR

The assets for the futuristic interior involve mostly the creation of textures for the shaders. The models themselves are purposely very simple for this exercise so that you can clearly see the power of the normal maps and other shaders when applied to even the simplest geometry.

Wall Panels

Since we know that we are creating a shader that will involve multiple maps—diffuse (color), specularity, illumination, opacity, and a normal map—we need to set up the Photoshop file so that each map corresponds exactly to each of the other maps. If you have the frame of a light colored in the diffuse map, and it's supposed to protrude on the normal map and

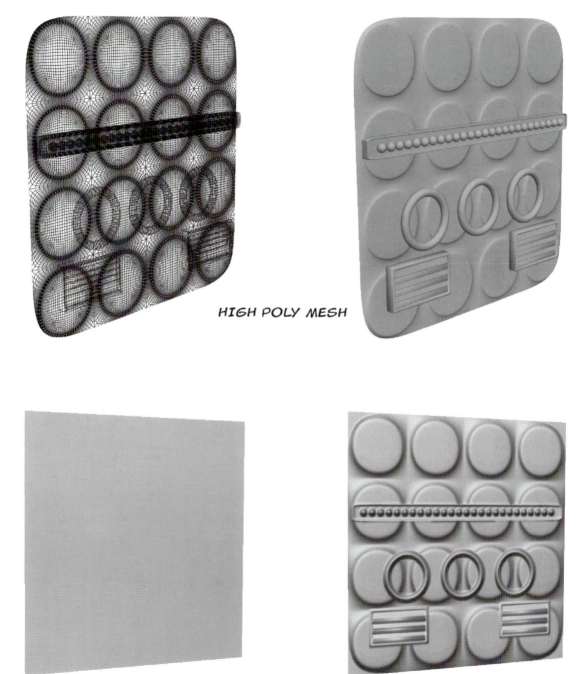

HIGH POLY MESH

POLYGON

POLYGON MAPPED

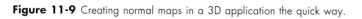

Figure 11-9 Creating normal maps in a 3D application the quick way.

you want the lens to be bright on the illumination map, all of these need to line up. Of course, Photoshop layers make this easy. This approach also allows for the rapid iteration of changes in each of the maps. Correctly setting up the file will greatly speed up your work, as all the maps created can be produced based on the first few layers you create. I usually start with a simple layout of the texture. For the wall panel, this is a black-and-white layout of the shapes of the panels and parts of the wall panel. Figure 11-10 shows the layers that compose the group for the shapes in the panel. From this I usually create the normal map right off to see if the concept can be achieved in 2D (Figure 11-11).

Color

This texture is created in the same way that the texture for the massive doors of the jungle base was created. Start with the group we just created for the layout of the panel and copy it. Name it *diffuse* or *color*. For the diffuse map, the stark black and white of the layout is taken way down (use Fill, not Opacity, to do this so that the layer styles are not affected). Having the shapes on separate layers will make texture creation easier on each map for various reasons. On the color map, you can use the various layers to apply subtle layer styles—a slight dark outer glow, for instance, to create the look of dirt in the cracks. You can use a color overlay to experiment with various colors quickly, and when you like what you have you can sample the color to create the paint layer (as we did in the jungle base). If you keep all parts of the texture that will later be displayed fully illuminated (such as lights on a control panel) on their own layers it will be much easier to create an illumination map later on. This applies to all the maps—even the specular map is easier when you can quickly isolate a panel using Ctrl—click on a layer.

This is also where I introduce overlays for dirt and scratches and other elements of color such as stenciled writing or stickers. These overlays can be used on each texture you create so that all the surfaces of the space you are creating will have consistency in the wear and tear and overall look (Figure 11-12).

Illumination

The illumination map is made by creating a new layer filled with black and Ctrl—clicking on the layers with the light colors on them and simply using

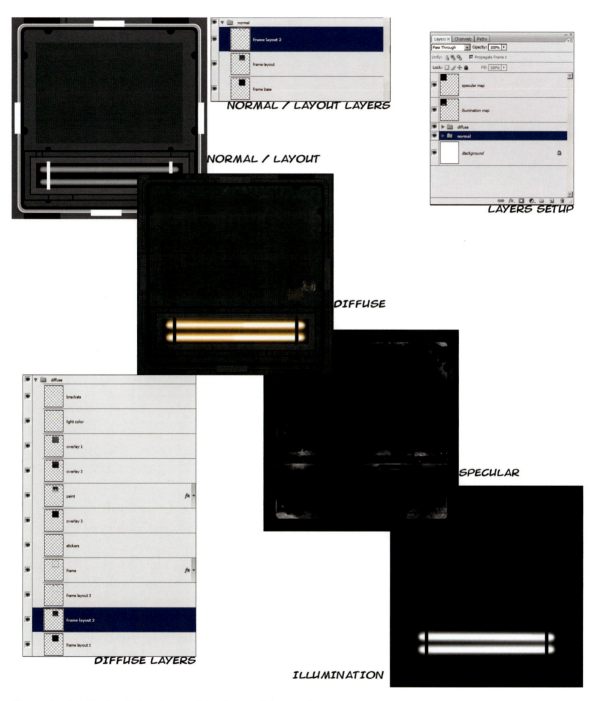

NORMAL / LAYOUT LAYERS

NORMAL / LAYOUT

LAYERS SETUP

DIFFUSE

SPECULAR

DIFFUSE LAYERS

ILLUMINATION

Figure 11-10 Black-and-white layout of the shapes of the panels.

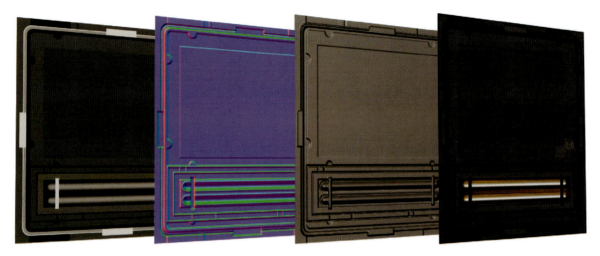

Figure 11-11 Normal map to see if the concept can be achieved.

Ctrl + I to invert the black to white on the new illumination layer. In this case, the only lights present are the two fluorescent-type tubes on the bottom of the panel. In Figure 11-13, you can see the difference between the texture with and without the illumination map present.

Spec

The specularity map is a copy of the entire texture that is darkened and then, because the various parts of the texture are on layers, we can Ctrl— click the layers to have precise control over the specularity of various elements of the surface such as the paint. The paint is chipped and peeling, and by selecting this layer's transparency, we can take the brightness up or down to make the paint uniformly shiny or dull. We can also dodge in scratches and scrapes. Remember that the white will be shiny and the black dull so that the edges of panels and the area around handles will be scratched and shiny. You can also paint with a white brush on a separate layer if you want to have more control over the effect and the ability to more easily redo and fix things later. In Figure 11-14, you can see the texture with the normal map and with the specularity map, and then all three together in the foreground. Another thing to keep in mind is that deep cracks and spaces shouldn't have specular reflection; this is one of the reasons many normal maps often look like molded plastic.

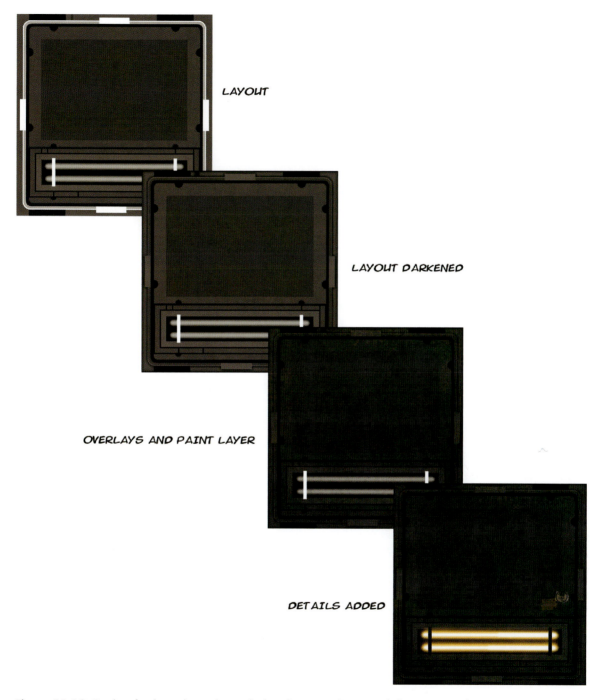

Figure 11-12 Overlays for dirt and scratches and other elements such as stenciled writing or stickers.

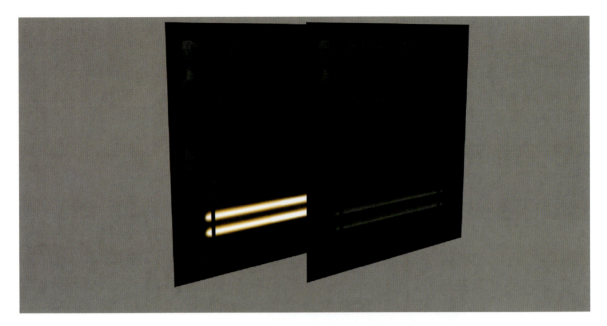

Figure 11-13 Texture with and without the illumination map present.

Figure 11-14 Texture with normal map and with the specularity map, and then all three together in the foreground.

Normal Map

The normal map starts out as a grayscale image, and I do several iterations with the NVIDIA normal mapping filter in Photoshop until I get the desired result. There are a few things to keep in mind when creating normal maps in this fashion:

- Watch for banding in the normal map. If this is a problem, work at a higher resolution, take the image mode up to 16 bits, and make sure the brush you are using is not only soft, but that the "spacing" is set as low as possible under the brush tip shape of the Brushes Palette.

- If you want to create multiple layers of depth, do this by working at multiple grayscale levels. Two objects crossing each other will appear as if they are on the same level and mashing together rather than on separate levels, if they are using the same values. Make one darker so that it seems to be farther back (Figure 11-15). Figure 11-16 illustrates the effect of changing the grayscale values.

- Remember that normal maps are very sensitive to value changes. If you want to include dirt on your normal map, the difference in value for the surface it is placed on should be very subtle. Brighten the

Figure 11-15 Multiple layers of depth.

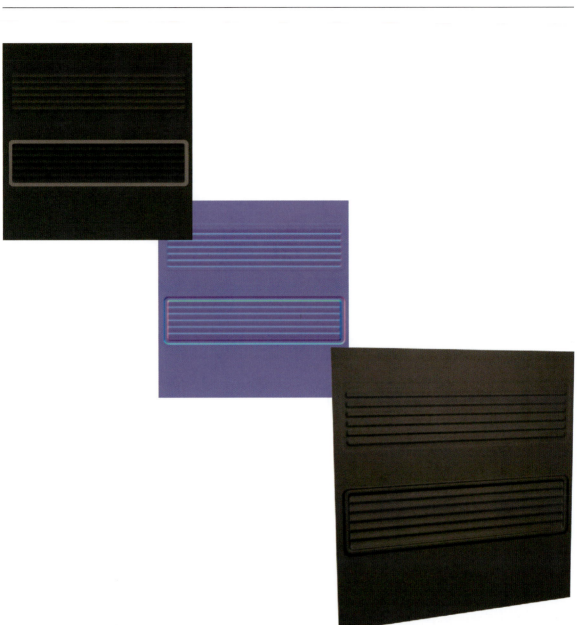

Figure 11-16 Grayscale value changes.

Figure 11-17 Dirt caution.

surface slightly and the dirt will protrude, darken it and the dirt will look like pits and dents. You may want to consider adding dirt last, after you have tweaked the major height appearances of the normal map. If you need to increase the values of the overall normal map at any stage, this also means that the effect of the dirt protruding from the surface will increase and will end up looking like huge lumps (Figure 11-17).

Save interesting objects for which you build normal maps, and create a library of vents, panels, and controls, among many others.

Wall Panel Variations

By creating a copy of the file that we just created, you can make variations of the wall panel—without lights, half-sized, or with different panel designs. By using the existing file, you can keep the texture visually consistent (Figure 11-18). Figure 11-19 shows more details for the open wall panel. This was constructed in the same manner as the other panels, but with added detail, that is, more panels and lights. Since there is so much detail in the normal map, I found that as I worked some parts looked good while

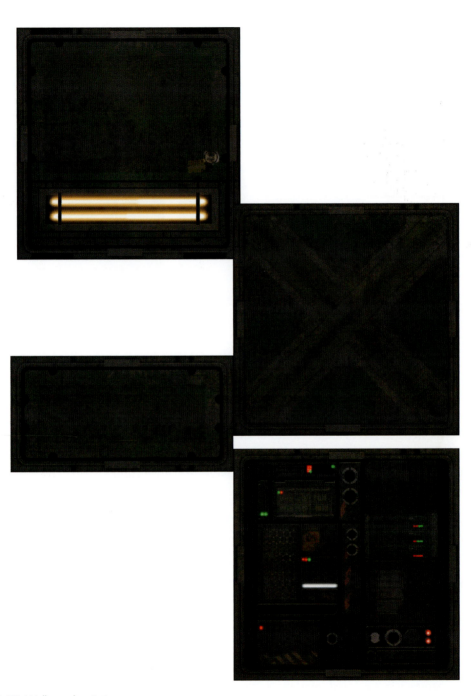

Figure 11-18 Wall panel variations.

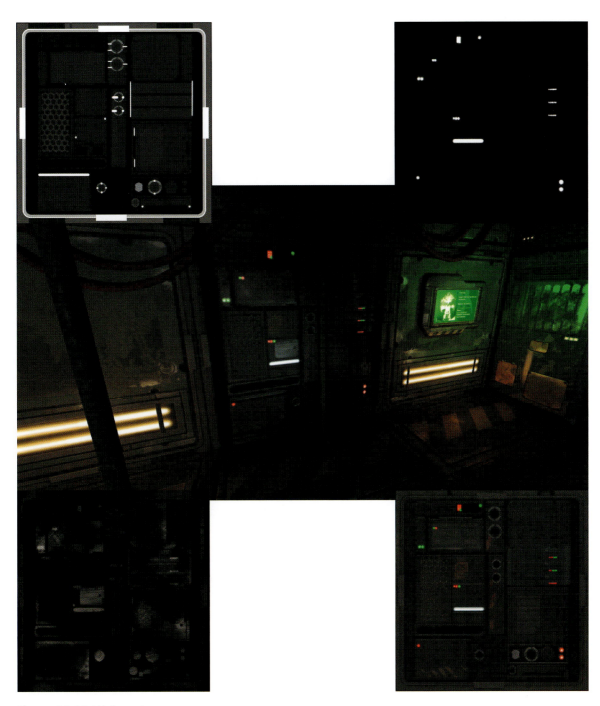

Figure 11-19 Wall panel open.

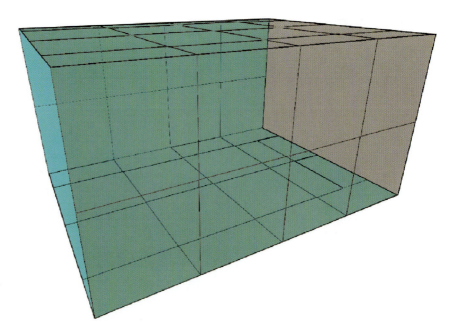

Figure 11-20 Wall panel open.

others needed more work. I wanted to continue to make some parts more prominent, so I simply saved a copy of the normal map at that stage and kept working. Later I combined the versions of each normal map and kept the parts I liked best to create the final normal map. In this case, I wanted to make the panels more prominent but that made the hose connectors too puffy, so I put the final normal map on top of the version with the good hose connectors and erased the connectors from the top layer. Remember to merge and renormalize. This is as complex as the geometry gets for the walls and floors at present (Figure 11-20).

Floor Panels

The floor panels are created starting with the wall panels, but these textures can be simpler (Figure 11-21), featuring diamond plate and caution stripes. I created a half-sized version with the caution stripe on it to be used around the edges of the hall (Figure 11-22).

Column

With the column, we introduce a slightly more complex mesh than the flat polygons of the floor and walls. This is still a simple mesh but involves a little UV layout (Figure 11-23).

Figure 11-21 Large floor panel.

Figure 11-22 Half-sized floor panel.

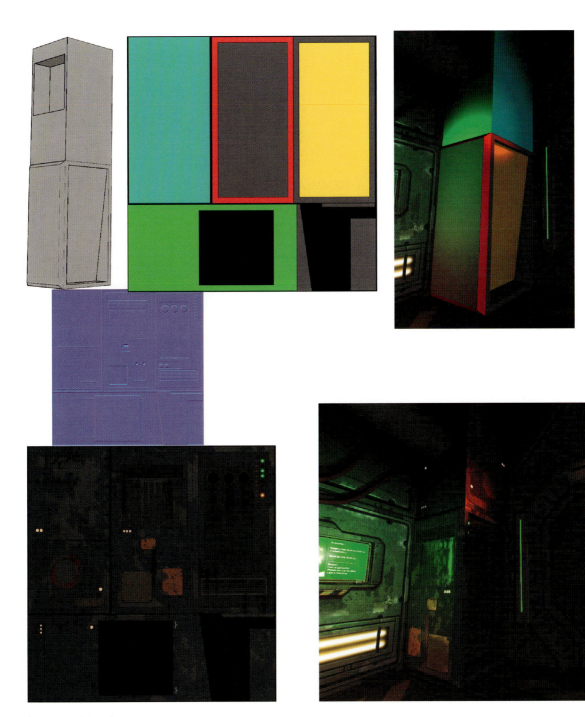

Figure 11-23 Column.

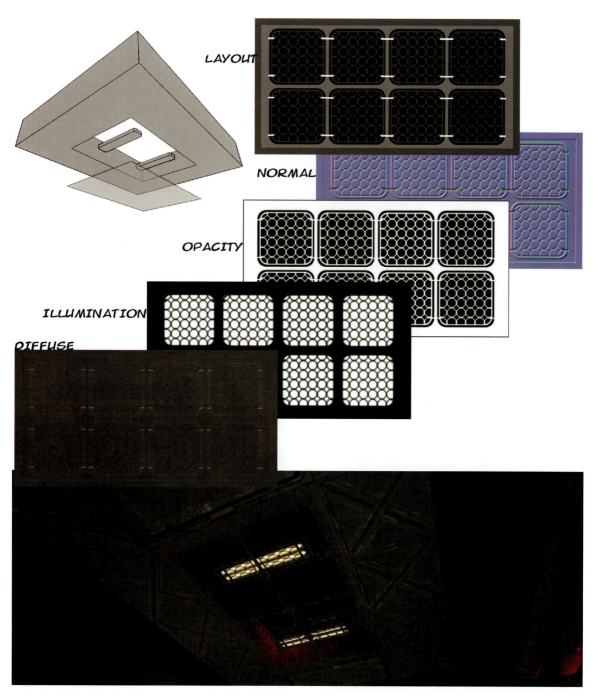

LAYOUT

NORMAL

OPACITY

ILLUMINATION

DIFFUSE

Figure 11-24 Light panel.

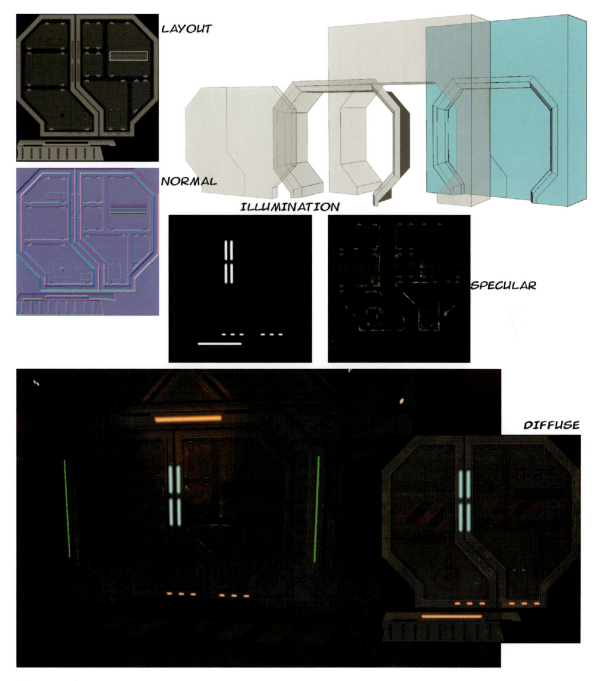

LAYOUT

NORMAL

ILLUMINATION

SPECULAR

DIFFUSE

Figure 11-25 Door.

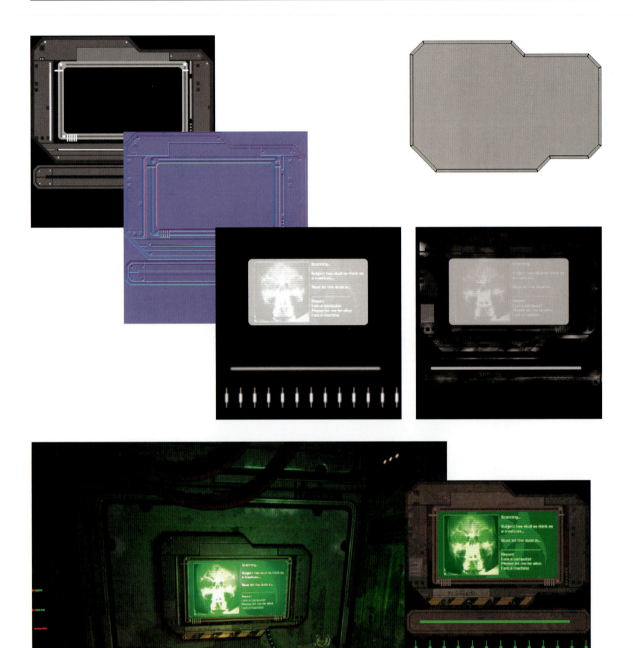

Figure 11-26 Monitor.

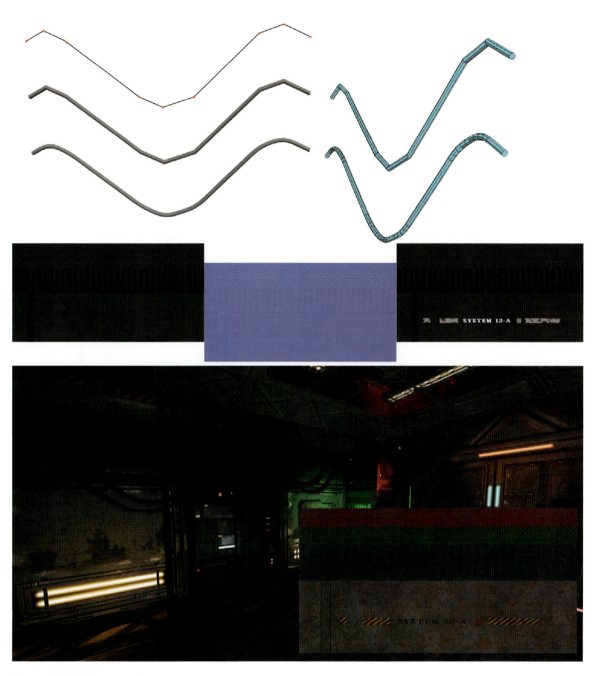

Figure 11-27 Pipes and hoses.

Figure 11-28 Hose detail.

Light/Ceiling Panel

The light panel (Figure 11-24) has only one unique texture, which is used for the grate. The others are wall panels and the lights themselves are from the wall panel with a light. There is also the introduction of the opacity map. While the illumination map can be a little fuzzy (so it appears that the area around the light is being lit), the opacity map needs to be exact if you want the grill to look clean. If it's fuzzy, the texture fades.

Door

On the door texture, I included the frame parts as well (Figure 11-25). The surface behind the door is a wall, so I textured it accordingly.

Monitor

The monitor (Figure 11-26) has a few overlays for the screen, and in addition to the illumination map, there is an actual light source in the scene that helps make it glow. The mesh is simply a line extruded and the front face beveled.

Figure 11-29 Final scene.

Pipes and Hoses

With the ability to add more polygons to our scenes, now we are able to include traditionally high-polygon (relatively speaking) objects such as hoses (Figure 11-27). Hoses are round and can be curvy—round and curvy means polygon intensive. Start with a horizontal tiling texture for a few hoses and a pipe or two. The addition of the specular and normal map creates a really cool texture on the hoses (Figure 11-28). Creating hoses is easy in Max if you don't bother with Lofting; create a spline running along the path you want your hose or pipe to run (can be bent in any direction in 3D space). In Max, enable rendering in the renderer and the view port, increase the radius to the thickness you desire, and fillet the vertices. You may also want to check the "Optimize" and "generate mapping cords" boxes on the control panel. Also make sure that the number of sides generated and the level of interpolation on the spline are not too high or you will generate needless polygons. Collapse to a mesh when needed. Figure 11-29 shows a rendering of the final scene with and without the shaders in place.

Index